Cultures of
South Africa

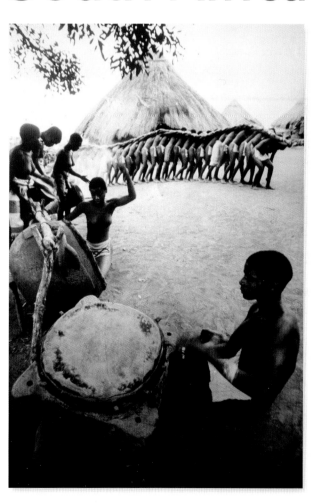

A CELEBRATION

Peter Joyce

with photographs by

Roger & Pat de la Harpe

SUNBIRD
PUBLISHERS

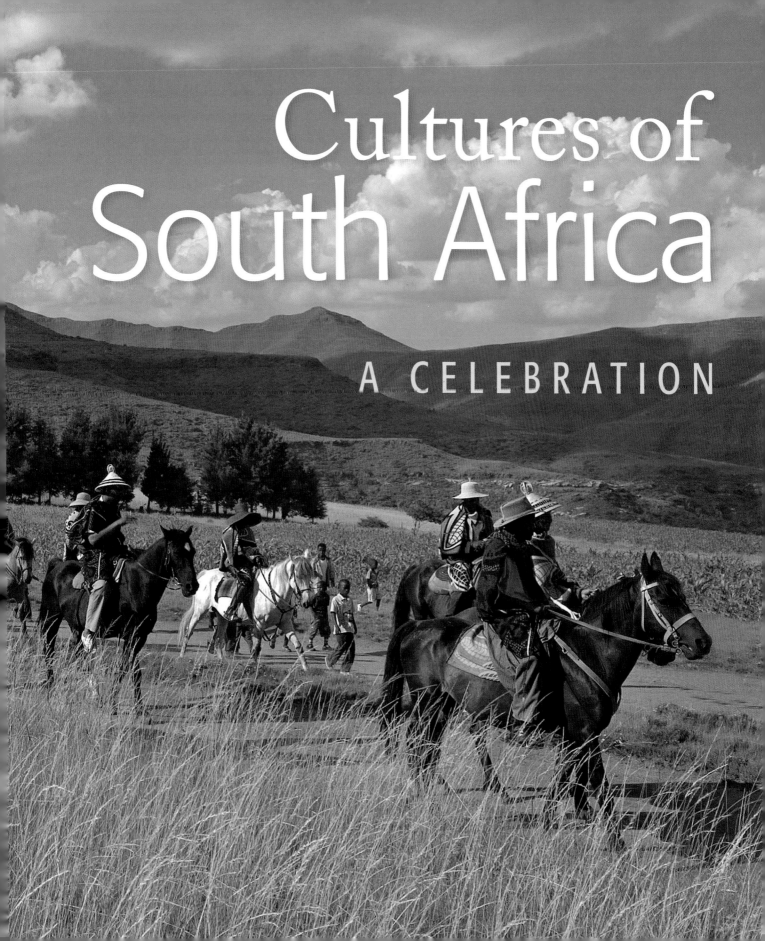

Cultures of
South Africa

A CELEBRATION

SUNBIRD PUBLISHERS

Sunbird Publishers (Pty) Ltd
PO Box 6836, Roggebaai, 8012, Cape Town, South Africa
www.sunbirdpublishers.co.za
Registration number: 1984/003543/07

First published in 2009
Copyright © text Peter Joyce
Copyright © photography Roger de la Harpe, unless credited below
Copyright © published edition Sunbird Publishers

MANAGING EDITOR Sean Fraser
DESIGNER Pete Bosman
REPRODUCTION BY Resolution Colour Pty Ltd
PRINTED AND BOUND BY Star Standard Industries (Pte) Ltd, Singapore

ISBN 978-1-919938-99-8

PICTURE CREDITS

AfriPics.com: pp 77 (Jack Weinberg), 97 (Anthony Bannister/Gallo);
The Bigger Picture/Alamy: p 107; The Bigger Picture/Reuters: pp 111, 127;
Corbis: pp 95 (Frans Lemmens/Zefa), 115 (Lindsay Hebberd), 123 (Lindsay
Hebberd); Ariadne van Zandbergen (www.afriaimagery.com): pp 65 (x2);
Gallo Images: pp 12, 14 (left), 98, 100, 101, 132–133, 134; Gallo Images/AFP:
pp 43, 92–93, 108, 124–125; Gallo Images/AFP (Gerard Julien): p 20; Gallo
Images/Die Burger: p 23; Gallo Images/Getty Images: pp 4–5; Images of Africa:
pp 2–3 (René Paul Gosselin), 75 (Shaen Adey), 81 (Hein von Horsten);
Ian Michler: pp 135, 138, 141; MuseumAfrica: pp 1, 4, 10 (left), 11, 18, 19 (x2),
22, 24, 26, 33, 40 (bottom), 48, 54 (right), 56, 57, 61 (top), 72 (top), 74, 87, 94,
104, 106, 116, 117, 128, 136 (x2); Nelson Mandela Metropolitan Museum:
p 21; Transnet Heritage Library: 40 (top)

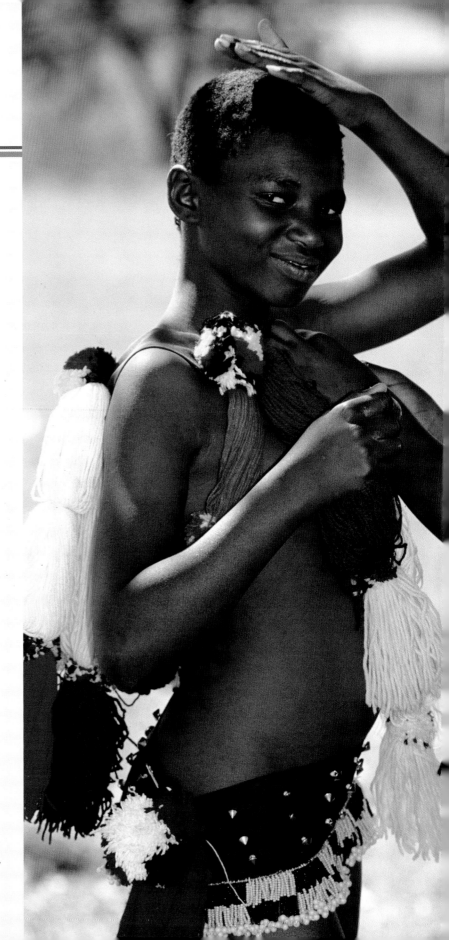

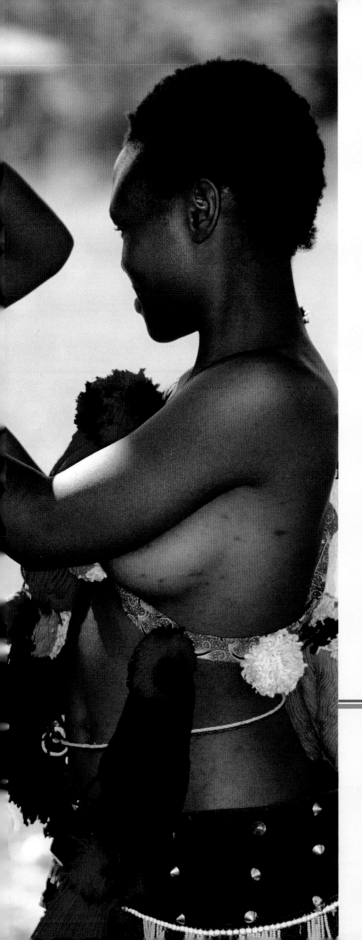

contents

COVER Zulu woman. Customs vary widely within the Zulu nation, but the responsibilities and rights of each marriage partner are always clearly defined, and always based on mutual respect.

HALF TITLE The snakelike rhythms of the *domba*, the traditional 'python dance' of the Venda people.

TITLE One of the great chiefs of the Mafeteng area honours a young bridal couple with a cavalcade of horsemen in Lesotho.

LEFT Every year the *Umhlanga* (Swazi Reed Dance) sees thousands of unmarried Swazi girls gather to pay homage to the Queen Mother and to perform for the king.

Introduction
The traditional Bantu

There is an inherent risk in writing about the languages and group identities of the many and various peoples of South Africa. The lines are blurred, sometimes imperceptible. Over the centuries, migration, merger and change have been the main historical constants on the human landscape; all is mix, nothing is absolutely clearcut.

The territorial coverage of this book is, therefore, inevitably arbitrary, chosen for practicality and clarity, roughly centred on but by no means restricted to artificial borders dictated by society and history and, most significantly, colonialism. Language and culture have no boundaries; elements of both are to be found and, indeed, are the principal cultural markers in lands well beyond what were formally designated the collective domiciles. The Swazi people – or, more correctly, the amaSwati – have their own, fully independent country, though a great many live in South Africa and SiSwati is one of that country's official languages. Lesotho and Botswana have similar status, so they too feature prominently in these pages. The overall emphasis, however, is on those language groups resident in South Africa.

Up to a point, the 'homeland' divisions of the apartheid government were valid enough, since the designated groups did indeed occupy these (and other, much bigger) areas. But they all came from elsewhere; some of them, in fact, quite recently. Many are the products of the fission and fusion of the past, with some peoples breaking away from the main body to form independent societies and to build their own canons of tradition, custom and law; others being absorbed, often voluntarily but sometimes involuntarily, into bigger or more powerful communities. There are a myriad exceptions to the general rule, of course. There are distinctive subgroups within individual groups, and some of these subgroups even have components that are culturally separate.

The canvas is huge, complex, infinitely nuanced, so the big picture is painted with very broad strokes, generalised and even oversimplified.

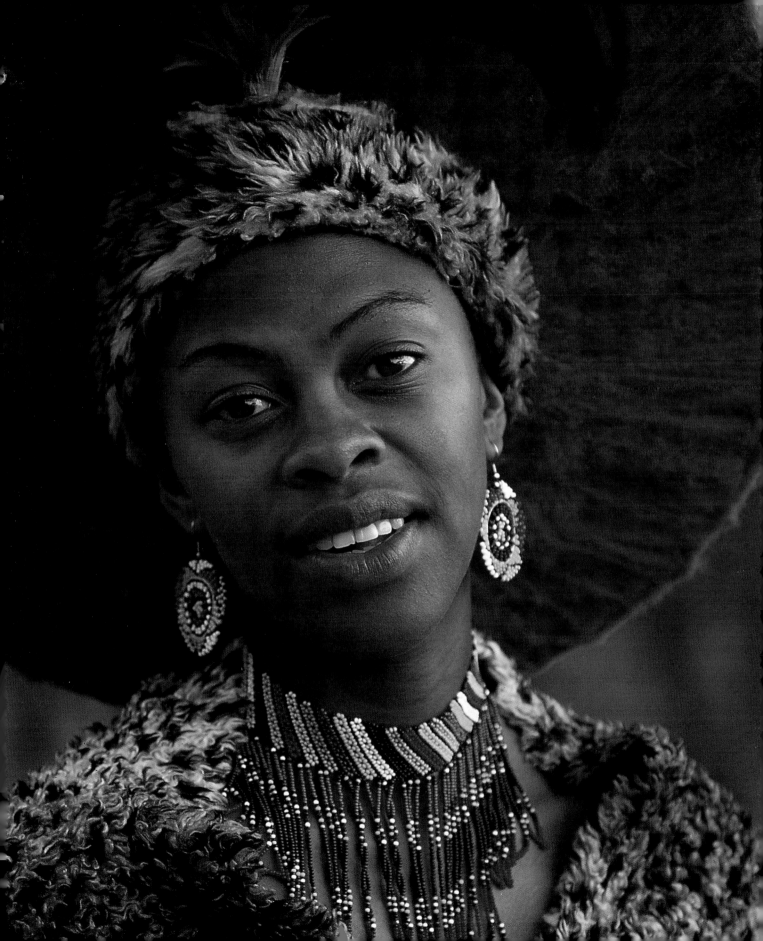

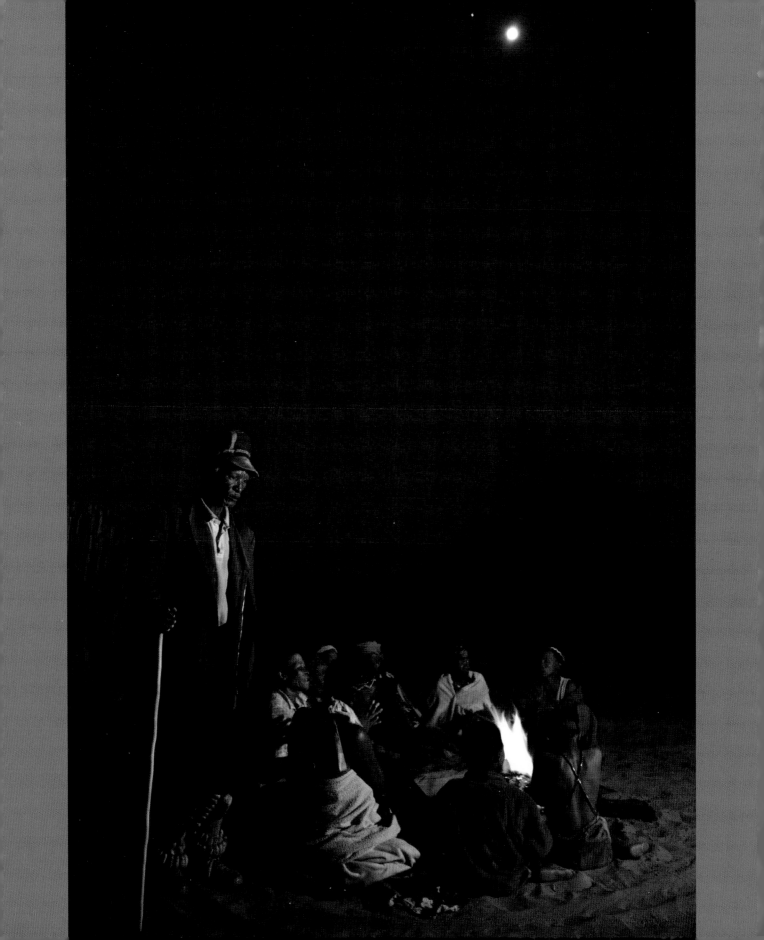

LANGUAGE AND CULTURE

Tradition and custom (and the segregationist policies of the apartheid government that saw the establishment of 'homeland' states) have seen to it that, to a large degree, the distribution of South Africa's population groups across the country has remained much as it has always been. However, with the advent of industrialisation, particularly the job opportunities offered by mining and other industries, traditional groups (and their language and culture) are now more widely spread than ever before and geographical delineation is no longer as clearly defined as it was in the past. The key below is thus a simplistic breakdown of an otherwise complicated split of South Africa's diverse peoples and cultures.

Distribution	Traditional group	Language	Percentage of population
	Sotho	Sesotho	7.9%
	Tswana	Setswana	8.2%
	Xhosa	IsiXhosa	17.6%
	Ndebele	IsiNdebele	1.6%
	Venda	Tshivenda	2.3%
	Tsonga	Xitsonga	4.5%
	Northern Sotho	Sepedi	9.3%
	Zulu	IsiZulu	23.8%
	Swazi	SiSwati	2.7%

South Africa has eleven official languages. Two of them – English and Afrikaans – are considered imports and are widely used as second languages. About 8.2 per cent of the population speaks English, and 13.3 per cent Afrikaans. However, if you go back far enough all the country's supposedly indigenous languages are, in fact, exotic. Around four out of ten people speak either isiZulu or isiXhosa in the home, and English is widely used in the education system and in business.

Of the indigenous tongues, those of the so-called San (Bushman) hunter-gatherers and the seminomadic Khoekhoen only traces remain – or rather, barely sustainable linguistic pockets survive, against the odds, mostly on the great sandy plains of the northwest, in Namaqualand and Namibia.

There are in fact just two African language systems in the region – Sotho and Nguni. Nearly all the other languages are dialects of one or the other; all are classed as 'Bantu', and even that is semantically incorrect. 'Bantu' refers to the people themselves, the Ntu-speaking people. Questionable, too, is the name 'San', though not incorrect so much as of dubious origin: it seems that, among some early Khoekhoen peoples, the word meant 'outsider' and carried other, related and more insulting overtones.

In *Cultures of South Africa: A Celebration* we have opted to use the conventional English-language adoptions of traditional group names that are more familiar among an English-speaking readership: the Xhosa, Zulu, Southern Sotho, Tsonga, Northern Sotho, Swazi, Ndebele, Venda and Tswana.

OPPOSITE In the stillness of the night. The San live in harmony with the environment, at one with this and other, mystic worlds.

9

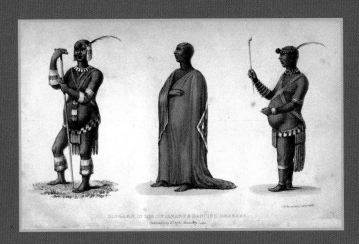

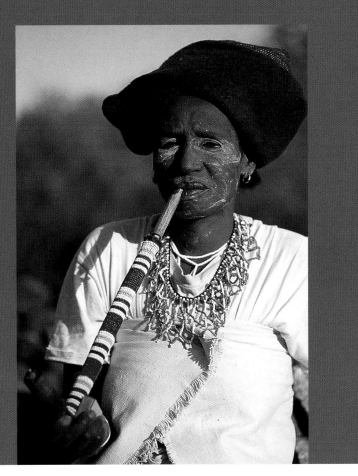

ABOVE Stylised colonial representations of Zulu king, Dingane in
dancing costume and daily wear.
RIGHT The traditional Xhosa smoking-pipe, which was modelled
on its long-stemmed European clay counterpart and attractively
decorated with beads or inlay. Originally, Xhosa smokers used a
pipe made from horn and reed.

Two commonly accepted words merit further mention. 'Nation' has been used here within a
strictly South African context (that is, excluding the separate but culturally linked states of Lesotho,
Swaziland and Botswana) because, although the language-based groupings do have a traditional
hierarchy ascending through the layers of authority to paramount chief, none has ever had a
national boundary. Each has been a highly fluid society.

The only possible exception is the Zulu, who embraced the modern concept of nationhood
under the leadership of Shaka Zulu in the early 1800s. From the start they lived and fought as an
integrated military state – a legacy that still commands a proud place in the hearts of Zulu people.

But even the Zulu were a fragmented group, a society more properly described as the Northern
Nguni confederation, an amalgam of some 800 large and small, some tiny, 'tribes' which Shaka
welded together by sheer force of personality and with the help of some impressive battle tactics.
The original Zulu themselves were an insignificant little patch on the Nguni tapestry, their number
no more than about 1 500.

This introduces the second contentious word, 'tribe'. By definition, a tribe is a closed society,
with it own history and lore, its dynamic internally fuelled, its territorial and, more importantly, its
cultural integrity stoutly defended against intruders. This kind of grouping has never really existed
on the southern subcontinent where, as noted, the groups have mixed, made alliances that have
evolved into bigger units, adopted and adapted, conquered and absorbed or fled and dispersed.

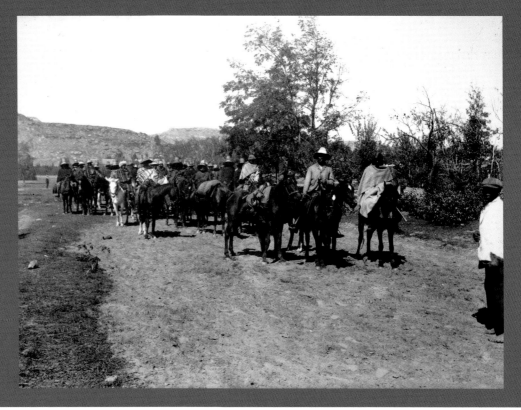

RIGHT Basuto on a pony-trek in the 1920s. Arab horses were originally crossed with thoroughbred English stock, and then selectively bred for the high and rugged countryside of the Maloti Mountains.

Overarching all, however, are the affinities. In most respects, the Ntu-speaking peoples still have common belief systems, the same reverence for chief and kin, the same code of honour, the same concept of land ownership and so on. The characteristics that unite are, in fact, far stronger than those that divide.

Legacy of the forefathers

The Bantu legacy is an impressive one. Their societies were organised to maintain a strict moral order, a sensible division of labour and the security and honour of the group. The whole social structure was based on the extended family unit and, less obviously perhaps, on clan relationships. These ways remain to a large degree integral to many modern communities, mostly among those individuals who follow traditional disciplines (predominantly in outlying rural societies) but also among those who have, in most other respects, adopted contemporary lifestyles more in line with white Western traditions. For this reason, there is some academic debate as to whether modern literature on the subject should be in the present or the past tense. Both approaches are justified – strictly traditional custom may well be relegated to history and has by and large been replaced with a more modern interpretation. This is certainly true of dress and, to a certain extent, lifestyle and even language. However, the fact remains that the traditions with which many South African

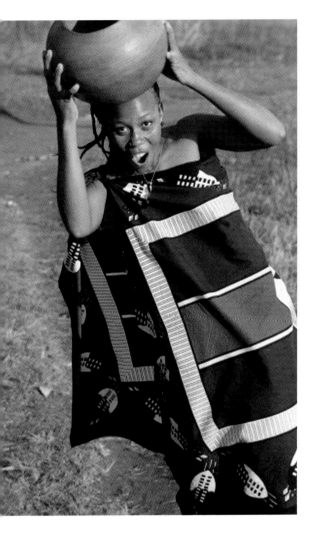

ABOVE Traditional ceremonial clothing was dictated by age, status and the occasion. Here a young Swazi woman carries a Swazi pot, fashioned from clay, and built upwards from a flat stone by progressive coiling.

families are raised today are premised on the customs that originated with the forefathers. For our purposes here, we have attempted to remain true to the current state of the nation – where we discuss clearly historical contexts (such as men being herders and warriors and women keepers of the homestead), we use the past tense, and where we discuss customs that have transcended history and still have a significant bearing on the everyday lives of individuals (the role of healers and diviners, and rites of passage), we use the present tense.

Arrival and settlement

The Bantu originated in the Great Lakes region of east-central Africa, moving south in slow rolling waves from the early centuries of the Christian era, washing down the eastern coastal belt and across the great interior, gradually taking over the lands occupied by nomadic San and, later, of the more technically advanced Khoekhoen.

The newcomers kept cattle, grew millet and used iron, factors that reinforced the territorial imperative and the need to dominate. The vanguard of the first of two great migrations reached today's KwaZulu-Natal around the end of the fourth century (Iron Age sites dating back to about AD 400 have been unearthed). Some 300 years later – nearly a millennium before the first of the white settlers set foot ashore at Table Bay – their leading edge had cut into what is today's Eastern Cape.

Later still, around the mid-tenth century, the northern Bantu established fortress-like settlements built of stone, powerful citadels of which Mapungubwe in what is today Limpopo province was the greatest, a sophisticated centre of commerce that linked into a trading network that reached, albeit somewhat indirectly, across southern Asia to China (see page 130).

None of these large-scale movements of peoples was a deliberately planned migration but, rather, a kind of spontaneous infiltration. When the non-inheriting sons of an extended family, for instance, wanted cattle and fresh pastures of their own they simply moved on. There was plenty of land for everybody and, provided you were reasonably well armed, it was free for the taking.

Perhaps the key event in the weaving of the more-or-less final pattern of southern African settlement was what the Nguni call the *mfecane*, the Sotho *difaqane*, loosely translated as 'the crushing'. This was a series of devastating local wars and forced marches that killed millions and turned millions more into refugees, a domino-like sequence of events triggered by Shaka's imperial conquests along the eastern seaboard. Hitherto stable communities were scattered, some fleeing south to Xhosa country (these were the Mfengu), others north and west onto the broad plains of the central plateau where they encountered resident groups who, in their turn, would move on to displace yet other populations, and so it went on for a decade and more. (See pages 59–60.)

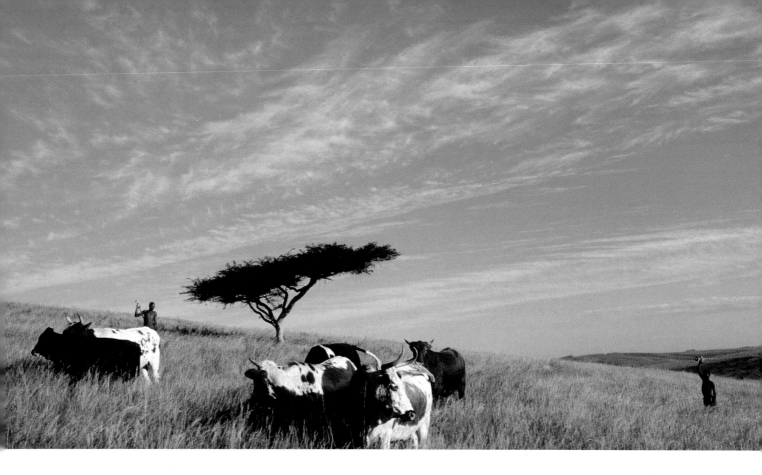

Custom and conviction

According to Bantu tradition, men historically served as stockmen, hunters and – when the need arose – as soldiers. The woman was queen of the homestead, caring for children and hearth. It was she who gathered the firewood, fetched water from the stream, cooked and cleaned, cultivated the fields and, at all times, preserved a demeanour of dignified respect towards her husband. Such demeanour, though, should not be confused with outright submission; it was part of a contract, and the respect was mutual. Indeed, if the husband failed to fulfil his marital obligation, she would in most cases be allowed by customary law to return to her family. Nor, in some communities, was she barred from attaining political position. A number of Bantu groups were led by their queens.

The ancestors featured – and still do – with striking prominence both in religious belief and cultural celebration, occupying the epicentre of the kind of spiritual and bardic tradition that characterised, for example, ancient Celtic societies and, in their heroic folklore at least, the Greeks in classical times.

The belief system remains both intricate and, to outsiders, confusing, but it can perhaps be simplified by isolating the four main components, or emphases. These are the existence of a Supreme Being, animism, veneration of the ancestors and recognition of their spiritual presence and, fourthly, the intercession of spirit mediums gifted with special mystical abilities. The precise nature of these elements differs in detail from group to group, but the fundamentals are more or less the same throughout Bantu society.

ABOVE Zulu herdboys and their precious cattle in big sky country. The animals were markers of wealth and status and rarely slaughtered, though they did occasionally feature in sacrificial rituals.

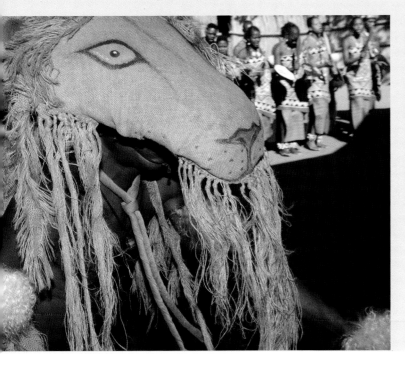

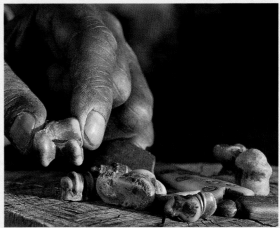

ABOVE The careful hands of a *sangoma* throw the bones. These traditional 'doctors' are specialists: some have 'second sight', while others use potions or dolls.

ABOVE Animism and related religious practices are common to all Bantu groups. Among some there is a belief that an especially venerated ancestral chief or folk hero can return in the form of an animal. This representation of a Swazi lion, though, is largely symbolic.

The concept of a Supreme Being is more an assumption than a discernible entity, based on the belief that someone must have designed the landscapes and the incredible, almost magical, interrelationship of all living things. While for many believers the Creator did exist, in most peoples' perception he or she was infinitely remote, vaguely defined, all-powerful, but not really involved in the minutiae of human affairs. In other perceptions, he or she may be closely associated with the sun, or the sky, or with the long-gone founder of the group. The name, too, varies; in the north it was, among others, Mlimo, Midimo or Milimo, and in the east Nkulunkulu (Great Great One).

Animism, a word derived from the Latin term for 'spirit' or 'vital breath', was and still is (especially in the rural areas) an accepted part of the natural order. Essentially, it means a conviction that inanimate and intangible as well as living objects – lakes and rivers, hills, stones, the wind and rain, together with animals and plants – have personalities, or souls. Spirits, it is believed, are everywhere, some residing within natural features and objects, others independent, some malign, some friendly, many simply mischievous.

Separate from these are the spirits of the ancestors, who have the power to help and, when displeased, to punish their descendants. These spirits have to be propitiated by sacrifice, perhaps of a chicken or a goat or, when special 'prayers' are demanded, of a cow.

The link between the ancestral and the material worlds is the diviner or spirit medium, who is able to diagnose a litany of mostly psychological ills, although his or her actual methods differ from community to community. The diviner is often mistaken by non-Africans for a 'witch doctor', but the two are by no means the same. This is a complex and sensitive subject. In traditional African society, witchcraft is feared and abhorred.

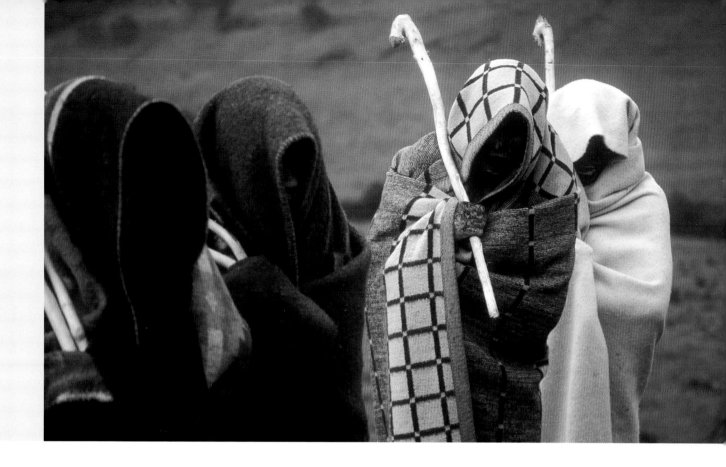

Another kind of healing, essentially different from the diviner's work, is that of the herbalist, who fills the role of doctor and uses his or her intimate knowledge of the veld, its plants and its animals to mix and make medicinal potions.

Birth, initiation, betrothal, marriage and death are celebrated and mourned in often elaborate and protracted ceremonies. In some societies it is the eldest son who inherits; in others the son of the senior wife, who may not be the child of the first union. Betrothal and marriage are carefully arranged affairs. The bride price is paid in cattle by the groom's family and gifts are exchanged. Before this, though, the couple has to complete their initiation into adulthood. The girls and boys follow separate, hallowed rituals before being admitted to full membership of the community. The transition is regarded with reverence as the most important step in life's journey, and the process is complicated and full of symbolism. The boys often undergo painful circumcision. Female circumcision – degrading and hugely controversial – does not feature in South African traditional society.

The conventions of authority and kinship are not easily summarised. They are immensely intricate, nuanced and, although there is much that is common to all, they too differ from group to group. Generally, however, loyalty is extended first and foremost to the chief, a person who can claim a noble bloodline. In many instances, he (and sometimes she) is accorded magical powers, knowledge of secret medicines and a special relationship with the ancestors or, at least, he keeps his shaman close to him to provide these powers.

On the other hand, the traditional chief is rarely an autocratic figure. He governs – or, perhaps more correctly, administers – according to customary law with the consent of the people and in

ABOVE *AmaKwetha* (Xhosa initiates) huddle together after the prolonged and painful initiation process. For much of the time they are costumed in grass skirts and masks, their faces whitened to ward off evil.

consultation with the elders. On occasions the consultation process involves the whole community in assembly.

One of the enduring legacies of the traditional Bantu is the great body of myth, legend and folk tale that survives and enchants – and which has found its way, in various guises, into other societies beyond Africa's shores. Aesop's famous fables, for example, are said to have been based on stories from Africa, that Aesop himself was a slave of African descent (the name could be a corruption of Aethiops, a man from Aetheopia, the ancient name for Africa). More clearly linked to the continent are the tales told by African Americans of the deep south, of Brer Rabbit and Brer Fox and other trickster characters. They were first published as the stories and songs of Uncle Remus, an old (fictional) slave. The wily hare is a central figure in the lore of southern Africa (his West African counterpart is a spider), and some say that in the USA he represented the slave whose only defences against oppression were a quick wit, resilience and a well-honed instinct for survival. Similarly, Africa's hyena became America's Brer Fox and Brer Wolf.

The chameleon is one of the constants of Bantu oral literature, and plays a remarkably consistent part in explaining how death came to the world (he was too slow to deliver God's message). Serpents also feature strongly; thunder and lightning are dramatically personified, and of course there are endless tales of witches and goblins, of spirits, and of the dead returning to life.

ABOVE Rickshas were introduced from Japan about a century ago as a practical way to get around the growing city, but modern means of transport soon took over and they, and their 'drivers', became an ever more elaborate tourist attraction. The designs bear little relation to authentic Zulu ornamentation.
OPPOSITE While the Zulu tradition is a strong one, based on a long and proud heritage, most Zulu men and women, even in rural communities, have adopted Western dress.

One last word: this book celebrates the traditional ways of South Africa's indigenous people. The old Africa has, however, long gone. The erosion process began with the expansion of the early white colonial settlements more than 300 years ago and the arrival of the Christian missionaries, then rapidly accelerated after diamonds and gold were discovered in the northern interior. The finds marked the beginning of the industrial era and of massively disruptive urbanisation. The great majority of South Africans have long been exposed to the blessings and curses of an acquisitive culture; group identity and the time-honoured order of traditional African society have been eroded, all but extinguished in the towns and cities.

Nevertheless custom, tradition and ancient loyalties do persist, most obviously in the remoter parts of the countryside. A first-time visitor to South Africa should not expect to see the streets graced by men and women dressed in tribal costumes, but they are still worn on ceremonial and festive occasions, most often in the rural areas. And something of the past is on view at the many cultural villages, or 'living museums', that have been created around the country.

That is the visual heritage, or what remains of it. More enduring are the abstracts, which are enshrined in the rules of courtship and marriage, for example; and in matters of inheritance and guardianship; in concepts of wealth; in clan seniority and chiefly seniority; in kinship bonds; and in spiritual relationships with the ancestors.

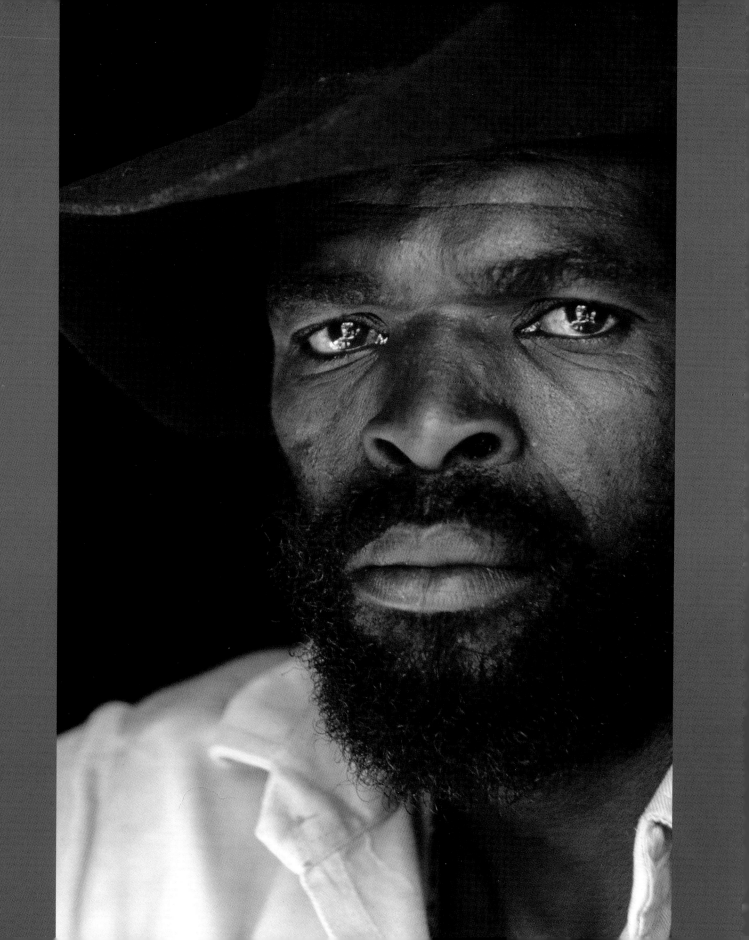

The new arrivals
From across the seas

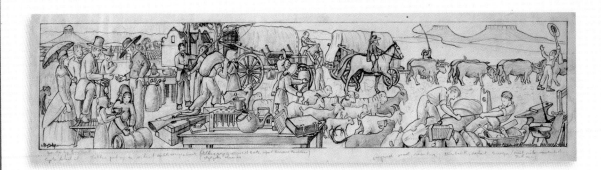

Many South Africans today can trace their cultural and linguistic heritage to one – or, indeed, more – of the varied groups that set foot on these shores in relatively recent times: the Dutch, the English, Jewish émigrés, indentured slaves from the East, and travellers from the rest of Africa and beyond. These varied groups made their home in South Africa either through choice or circumstance and many mingled happily and productively with indigenous African groups that had already settled on the subcontinent.

The Dutch connection

Many of today's Afrikaners are able to trace their roots back to the first Dutch party that arrived way back in the 1650s. In the succeeding centuries of migration, conflict and settlement their descendants took occupation of much of the land stretching across the great interior plateau to the Limpopo River in the far north.

The Dutch element, however, is not as large as one would perhaps assume. Over the decades, people of other nationalities joined the growing community, and its gene pool is a rich mixture of antecedents. One estimate pegs the ancestral mix at only 40 per cent Dutch, a surprising 40 per cent German and a lesser though still significant proportion of British (principally Scottish), French, Khoekhoen and Nguni.

The French strain emanates from Protestant Huguenots who fled the religious troubles of late seventeenth-century Europe, and who found a home in the countryside north and east of the Cape outpost. Their legacy can be seen in the simple, elegant architecture, in the extensive vineyards, and in such Afrikaner names as Du Plessis, Pienaar, Marais, Du Toit and Le Roux. The

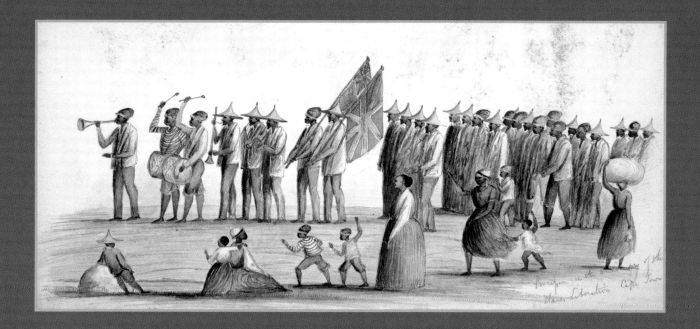

OPPOSITE A depiction by artist WH Coetzer of the Great Trek, the migration of Boers into the interior in the 1830s.
ABOVE Former Cape slaves celebrate on the anniversary of abolition with a parade through Cape Town's streets.

BELOW The signatures of Huguenot immigrants. They and their descendants were completely assimilated into Afrikaner society, and many Afrikaans-speaking families continue to carry the names of the French Protestants.

'van' prefixes are, of course, Dutch. Curiously enough, nothing remains of the German influence: assimilation was complete.

When the British occupied the Cape – 'anglicising' the colony, liberalising its race laws and bringing an end to slavery – life seemed to become intolerable to many Afrikaners (then known as Boers, or 'farmers') of the troubled eastern 'frontier' lands. So from the 1830s Boer families began packing their belongings, hitching up their wagons and heading north and east in search of their Promised Land. This movement became known as the Great Trek, a mass migration away from perceived oppression and toward independence and an Afrikaner national identity. Its northern prong struck deep into the north, whose great plains, contrary to popular perceptions, were anything but empty. To the African peoples of the region, the trek was hardly a heroic odyssey but rather simply a massive land-grab and it was bitterly resented.

In due course the settlers created their independent republics: the Orange Free State and the Transvaal. Sustaining a hatred of British imperialism, fearing the loss of their faith and freedom and, above all, of being 'swamped' by the great mass of black Africa, both republics introduced divisive race laws that would ensure that their countries remained 'white'. This was the dynamic that helped create the apartheid state that was to emerge in the all-white elections of 1948, when the ruling

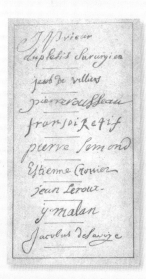

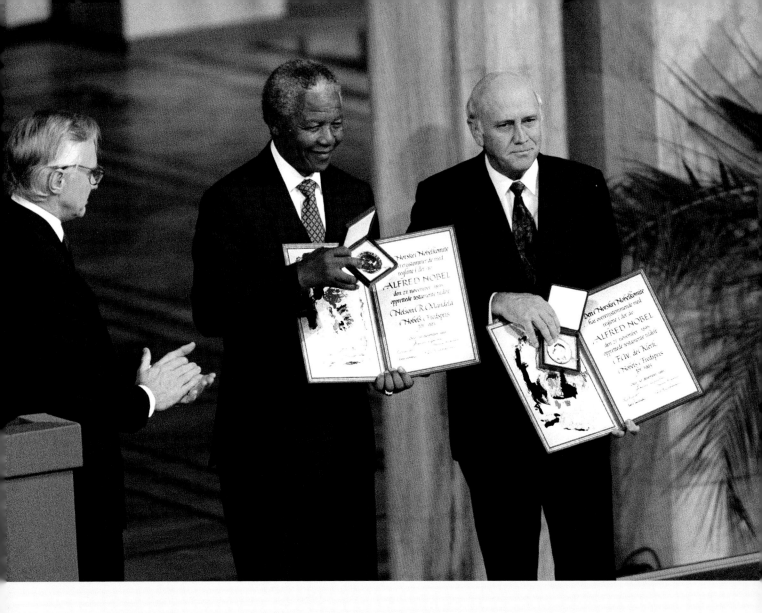

ABOVE Bridging the great divide: Nelson Mandela, a Xhosa, and FW de Klerk, an Afrikaner, share the 1993 Nobel Peace Prize.

National Party began to parcel up the country along highly inequitable racial lines. This was to be the South Africa of the next forty-odd years — until, eventually, Afrikanerdom began a dialogue with its fellow citizens that led to racial accommodation and the introduction of democracy.

Undoubtedly, it was the politics of Afrikanerdom that had the greatest influence on South African society, but its language, too, had significant impact on the socio-political environment of the twentieth century. Afrikaans is one of the world's youngest languages, its stem the High Dutch of the 1600s. It evolved as a kind of patois or dialect, taking on new words and inflections over the years of isolation from the motherland and, later, from the Cape settlement itself. But only after a prolonged and often acrimonious campaign during the nineteenth century and with the emergence of Afrikanerdom as a serious political force, was it formally recognised.

Despite all its conservative influences, Afrikaans and the Afrikaans-speaking community contributed enormously to the new South Africa of the 1990s. Liberal-minded artists and writers, churchmen and academics were especially influential, but many others all contributed to the reformist movement that began to creep onto the political stage in the 1970s.

Enter the English

The Anglo-South African segment of the population differs markedly, certainly in historical and cultural terms, from its Afrikaner companion. Its origins lie in the cities rather than the countryside; in business and industry rather than farming; in the coastal belt rather than the interior. Its background is colonial, not pioneer.

The first of the English waves washed ashore at Cape Town in the late 1700s when redcoats took over the Dutch colony and, in due course, provided the military muscle to 'anglicise' the Cape. Part of the process involved organised immigration. In 1820 some 4 000 English settlers were brought in to stabilise the strife-torn eastern 'frontier' areas – the disputed Xhosa lands. Most of the newcomers were English townsfolk who knew little or nothing about farming and they soon gave up, retiring into the region's garrisoned outposts, but, still, they did help change the character of the colony.

Meanwhile other Britons were making their way to Natal. The first English-speakers here – ivory hunters, traders and a small party of adventurers – had been granted land in today's Durban area by a surprisingly amiable Shaka Zulu. The settlement took root, and it grew – though very slowly – and the region remained staunchly British in its outlook and loyalties for the next hundred years and more.

Discovery of the first diamonds (at Kimberley) and then gold (Johannesburg) prompted the second wave of English-speakers or, more correctly, of what the Boers called *uitlanders* (foreigners) from all over the subcontinent and the world. And finally, after the Second World War, a substantial number of Britons decided on a new start in sunnier climes and, for some, South Africa seemed the ideal destination.

BELOW The arrival of the English in 1820. Boatloads of immigrants were rowed ashore at the infant settlement of Port Elizabeth (known as Fort Frederick at the time) and driven inland in a bid to stabilise the eastern 'frontier' region.

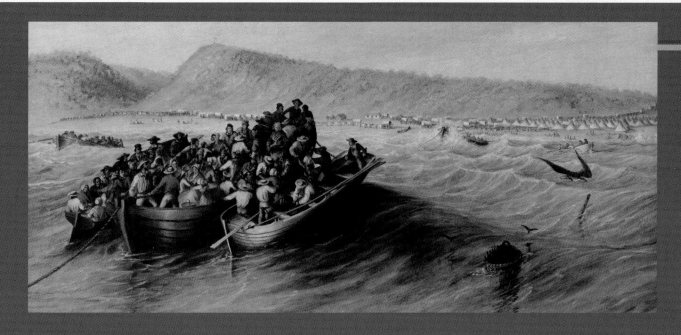

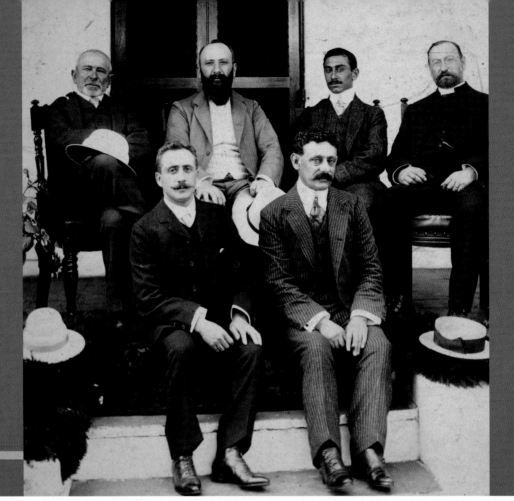

RIGHT From itinerant trader to tycoon, Sammy Marks (top left), started out as a hawker of cutlery and cheap jewellery, graduated to diamond buyer, and built an industrial empire. Pictured with him are (back, left to right) are David Woolfsohn, Louis Mark, the Very Reverend Rosenberg and (front, left to right) Joseph Heyman and Sir Harry Grauman.

Stars of David

South Africans of the Jewish faith have a surprisingly long history: several (non-professing) Jews were members of the first colonial settlement in the 1600s, despite the ban on non-Christians. But it was only after religious freedom was granted in the early 1800s that the number began to show meaningful growth. The inaugural congregation was founded in 1841, in Cape Town, and the first synagogue (Tikvat Israel, or 'Hope of Israel') made its appearance eight years later. It is still standing.

Many of the great developments of the nineteenth century called for Jewish financial and business expertise. Jewish trekkers moved into the great interior with the Boers and created a trading infrastructure for the young republics, helping to direct their economic progress. Best known of these individuals, perhaps, was Sammy Marks, a Lithuanian immigrant who started out as a hawker and eventually created a business and mining empire. At the same time, Jewish migrants were arriving in growing numbers, many of them refugees from the savage pogroms of Eastern Europe. Much later, in the 1930s, the trickle became something of a flood when the Nazis' brutal anti-Semitism drove thousands out of Germany.

South Africa's Jewish community, unsurprisingly, has always been in the vanguard of the liberal movements, and many of its members fought long and hard against apartheid.

Ancestral blends

During the grim decades of apartheid a large number of South Africans – well over three million of them – were racially classified as 'Coloured', a term that covers a people of diverse descent scattered across the country. The Northern Cape, for example, is the historic homeland of the Griquas, a distinctive group who have their own story to tell, but the great majority of coloured people live in the Western Cape and trace their antecedents to a variety of ancestral gene pools – to unions between Dutch settlers, indigenous Khoekhoen or slaves from Indonesia, Sri Lanka, Malaya, India, the Indian Ocean islands (notably Madagascar) or elsewhere in Africa. Admixtures inevitably followed, with the Xhosa, for instance, adding their progeny over the years.

There is religious and linguistic diversity, too, within the society. Afrikaans is dominant, though the dialect heard in the Cape Flats north and east of Cape Town is a kind of Afrikaans patois known as *Kaapse taal*, but a large percentage of Cape coloureds can be classed as bilingual. Indeed, some of them made a conscious effort to learn English in the latter part of the twentieth century in deliberate protest against racial segregation.

Of South Africa's estimated 3.7 million-strong coloured population, nearly 90 percent belong to the Christian faith, a high proportion to one or other of the fundamentalist Reformed churches. Tragically, despite these affinities with Afrikanerdom, the community had a rough time during the dismal decades of 'separate development'. Even though it was a fairly integrated part of wider Cape society from very early colonial times, the coloured community was given its own and, in practical terms, inferior race classification. Its residential areas were delineated, and its heart was ripped out when District Six, the ramshackle, vibrant inner suburb of Cape Town, was declared a 'white' area and the residents moved away to the rather soulless plains of the Flats. Since the creation of a democratic state in the 1990s, however, the community has taken its rightful place in the cultural and political life of the new South Africa.

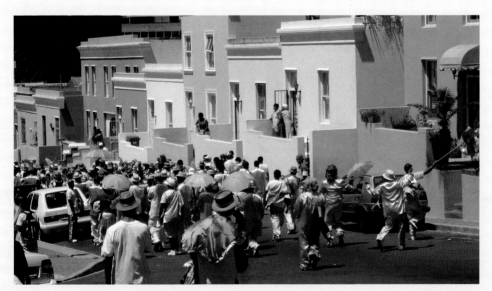

LEFT Residents of the Malay Quarter, more correctly Bo-Kaap, celebrate each new year with a joyous street parade of music and dance.

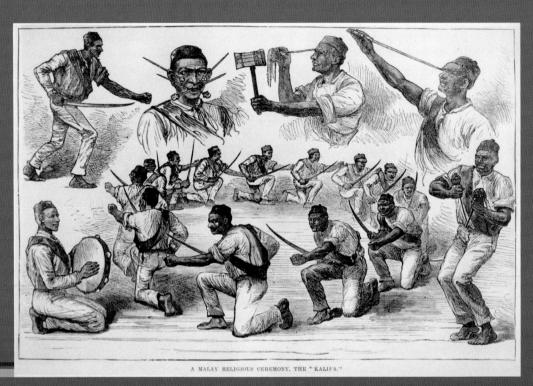

RIGHT Engravings published in the *Illustrated London News* in 1888 depict the famous *Khalifa* sword dance. It was performed in a self-induced trance, and wounds would be inflicted without apparent damage: the blade pierced flesh bloodlessly, leaving no mark.

A MALAY RELIGIOUS CEREMONY, THE "KALIFA."

Islam at the Cape

Among notable subgroups in coloured society are the Nama, direct descendants of the Khoekhoen peoples of the past, and the Griquas of the north-central (Kimberley) region, originally also of Khoekhoen stock. But better known to the world are the so-called Cape Malays, a still-integrated community that traces its origins to the slaves imported by the Dutch East India Company from the Malayan archipelago and Indonesia. It was these Muslims who introduced Islam to the country, a faith that has been sustained and extended into the main body of the community.

The first Malays were known for their practical and artistic skills, and especially for their expertise as silversmiths, carpenters, decorators and builders, and they were highly influential in the evolution of the Cape Dutch architectural style. The famous gables, for example, were originally Eastern features. The 'immigrants' (if one can call them that, for there was little or no choice in their immigration), also included high-born political exiles, among them the Rajah of Tambora and the revered Sheik Yusuf, believed to have been a direct descendant of the Prophet Mohammed. A sizeable number of Cape Muslims live in the 'Malay Quarter', more correctly known as Bo-Kaap ('above Cape'), a pretty suburb of flat-roofed little houses huddled on the slopes of Signal Hill on Cape Town's western fringes. Cobbled streets and mosques complete the picturesque setting.

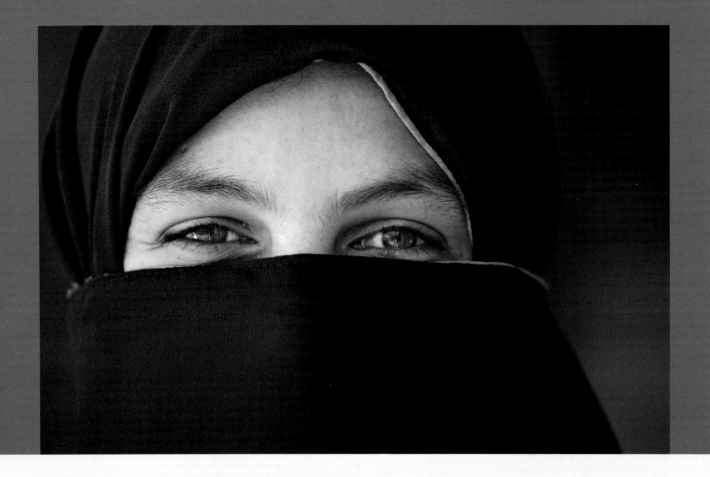

A highly visible part of the Malay culture until quite recently was the *Khalifa*, an Islamic ceremonial sword dance performed in a trance-like state. But many of the imams disapproved of the practice, mainly because it involved self-mutilation, and it has now been reduced to the status of an occasional spectacle. More resilient has been Malay cuisine, drawn from Indonesia and later refined by Dutch and Indian additions, and an exuberant musical tradition that remains integral to their cultural identity. Many of the songs, or *gammaliedjies*, are drawn from an eventful and often turbulent past, although the actual origins of the lively, lyrically racy numbers remain obscure. The music, and the dancing it accompanies, is perhaps best enjoyed at the annual Minstrel Carnival (formerly Coon Carnival, and also known as the Kaapse Klopse), held on the second day of each new year. Hundreds of brightly costumed, umbrella-carrying and straw-hatted troupes make their noisy way through the streets in a parade that can rarely be rivalled for its colour, movement and sheer collective joy. The festival made its first appearance soon after a minstrel group from the United States visited the Cape in 1848. South African slavery had only recently become a thing of the past, liberation was in the air, and the visit was a huge success. The Americans were white with blackened faces; the dark-skinned locals, in a gesture loaded with irony, decided to imitate them, but to paint their faces white.

ABOVE The Islamic community is bound together by religion: its members rarely marry into other faiths, and pilgrimages to both the local *kramats* – shrines to holy men – and to Mecca are undertaken. Women, especially, tend to adhere to conservative rules of dress, most notably on occasions of religious significance.

A small part of India

BELOW Portrait of a lady. The photograph, taken around 1910, captures the dignity of traditional Indian society in Natal. At that time, Mohandas Gandhi was fighting hard for the rights of his countrymen in South Africa.

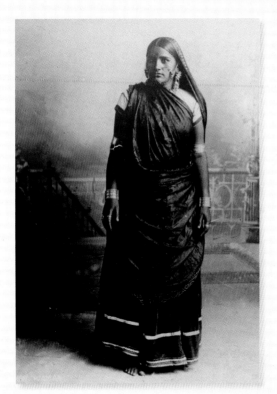

South Africa hosts one of the largest of the world's Indian populations outside India itself. It numbers 1.2 million, its major concentrations are in KwaZulu-Natal and on the Witwatersrand, and it owes its existence largely to the shortage of labour in Britain's vast nineteenth-century empire after the abolition of slavery in the 1830s. India, with its teeming millions and pride in its work ethic, was well placed to fill the need, and its citizens (all of them British subjects) were encouraged to move freely through British territories.

Thousands began to arrive in the 1860s to work on the huge new sugarcane plantations of South Africa's lushly subtropical eastern coastal plains. They were indentured (contracted) for between three and five years, reasonably well looked after, and at the end of their term were given three choices: a renewed contract, repatriation, or settler status plus a piece of land. Most chose the third option, and made new homes in culturally discrete communities.

The society grew as free, or 'passenger', Indians sailed west to join their compatriots, most of them putting roots down in the Durban-Verulam-Pinetown urban complex. They brought valuable skills and an unrivalled business expertise with them. But, predictably perhaps, their commercial success – and the colour of their skin – provoked resentment among the incumbent white overlords. Incipient apartheid was very much a feature of colonial life. Restrictive laws were passed, and it was to right some of these wrongs that a slender young Indian lawyer came to Natal's shores in 1893. His name: Mohandas Gandhi.

Spearheaded to a large degree by Gandhi and his non-violent philosophy *satyagraha*, Indian activism intensified during the twentieth century's first decade, culminating in serious unrest in the plantations and coalfields of Natal and a mass march of Indian families across the colonial border into the Transvaal. Gandhi, who had already been arrested and jailed on two occasions, this time drew a nine-month prison sentence. Nevertheless, the troubles had a positive outcome. The Union government, and specifically its Minister of the Interior Jan Smuts, eventually (in 1914) reached an agreement that produced the Indian Relief Act. Gandhi, believing his work in South Africa done – and conscious, no doubt, that the coming war in Europe would offer opportunities to bring Indian independence a little closer – hurried back to his motherland. But, while a prisoner, Gandhi had fashioned a pair of sandals for Smuts, which the latter treasured all his life. Commenting on his old adversary's departure, Smuts said (perhaps with a touch of relief) that 'the saint has left our shores'.

Today, the majority of South African Indians use English as their first language, although some of the older folk have retained the ways and words of their forebears and speak Gujarati (of the Mumbai region), Hindi (north-central India), Urdu (north India) or Tamil (south India) at home. Nearly everyone though, old and young, understands their ancestral tongue. Tamil has undergone

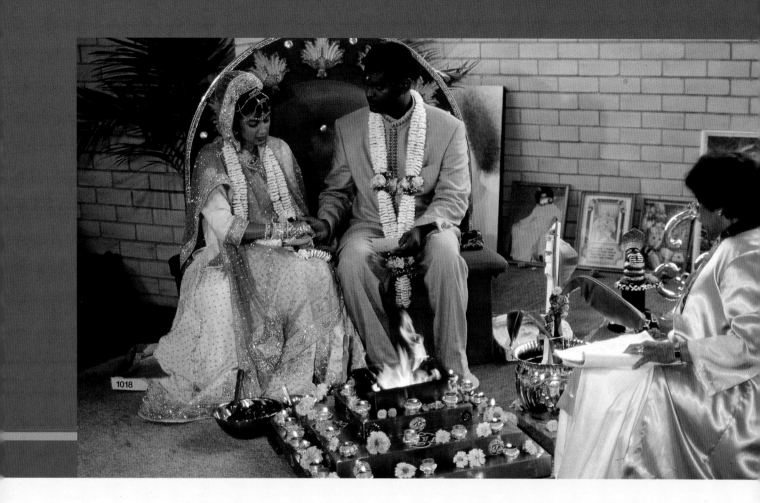

something of a renaissance in recent years, in line perhaps with intensified group awareness across the ocean. Hindustani, a mix of Hindi and Urdu dialects, remains a kind of lingua franca. Most of the community are Hindus, but a substantial number belong to the Muslim or Christian faiths. The region's Muslim element embraces pockets of Pashtuns from Pakistan's rugged northwestern areas.

Wander down Durban's Victoria Street to the market and you could easily imagine yourself in Delhi or Chenai. The pavements draw colour from sari-clad strollers and from little shops displaying everything from silks and satins to shoes and shirts and other prosaic goods; the air is scented with spices and sandalwood, noisy with the semitonal sounds of Eastern music. Grey Street boasts the southern hemisphere's largest mosque, a magnificent golden-domed affair. Hindu temples grace the wider area.

The various sections of the Indian community have retained many of their traditions, the heritage held in place within a matrix of religious conviction and a patriarchal extended-family system that, to a large degree, governs relationships, behaviour and social interaction. But much has indeed changed: traditions are slowly being eroded, and what you see at first glance is somewhat illusory. Young Indians are highly Westernised (as are their counterparts in urban India). Families are becoming smaller; male authority no longer goes entirely unquestioned. But the essential values of another continent, another culture, are still in place in this 'little corner of India'.

ABOVE The solemnity of a Hindu wedding. Much of traditional Indian culture is preserved within the community, although its younger members have become less conservative and more independent. Arranged marriages are a rarity in contemporary society.

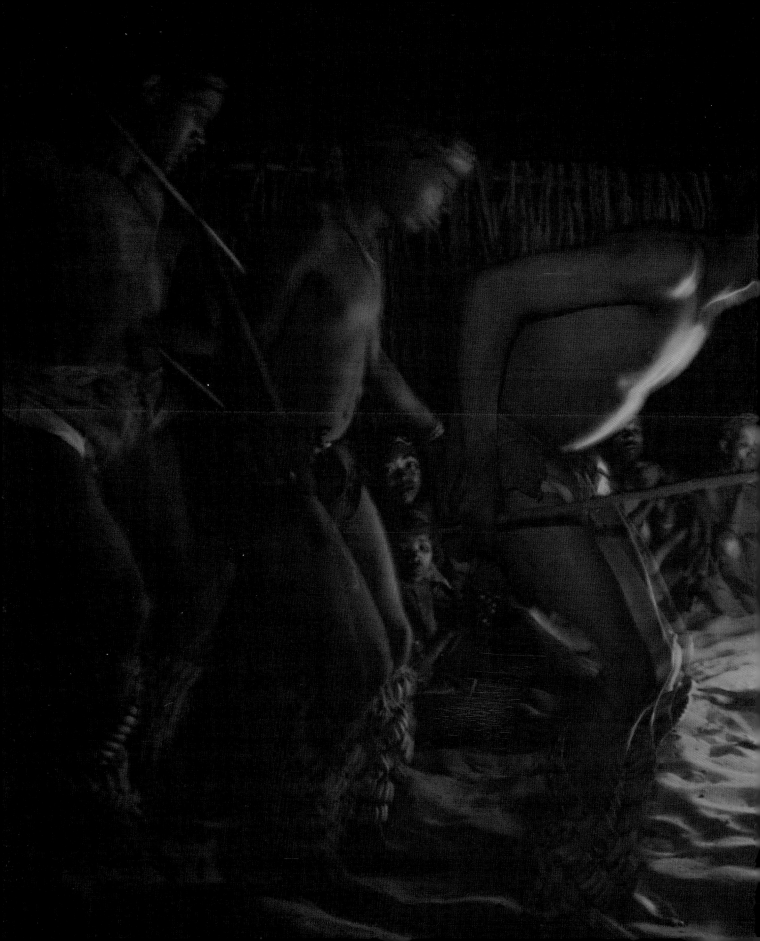

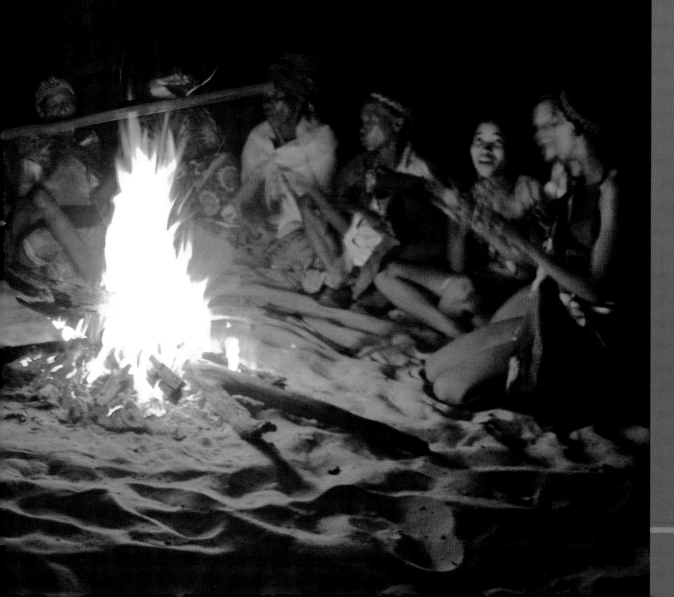

San
People on the move

PREVIOUS PAGES Fire, chant
and mystic ritual in the great
spaces of the north.
OPPOSITE This woman's face
reflects decades living in a
sun-blistered environment.
Lines, though, are not accurate
indication of age as wrinkles
and skin-folds often appear
relatively quickly among
the San people.

Until fairly recently, small bands of sallow-skinned people roamed the great, sandy wastes of the subcontinent's northwestern lands. Theirs was big-sky country that intimidated most others with its harshness, and their lifestyle differed little from that of their Stone Age ancestors. They were free to follow their nomadic hunter-gatherer ways, living in harmony with themselves and with nature, posing no threat to either the wildlife or the vegetation, their routines governed only by the seasons and by the movement of the herds.

These were the Bushmen, better known in South Africa as San but also called Basarwa, !Kung, Sho and Kwe in various other places. Laurens van der Post immortalised them as 'the Beautiful People', but they also have been termed the First People. According to the American scientist Spencer Wells, they were the 'genetic Adam', the oldest of the world's humans, the stock from which all of us, everywhere, can trace our ancient heritage. Other experts have linked them to the Negroid race, one of the planet's four major racial divisions, which originally occupied Africa's equatorial forest belt. The Bushmen, they say, are a Negroid offshoot who moved down from the great forests and adapted, both physically and culturally, to the open, sunlit plains and far horizons of the southern subcontinent. And they once dominated the region, a gentle people, mystically connected with realms beyond our understanding, at one with the simple routines of this life and their existence in the dreamlands of their trances. They were wholly without aggression, perhaps because they had no human and few natural enemies. But their idyllic world began to change some 2 000 years ago, when culturally related but technically more advanced communities appeared. The newcomers, known as Khoekhoen, were seminomadic pastoralists whose cattle and flocks of fat-tailed sheep demanded good grazing. The Khoekhoen periodically migrated in large, disciplined groups, but were acquisitive, with firm ideas about territory, conscious of their proprietary rights and prepared to assume and defend them. The displacement of the San had begun.

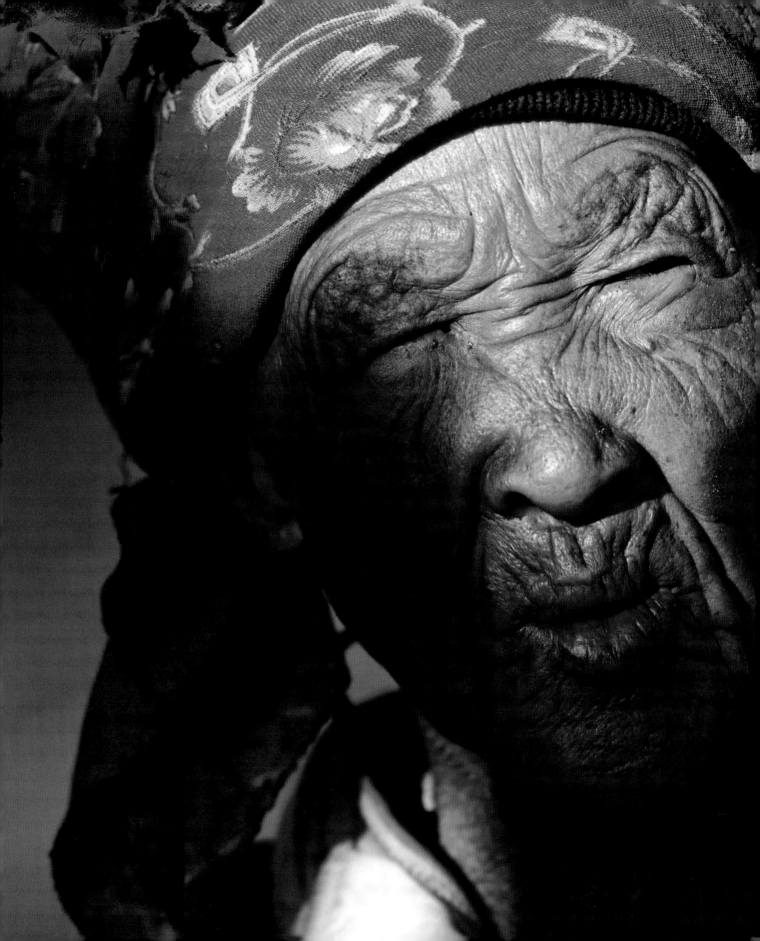

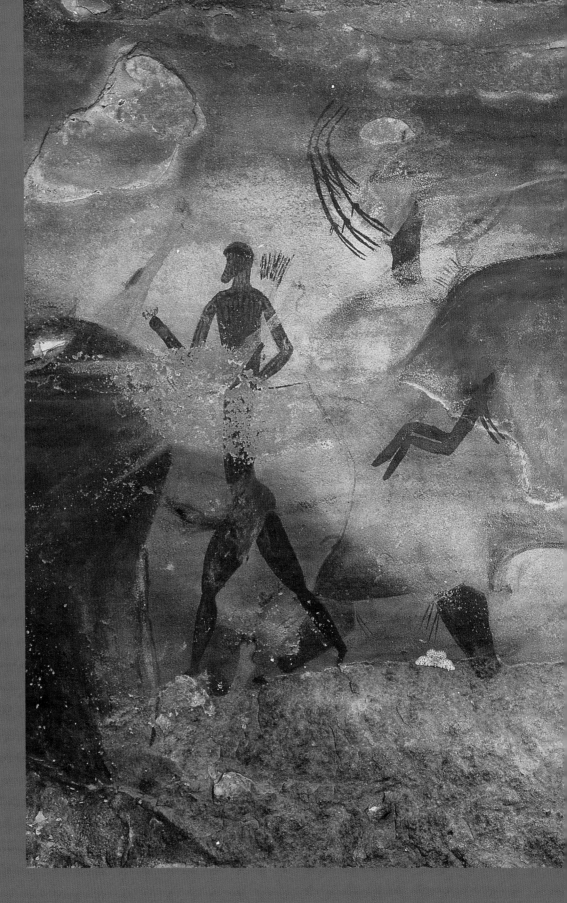

RIGHT The hunt, immortalised on a cave wall. San artists perfected an advanced foreshortening technique millennia before the modern era, and it is this three-dimensional approach that gives their paintings their remarkable vibrancy. Visually eye-catching though the pictures are, it is the symbolism, the 'meaning' they convey, that preoccupies students and researchers.

There were three major Khoekhoen groupings: the Korana of the central interior, the Einiqua in the west, and the Namaqua in the southwest. In due course, the Namaqua divided, with one segment migrating to what is now Namibia, and the other turning south to occupy the Atlantic coastal belt that is the Cape Peninsula, its hinterland and the southern maritime zone. These were the first indigenous communities to come into contact with the European exploratory fleets and their colonial heirs.

Meanwhile another incursion was under way, a slowly unfolding but massive one. During the early centuries of the first millennium even more advanced peoples – the Bantu from the Great Lakes regions of central and eastern Africa – were moving south. These two great migrations destroyed the San's pre-eminent status as lords of the veld. Many of the incumbent peoples were absorbed into the new societies, sharing something of their culture and language – notably the highly distinctive click sounds – with the Nguni (Xhosa) of the south and, to a lesser extent, the Northern Nguni (Zulu) in the east. Other groups were simply squeezed out of their traditional hunting and gathering grounds, while some were destroyed in open warfare.

Much later the southern clans came into contact with the growing Dutch colony at the Cape to provoke a bloody and protracted clash of cultures – the two mindsets were fundamentally irreconcilable, especially when it came to concepts of wealth. To the San, a herd of cattle was just game to be hunted and eaten when the appetite spoke; land was the tangible element of a universe of free souls, to be used as necessity demanded but otherwise respected, venerated even.

These thought processes were entirely alien to the rugged, well-armed white herders and farmers, who retaliated savagely to stock theft and, on occasion, banded together in posses to mount punitive expeditions. The San usually gave as good as they got, but modern weaponry eventually took its toll. It is said that some 200 000 of the First People were killed during the first two centuries of the colonial era. In time the only viable communities to survive were in occupation only of the forbidding Kalahari region and the desert wildernesses of Namibia.

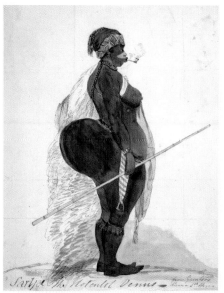

ABOVE Silhouette of the tragic Khoekhoen Sara (Saartjie) Baartman, taken to Europe in the early 1800s to be exhibited for what was perceived to be her unusual appearance, notably her extended buttocks (a genetic adaptation to drought conditions). On Nelson Mandela's initiative, her remains were brought back and interred with honour in her home country on Women's Day in August 2002.

Pictures of the past

The most visible legacy of the old San peoples is a treasure-house of rock art, an array of paintings, some of which are regarded as the finest of all examples of prehistoric creativity. The best of them feature the rituals of the San spiritual world and the animals of the wild, their animation speaking across the centuries, evoking a real sense of the life force expressed in the dance, the hunt, the flight of a buck, in the surge of a buffalo.

There are more than 15 000 rock-art sites in South Africa, perhaps three times as many in the wider region. The paintings cannot be precisely dated, but it is thought that the earliest – found in Namibia – is about 27 000 years old. Most, though, date from and after about 2 000 years ago. The galleries are at their most prolific along the highlands of the east, where one of the caves contains over 4 000 individual subjects.

Modern society tends to regard San art as simply decorative, but it meant much more to the painters. For the most part, their art had a religious function, the subjects confined to entities that had mystical significance. The smaller wildlife, that which provided the ordinary meal of the week, like the tortoise and the small buck, was rarely – if ever – depicted. It is the larger, more charismatic forms, those with huge symbolic value, that predominate – specifically, those that have appeared in the trance dances and allowed the shamans to enter another, ethereal world, and to take on a supernatural ability to control the physical world, to make rain, to heal, to locate game and so forth. There were no words to describe this potency, so it was visually portrayed on the walls of caves and rocks and overhangs. The most common subject was the eland, revered for its fat, an essential ingredient of the marriage and other ceremonies.

The simple life

The traditional San hunted and foraged in clans, or bands, small and self-sufficient units each with its clearly defined territory. The individuality of the clans was striking, their independence complete: in some instances, for example, even the languages they spoke were mutually incomprehensible.

Possessions were simple and few, restricted to what could easily be carried over long distances, the burden consisting of little more than loincloth or apron, a blanket, digging stick, skin kaross (a cloak that could hold items like firewood and food, perhaps) and a smaller kaross for the baby. Shelter was rudimentary, thrown together with sticks and grass and just substantial enough in the rare rainy periods to keep out the wet. The structure was a little more permanent during the long droughts, when the settlement clustered in circular fashion near a water hole. At these times the land was virtually bare of plant life that could offer sustenance, but wild animals were also attracted to the water and so meat became more plentiful.

San society was, for want of a better term, democratically organised. It had its hereditary chiefs, but decisions were invariably made through consensus. Women enjoyed equal status, in practically all matters, to their menfolk; children were cherished, spoilt even, discouraged from aggression, encouraged to play, to sing, to show their feelings and to laugh. Laughter was one of the constants of San life.

Generally speaking, it was the women who usually gathered the roots and edible berries and wild melons (the source of both food and water); the men hunted with a wooden bow strung with sinew, and arrows, which they carried in a skin or bark quiver. The arrowheads were tipped with a poison made from insect grubs, a toxin that acted slowly on the prey's nervous system, and the hunting party would follow the wounded animal for days, over enormous distances, before it finally dropped.

When the kill was made and the carcass carried to base, the whole group joined in a feast that involved song and trance-like dance, rituals led by the shaman and which often lasted until sun-up. San music was based on an atonal scale as unique to the people as their clan language. When game was scarce, the group would split up into smaller parties in search of whatever food items were available, adding snakes, lizards and even scorpions to their diet. In especially prolonged droughts the women would chew the bark of a particular tree that had prophylactic properties,

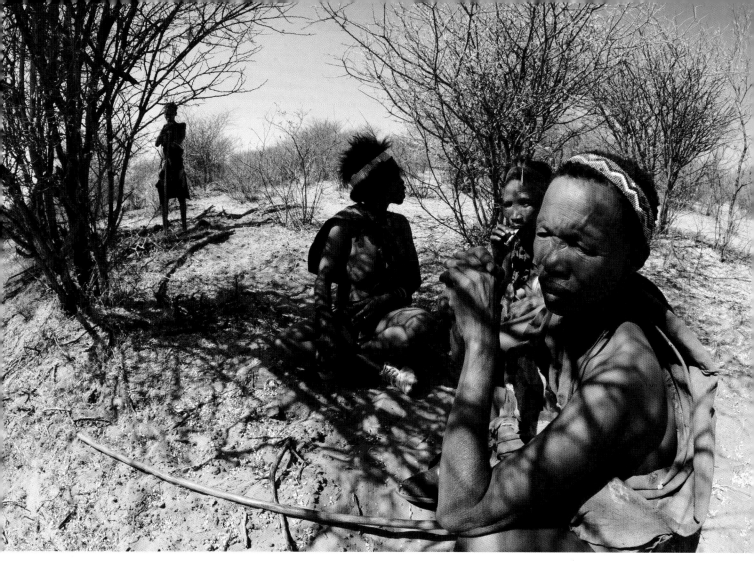

so limiting the number of mouths to feed. These hunter-gatherers would also store water in ostrich shells, which they buried deep beneath the surface of the apparently featureless desert and, when the need arose, find them again with uncanny accuracy. Ostrich shells had another, more decorative purpose, serving as the material for beads.

The traditional San way of life has all but vanished, in South Africa at least. Most of the people have been embraced, usually uncomfortably, by the modern world. Some, though, have had their ancient hunter-gatherer lands restored to them. In the Kgalagadi Transfrontier Park, San men serve as trackers and guides, but little else of the heritage remains, apart from the art. In 1997 an old man called //Am//Op died. He had been the leader of the //Khomeni group of the southern Kalahari and locally famed for the music he created with his mouth-bowl. His name, which means 'survivor', was given to him by his parents, who had escaped from a party of 'Bushman-hunters' from Namibia in 1899. Paying poignant tribute, musicologist Cait Andrews said: 'His personal song was the survivor's song. He is gone now, and with him an era has died, a language, and a lot of knowledge.' These words were spoken of one old man, but they also mourn the dissapearance of an entire and precious culture.

ABOVE San gatherers at rest. The Kalahari is properly defined as an 'arid wilderness' rather than a true desert, and is surprisingly rich in game animals. Today few San communities resort to the hunt perfected by their forebears.

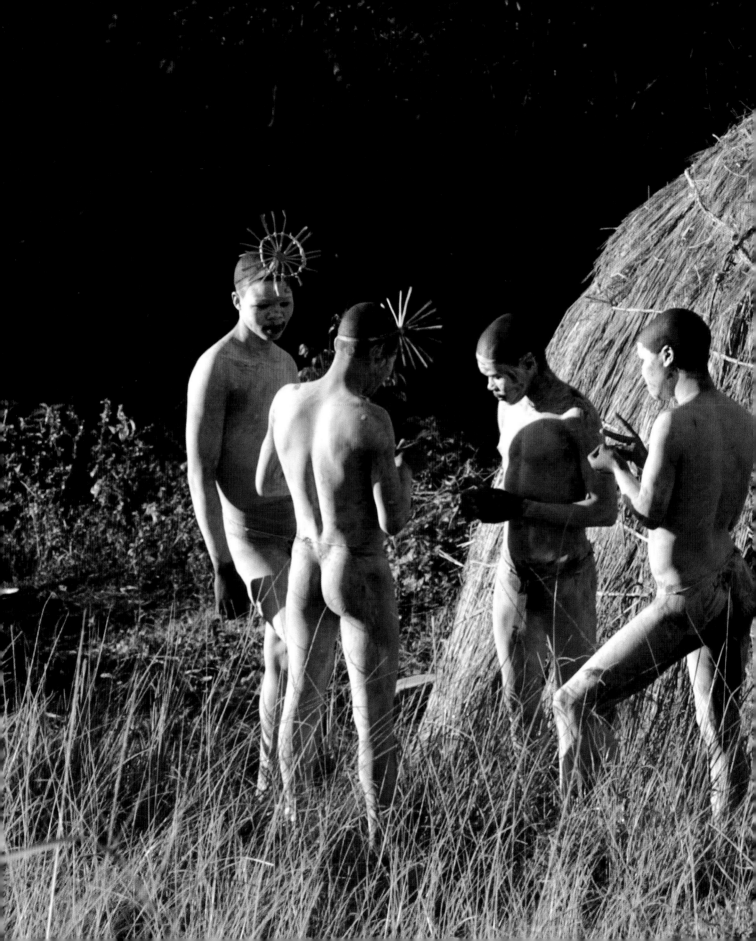

Xhosa
People of the south

PREVIOUS PAGES Xhosa initiates gather beside their seclusion hut. The coming-of-age rituals are lengthy and, for the Xhosa, include circumcision.
OPPOSITE Intricate beadwork is a relatively recent feature of Xhosa culture. Beads were introduced by European traders in the 1800s, and the craft caught on quickly, producing adornments that are heavy with symbolism.

When the Portuguese ocean-going vessel *São João* foundered off the treacherous Pondoland coast in 1552, the resident chief, Nyaka, took good care of the 440 men, women and children who survived the wreck. The castaways stayed in the chief's domain for a while, the men even pitching in to help their host to stamp out a minor rebellion, before setting out on an odyssey, a remarkable 1600-kilometre overland trek to the settlement of Lourenço Marques (now Maputo). Most died along the way – just eight Portuguese and 17 slaves eventually staggered to safety – but it was mainly hardship and sickness that accounted for the toll, not hostility from the indigenous folk along the way.

A later explorer wrote that the villagers he came across were 'among the finest specimens of the human race' and that 'one may travel 200 or 300 miles through their country without any cause of fear from men …'. There can be few such judgments in the annals; one has only to look at the story of early Asian and European cultural contacts to see how special were the people of the south. Kindliness and hospitality were constant ingredients in the collective character of the precolonial Ntu-speaking folk, and they are qualities that have distinguished the traditional communities through many decades to the present time.

Origins

When speaking of the Xhosa, most of us tend to generalise, to be rather loose in our perceptions, placing this particular group in historic occupation of the entire country from just beyond modern Port Elizabeth to the border of what is today KwaZulu-Natal. In fact the Xhosa are only one of several major traditional societies – among them the Thembu, Mpondo, Mpondomise, Bhaca, Bomvana, Mfengu, Ntlangwini, Xesibe – who speak dialects of the same language but

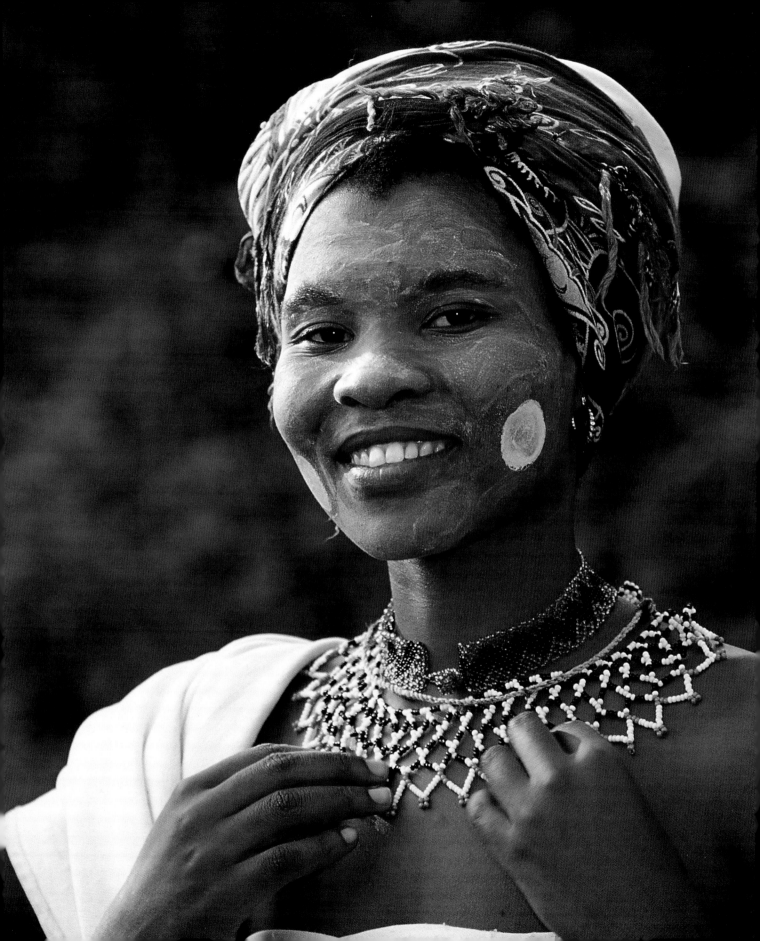

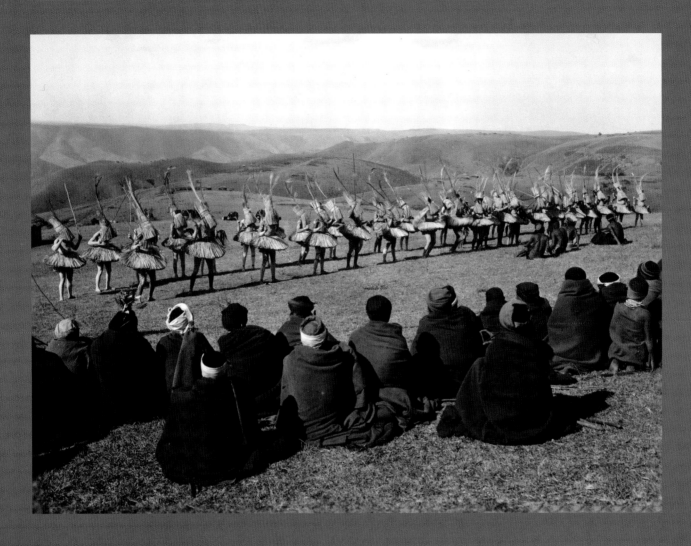

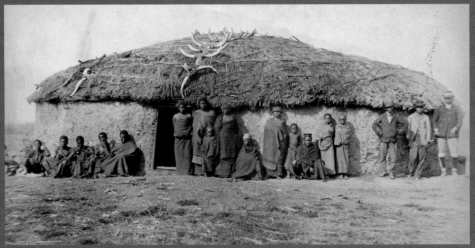

ABOVE Grass-skirted and masked Bomvana dancers perform for their kinfolk near Elliotdale in the Transkei region of what is today the Eastern Cape.
RIGHT Baca villagers gather outside a largish hut, known as 'the Great Hall of Pondoland'. Note the horns perched dramatically on the roof.

were independent of each other. Collectively, these entities are more properly classed as the Southern or Cape Nguni, as distinct from the Northern Nguni, who are now generically referred to as the Zulu.

The Xhosa, however, were the specific pathfinders in the slow, sporadic migration of Ntu-speaking peoples down the eastern and along the southern coasts. In the process, they effectively displaced the incumbent nomadic Khoekhoen and San of the region, generally (though not always) without force of arms, often simply absorbing them because, at that time, there was plenty of grazing and hunting land for everybody and the 'invaders' had few inhibitions about intermarriage. Inevitably, too, they incorporated some of the Khoekhoen and San cultural elements, notably the click sounds that distinguish their language.

This easy-going tendency to absorb and borrow had its counterpoint in a readiness to separate, fission given impetus by what foreigners may perceive as the rather inflammatory rules of succession. A chief's first-born son, who along with his followers belonged to the 'right-hand house', would not inherit the chieftainship. That right belonged to the first son of the senior or Great Wife who, in a polygamous society, was seldom the chief's first wife. The first-born would then be expected to move away to form his own more-or-less independent group. Occasionally he would challenge for the chieftainship, and that often led to violence, especially when land became scarce – which it did towards the end of the 1700s, with mounting population pressures and the eastward advance of the white colonists. Always, though, the various groups and subgroups would continue to give their allegiance to the paramount chief. The latter's authority was largely moral and advisory, and he rarely interfered in the internal affairs of individual groups.

The story of the Xhosa people is therefore hugely complex, even confusing to strangers in terms of both the events and the social dynamics.

Clash of cultures

The Xhosa – or, more accurately, the amaXhosa, when referring to the people – were more-or-less one nation until the reign of Phalo (1702–1775), who settled in the region north of the Kei River, in what much later became, in part, the Transkei and they remained there from about 1730 until Phalo's death. The Xhosa then fragmented, producing a succession of factional leaders who figure large in the annals of history – Gwali, Gcaleka, Rharabe, Ngika, Ndlambe and Hintsa, among them.

In due course, some small groups advanced to the Great Fish River, into a region called the Zuurveld, and it was these people who first came up against the encroaching white settlers.

The first open conflict erupted in 1779, and there were to be eight more over the following hundred years as two mutually alien societies competed bitterly for possession of the region. There was never any real chance of a fair compromise, as the cultural gap was simply unbridgeable. Most importantly, there was a fundamental difference in the opposing concepts of what constituted 'possession' – to black people, land was a common property, to be shared by all, a notion entirely foreign to white farmers who believed firmly in legally sanctioned individual ownership. But whatever the rights and wrongs, the wars ultimately – and perhaps inevitably – ended in defeat for the Xhosa and the wholesale annexation of the Southern Nguni lands.

The fifth war (1818–1819) was pivotal. The ambitious regent Ndlambe, in company with Nxele, a charismatic prophet, led some 10 000 Xhosa soldiers across the border and marched on the settler stronghold of Grahamstown. Nxele, who had publicly foretold the outcome of the conflict, promised his followers that the god Dilidupu would reincarnate the Xhosa ancestors and together they would fight a 'holy war' against the settlers. In the event, the attack was launched with tactical skill and extraordinary courage, but the English garrison managed to hold out and Ndlambe was driven back, while Nxele was captured and imprisoned on Robben Island. In 1820, Nxele organised a daring attempt at mass escape from the island prison, but drowned when heavy seas swamped the boat.

In the same year two new players appeared in the arena when Cape governor Lord Charles Somerset brought out some 4 000 British settlers as part of his 'anglicisation' policy and, more immediately, to help 'pacify' the troubled eastern border areas. Around the same time, more but differently motivated settlers arrived from the north. These were the Mfengu and other refugees fleeing the ever-widening sweep of the Zulu army. As a result, the frontier region became both confused and congested, and tensions intensified.

The great cattle-killing

More wars followed, despite a series of treaties initiated by the colonial government, and huge areas were incorporated within the formal boundaries of the Cape. The second of these conflicts (1850–1853) was long, and costly, and in due course Xhosa military capability was all but destroyed – but not, as one might expect, by defeat on the battlefield. The destruction was largely self-inflicted, and it was triggered by a prophecy.

In 1856 a young girl named Nongqawuse claimed to have had a vision that seemed to confirm a prediction made by her uncle, the spirit medium Mhlakaza, which forewarned of something approaching the Christian Armageddon. At the time the Xhosa were especially vulnerable to mystical pronouncements. They were in psychological crisis, their herds decimated by lung disease, their traditions threatened, their very identity under constant threat from acquisitive and well-armed white settlers. They were, it seems, ready to listen to anything that promised salvation, ready to cherish any spark of hope. And Nongquwase provided it. She had, she said, received instructions from the ancestors: the people must destroy all their cattle and their grain harvests, and after such 'cleansing' the ancient Xhosa chiefs would rise again and drive the white men into the sea. Then the cattle kraals and byres would be full again, and illness and old age would be no more.

The people listened – and in doing so brought about a national catastrophe. Thousands starved to death. The Xhosa population precipitously declined and, although there was to be one final convulsion – the ninth frontier war (1877–1878) – the power to resist had been disastrously weakened if not broken altogether. The remaining Xhosa lands were incorporated into the Cape Colony.

Eventually, following the Glen Grey Act of 1894, the Southern Nguni were granted a pallid form of self-government. The intention was perhaps laudable enough – black people were to be accorded their basic rights – but in the long run it proved fatal. The Act was, after all, an admission

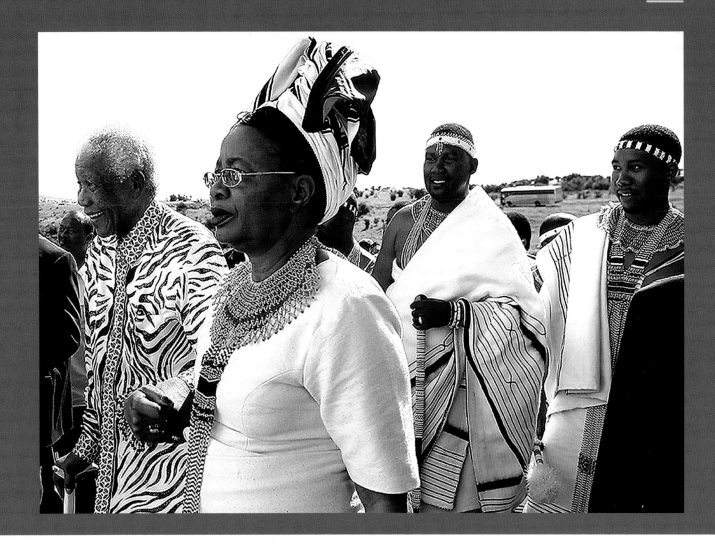

that the two cultures could not live together in harmony, and that 'separate development', a euphemism for apartheid, was the solution to the race issue. Far in the future, an Afrikaner nationalist regime would create two artificial republics, called Transkei and Ciskei, as homelands for the Southern Nguni. They lasted a bare two decades until, with liberation in the mid-1990s, they became part of South Africa again.

Markers of unity

A remarkable number of distinguished South Africans – much of the political leadership, in fact – call the traditionally Xhosa region of what is now the Eastern Cape home, among them Nelson Mandela and Thabo Mbeki. Mandela, the son of a chief of the royal Thembu house (he traces his ancestry back to the founder of the Xhosa-speaking nation), was born at Mvezo, a tiny hamlet near Mthatha.

ABOVE Nelson Mandela, a member of the royal Thembu family, and his wife Graca Machel return to his homeland to witness the inauguration of his grandson, Mandla (centre), as chief of the Mvezo Traditional Council, a position stripped from Hendry Mandela (the young Nelson Mandela's father) by a white magistrate in 1919.

43

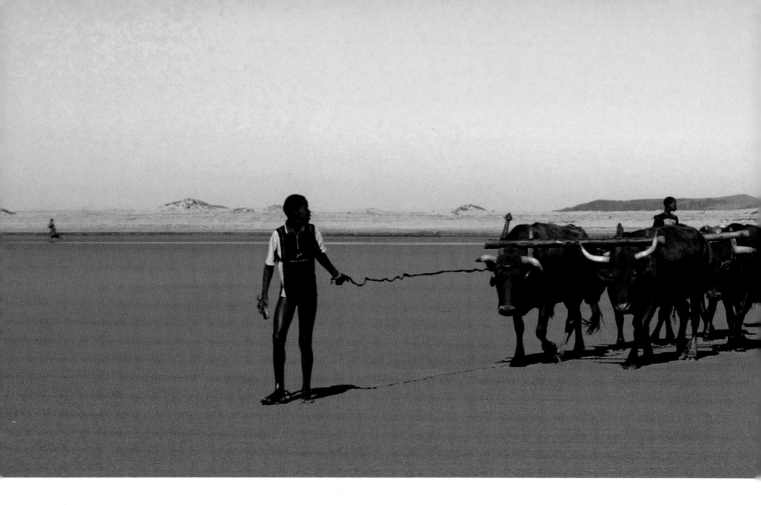

ABOVE Ox-wagon transport on the smooth, hard sands of Transkei's Wild Coast. Cattle roaming the beaches and adjoining countryside is not an uncommon sight even today, given the nature of the region and that the majority of the local Xhosa are rural-based.

Within the Xhosa, as in practically every other major group, there is a bewildering diversity of local tradition, custom and costume. However, those things that unite them – the rules of allegiance, customary law, the bonds of kinship, a common language et al. – are far more powerful and enduring than those that separate them.

Differences in dialect, custom, dress and so on are not divisive factors. Nor is union across group lines, and little weight is placed on blood 'purity'. Some Xhosa, for instance, have features similar to those of the culturally and physically quite distinct Khoekhoen and San, the original inhabitants of the region. And indeed there is a genetic connection, and if this is considered at all it is with some pride. The blood link is perhaps most obvious in the small Gqunukhwebe group, and among the larger Mpondomise, one of whose early chiefs married into San society.

Traditional communities live and work within clear patterns. In contrast to peoples further north, the various subgroups do not arrange themselves in villages but, rather, in extended families in homestead clusters of cylindrical and coned mud-brick, sometimes wattle-and-daub huts with attached cattle kraal and sometimes a sheep enclosure. In material terms, traditional society was remarkably democratic: the chief's Great Place, for example, was not much grander than the homes of his subjects. Groups of homesteads were connected, sharing common grazing and farming land. Indeed the emphasis throughout the community is still on sharing, and giving according to need. Xhosa families routinely help one another in such tasks as tilling the soil and hut-building.

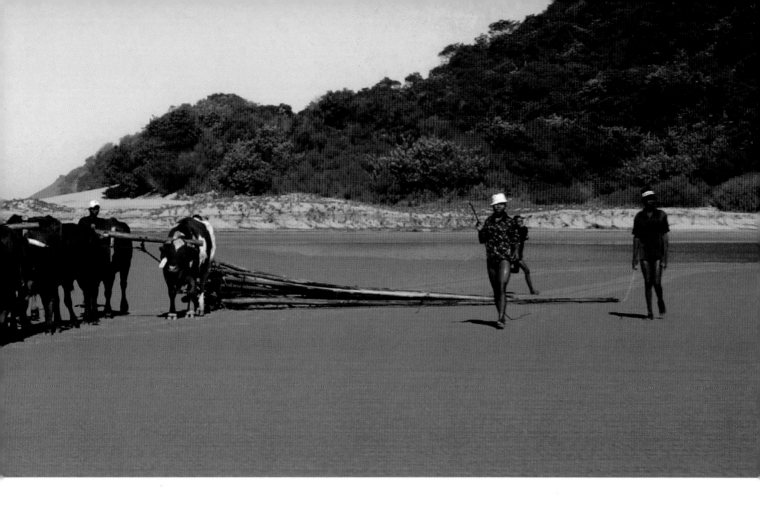

The Xhosa man traditionally fulfilled the roles of herder, hunter and soldier, while the woman looked after the home, the land, and the cultivation of crops. The society was – and, to a large degree, remains – a patriarchal one in which women were accorded no formal political authority, even though a leader owed his position to his mother's status. Kinship is defined both within and outside the subgroup. The clan is a wider entity, composed of people who can trace their lineage back to a common, distant (and often ill-defined) ancestor, and who are scattered among the various communities but are bonded by genetic ties. Members of a clan are able to recite their genealogy through a dozen generations and more, and clan names are important identity markers. Curiously perhaps, military structures were based on the clan system rather than, as one might expect, geographic area.

In traditional society, social standing revolves largely around cattle, the ultimate measure of wealth and success, the means of exchange in marriage arrangements and, with goats, the preferred objects of sacrifice to the ancestors. More whimsically, cattle-racing featured as an occasional and popular pastime, though stick-fighting was – and, in some rural areas, still is – the principal sport among youths and young men.

Ritual and ceremony have always been colourful, sometimes spectacular affairs. Birth and marriage are celebrated, death mourned in public get-togethers – as they are almost everywhere in traditional Africa. Music plays a central role in all of this, although among the Xhosa it is generally less important than the percussive sounds of the dance. The so-called 'shaking' dances of

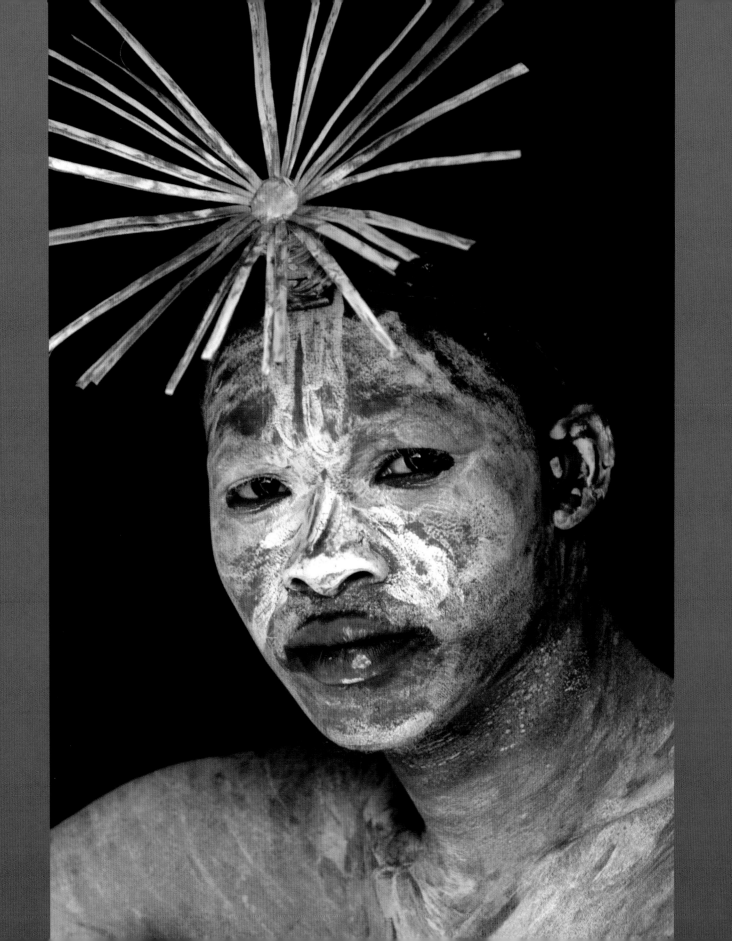

the young men, performed in unison and meticulously choreographed, feature leg- and arm-rattles, which all but drown out the 'band'. The latter produce simple, repetitive, often three-note sequences on their equally simple wind and string instruments.

Traditionally, the initiation of girls into womanhood involved seclusion for a short period, followed by ritual washing. For boys, however, coming of age was lengthier and, today, somewhat controversial: traditional circumcision methods, especially those practised in outlying areas with little or no access to the clinical standards set by Western medicine, can be dangerous and deaths as a result of infection are still recorded. The wider rites, however, are harmless enough and fascinating in the glimpse they offer of a culture fast being eroded.

The initiation process is prolonged, and is played out in specially built huts away from the rest of the community. The youths whiten their faces and bodies as protection against evil, and during their seclusion they dress up in grass skirts and masks (which hide them from the taboo gaze of women). And, in some groups (Xhosa, Thembu, Bomvana), they perform lively dances. The dancing dress is elaborate, embellished with two reed horns that speak of the virility of the bull. At the end of the three- to four-week period the boys wash and then smear themselves with red ochre, and the huts are then ritualistically burned.

Bethrothal has also always been a protracted affair involving complicated negotiations between the two families. *Lobola* (bride price), usually paid in cattle (or, these days, money), is met by the prospective husband's broader group rather than his immediate family. Strict customary laws govern the choice of spouse and marriage within the clans of all four grandparents is forbidden. The actual marriage ties, though, were not nearly as conservative. The wife had, of course, to honour and remain respectful of her husband, but was free to move back to her father's homestead if she was mistreated. Among the gifts still traditionally presented to a bride is a cow that is especially sacred to the ancestors, and necklaces fashioned from the hairs of the cow's tail. Both are said to have magical properties.

The Xhosa spiritual world is full of magic, of strange, often shadowy beings, of gremlins and nymphs and tree-sprites, indistinctly perceived beasts and birds, of omens and taboos of a bewildering variety, which the outsider cannot hope to comprehend. Prominent figures include the uThikoloshe (anglicised to Tokoloshe), a hairy and potentially malicious goblin; the Lightning Bird; and the kindly *abantu bomlambo* (People of the River), human-like beings who live in pools and streams and take care of those who drown.

Animism is the prime dynamic: physical features and natural objects — a hill, a river, a rock, a tree — are thought to have personas. Misfortune and illness were and often still are attributed to unnatural or supernatural agencies. All this coexisted with the central element of the belief system: the omnipresence of the ancestors and their power over their descendants, and of a vaguely defined Supreme Being.

The link between the physical and spiritual worlds is the *sangoma* (a generalised term) or *igqirha* (the Xhosa term), a medium and diviner, who may be either a man or a woman and who communicates directly with the ancestors while in a kind of trance (rather than through bones or other material items). The *sangoma* is not to be confused with the *nyanga*, who is a herbalist and healer and becomes such only after a long apprenticeship.

OPPOSITE *AmaKwetha*, their bodies whitened and their heads adorned during the seclusion period of initiation into manhood.
ABOVE Graduation day. Xhosa youngsters, who have just been circumcised, stand before their fathers with heads bowed. Yesterday they were boys, today they are men.

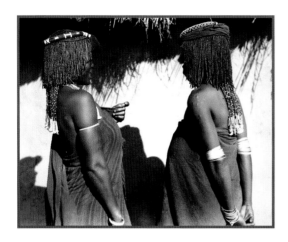

ABOVE The Mpondo are a distinct group but have cultural similarities with the Xhosa. In this early photograph simple headrings crown heads of braided hair intertwined with beadwork.

However, even though the two perform different duties – one is a kind of shaman who presides over a variety of rites, including the all-important coming-of-age rituals, the other a traditional doctor – the offices are often held by the same person. Both, too, are inclined to dress in especially colourful, elaborately beaded costumes.

An individual is 'called' by the ancestors to become a *sangoma* through an initiation illness (*ukuthwasa*). The spiritual imperative is launched by episodes of mental aberration, of what English-speakers might term 'moments of madness'. Specific 'signs' include fainting fits, strange dreams, a heightened sense of anxiety and abnormal behaviour.

It is only when the training period is complete that the call comes. A potential novitiate will be identified at an early age for his or her affinity with the spirit world and then embarks on a regime among whose key elements are song, dance and séance – and the taking of *ubulawa*, 'medicines of the home'. These play a major role in the novice's and the diviner's relationship with the ancestors.

Westerners find it difficult to grasp the precise nature of Nguni spiritualism. The spirits cannot be seen, much less touched. But in conversations with practising diviners, a common – if ill-perceived – thread seems to emerge, at least in some cases. The ancestral personas, some say, are part of ourselves, hidden within, and we have the ability to awaken them. Once awakened, they become very real. Perhaps the nearest outsiders can get to a definition is 'sixth sense'.

Clothes and colour

Costumes differed and differ widely among the various groups, and they were often dramatically colourful. Best known, perhaps, are the ochre blankets of the 'red blanket people': the Xhosa, Mfengu and Mpondomise. White, however – and nowadays pale blue – are the traditionally pre-ferred colours for ceremonial occasions, and during periods of mourning. Among the red blanket people, a married woman wore a long, black-braided skirt and white apron, as did an unmarried woman of marriageable age, but with breast-covering.

Especially striking were the women of the Bhaca group, who traditionally live near the Eastern Cape's border with KwaZulu-Natal. Married women wore bright beaded wraps over their long, panelled underskirts, their hair tresses ochred and oiled and worn low over the eyes like a beaded knob, held in place by a roll of cloth. A beaded cap completed the outfit. As always, though, styles differed in detail from subgroup to subgroup.

The Xhosa are renowned for their beadwork, which is a relatively recent addition to the local scene as beads made their appearance only with the arrival of nineteenth-century European traders. Fashion and ornamentation usually reflected the stages in a woman's life: a certain headdress for the newly married; another for the new mother, and so on. Hairstyles, on the other hand, tended to distinguish the group: Bhaca women adopted a mop-like style; Mpondo women displayed elaborate, heavily oiled twists, while the men had small, meticulous plaits. Xhosa headgear – turbans of various shapes and colours – was especially artistic, with a mother who had

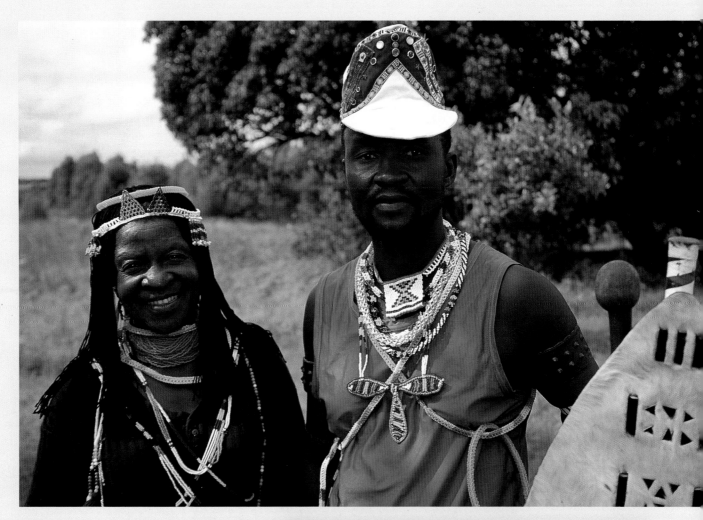

ABOVE An Mpondo couple. Today, traditional ornamentation such as decorative beadwork may be worn with contemporary clothing. RIGHT Finely woven beadwork decorates gourds and horns used to store either the healer's medicines or ordinary charms.

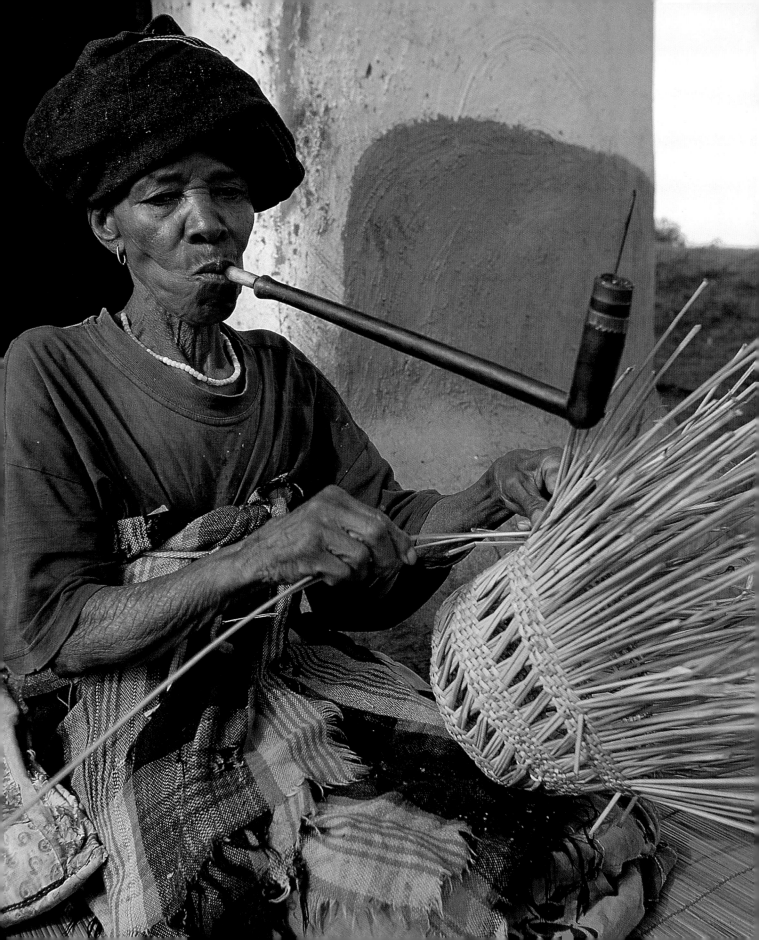

borne her first child, for example, wearing the twisted fabric low over her eyes. Mfengu women favoured large beadwork collars; smokers of tobacco and sniffers of snuff kept their accoutrements – notably the traditional long wooden pipe – in a large, beaded handbag.

Dress codes were rigid and strictly observed in the initiation schools. During the long days of seclusion, the day-to-day boys' garb consisted of a skin kaross or blanket, the hues a standard grey or white bordered with a darker stripe and decorated to match their 'smoking bags' of pipe and tobacco. However, as noted, the dancing costume was much more elaborate.

Havens of the wild

The traditional home country of the Xhosa-speaking peoples – the Gcaleka in the south, the Mpondo, Cele, Xesibe and Mpondomise in the north, the Thembu and Bomvana in the centre – can seldom be matched for beauty and vivid variety. The 280-kilometre Indian Ocean seaboard stretching from the river-port city of East London to the KwaZulu-Natal border is known as the Wild Coast, and aptly so too. For the most part, it remains unspoilt, a wilderness of high cliffs, coves and caves, pretty estuaries (an unusual number of rivers find their way to the sea along this shoreline), lagoons, rock pools and stretches of pale gold sand. Its most distinctive physical feature is perhaps the Hole-in-the-Wall, a gigantic detached cliff with an arched opening through which the great rollers thunder (its African name is *esiKhaleni*, which means Place of Noise). The region has many game and nature reserves. Biggest of the sanctuaries is the Great Fish River Nature Reserve, a 45 000-hectare expanse sprawling across the dense valley bushveld that girds the middle reaches of the historic watercourse called the Great Fish River.

At the other end of the region, near Port St Johns, are the subtropical grasslands of the Mkambati Nature Reserve. And just south of Port St Johns are the small and scenically enchanting Hluleka and, farther down the coast, the twin Dwesa and Cwebe reserves, separated by the Mbashe River and known for their secluded little bays and long sandy stretches that yield a fine array of seashells.

The land of the Xhosa is naturally fertile as well as beautiful, but population pressures and overgrazing have degraded much of the countryside. Wherever you look, it seems, there are clusters of small, round homes, and in places the soils simply cannot cope. Still, the rolling hills and the rivers are indestructible, and the higher ground of the interior is gently forested.

The Amathole mountain range, including the rather impressive Gaikaskop (1 962 metres) and Hogsback (1 938 metres), far inland from East London in the old region once known as the Ciskei, is rather special, but it is the reserve at the western end of Xhosa country, within easy driving distance of the city of Port Elizabeth, that is one of the country's major wildlife sanctuaries. The Greater Addo Elephant National Park is home to the remnants of the once-great herds of Cape elephant and a standing testament to the foresight of the early conservationists.

Rather less grand but arguably even more scenic is the Mountain Zebra National Park, nestled in the great amphitheatre of the Bankberg range far to the north, near the town of Cradock, and created in the 1930s for a grievously endangered species. The zebra, too, are now flourishing, to the extent that many 'spare' animals have been translocated to other sanctuaries over the years.

OPPOSITE The skills of the ancients. A Xhosa woman fashions an attractive basket from the grasses and reeds of the countryside. Pipe-smoking is more or less confined to the older generation, and is as popular among the women as it is among Xhosa men.

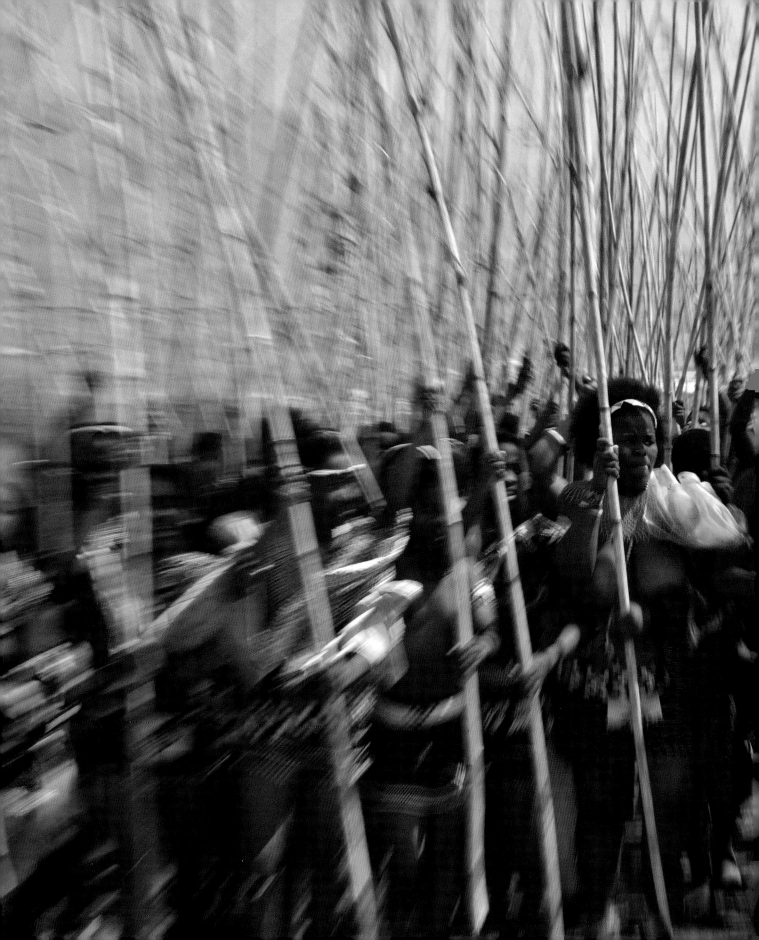

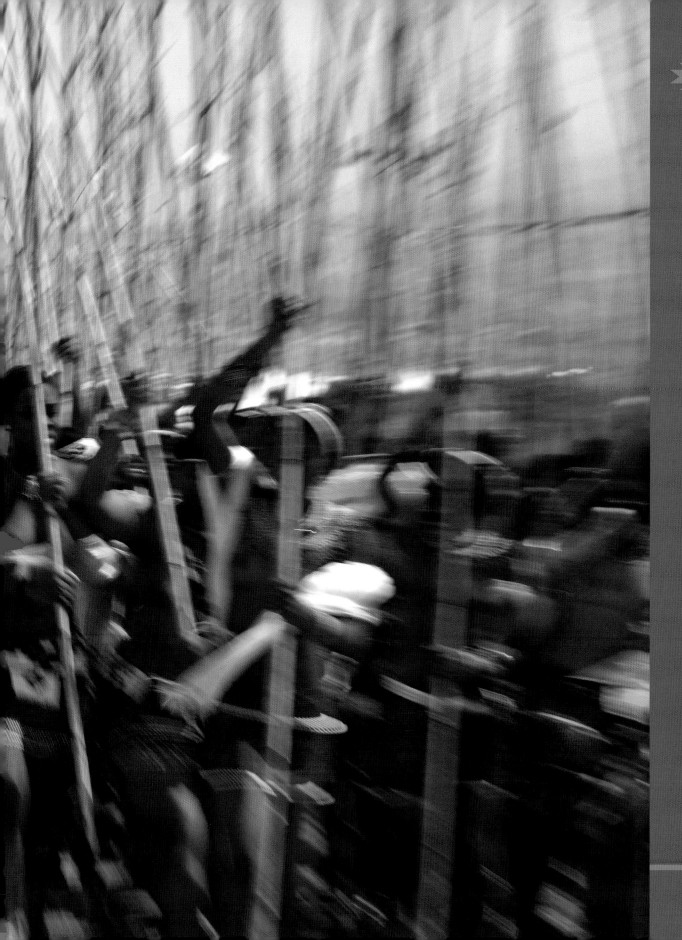

Zulu
Warrior nation

PREVIOUS PAGES Zulu girls bear reeds, a symbol of virginity, to the king's palace, where they will perform the spectacular Reed Dance.

ABOVE King Cetshwayo, feared by colonial Britain for the power he wielded, dons Western garb, and yet retains the headring indicative of his status in traditional society.

OPPOSITE Sombre dignity, in the person of Prince Galenga, great-grandson of Shaka's cousin, Biyela, and member of the Zulu royal family.

It all seemed so exhilarating to the young officers of Lord Chelmsford's redcoat army. Many had campaigned against the poorly armed Xhosa in the eastern 'frontier' region. Now the invaders were encamped on the sunlit summer veld, beneath the looming bulk of a remarkable natural feature. The date was 22 January 1879. The time, shortly after noon. The place, Isandlwana, Zululand.

Theirs was a somewhat depleted but still-strong force. Commander-in-chief Chelmsford had marched off to reconnoitre the way ahead, leaving behind a confident – and criminally unprepared – base camp. Regulations required a protective enclosure, but this basic precaution had been shrugged off. No entrenchments were dug; all threats discounted.

Within an hour, nearly every man camped beneath that hill would lie dead on a field soaked in blood. Unknown to the British, a 24 000-strong Zulu army was hidden, motionless, in a valley some six kilometres to the east. It had made excellent progress since being ordered by Cetshwayo, five days before at the military kraal of Nodwengu, to drive the intruders back into Natal Colony. But now the moon phase dictated that the warriors delay their attack. As fate would have it, though, their presence had been detected by a British patrol, and the Zulu army was forced to act straightaway. The regiments rose and the men moved forward at a steady trot towards Isandlwana. Each carried a short, stabbing spear and cowhide shield emblazoned with his regimental markings.

Forewarned, the hurriedly formed redcoat defensive line managed to halt the advancing phalanx with rifle and cannon, but only for a moment. The Zulu deployed their classic chest-and-horns battle order and surged forward to overrun first the British right, then the main camp, and finally the little pockets of resistance that remained. The assegai had done its work. The battle was almost complete, and just a handful of survivors escaped the charnel house.

To the Victorian British, Isandlwana was to be among the century's greatest military catastrophes. To the Zulu, it was confirmation of their credentials as a warrior nation, one which was still barely half a century old, and which had been founded by Shaka, military genius supreme.

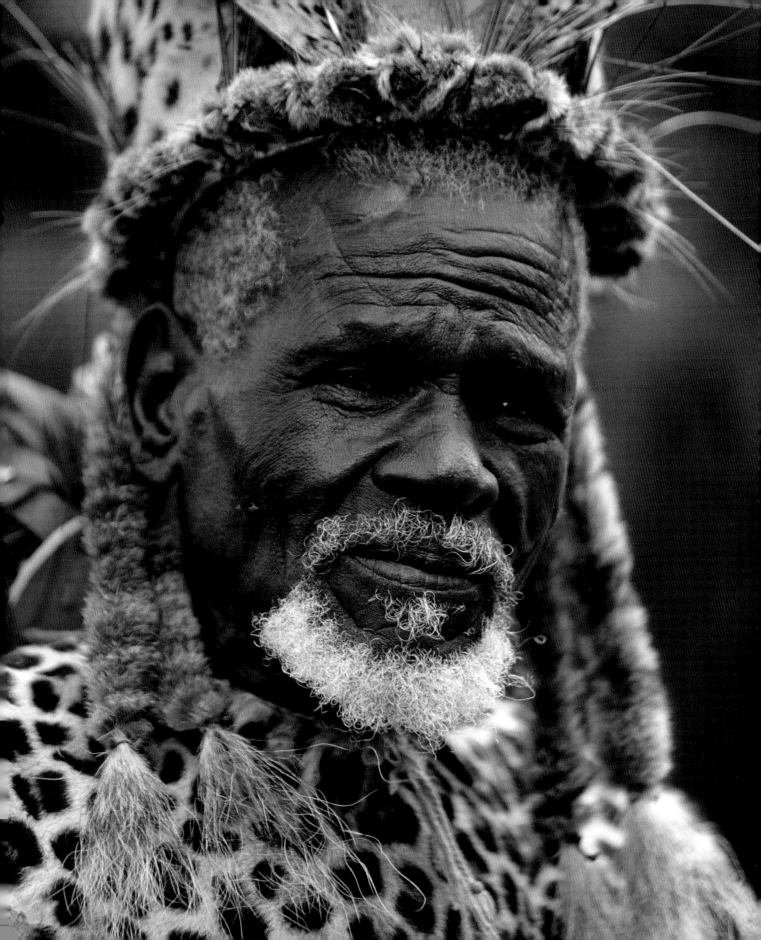

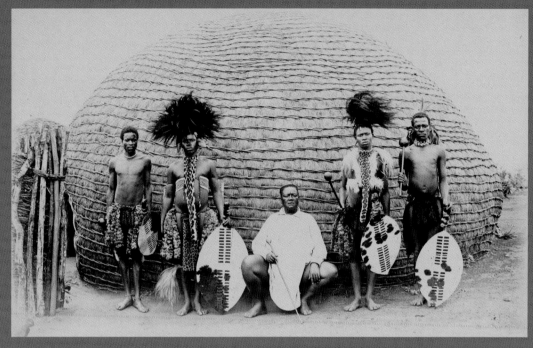

RIGHT A Mthethwa group, one of three major 'nations' in pre-Shaka Zululand, and one led by the powerful Dingiswayo.

The origins of power

Until the early years of the nineteenth century South Africa's eastern coastal belt was home to a confederation of 800 more or less independent Nguni-speaking groups, all sharing a language and culture but each with its own personality. The Zulu were a just a tiny patch on the tapestry.

The word *zulu* means both 'the sky' and 'heaven'. It is also the name of the common ancestor, the sixteenth-century founder who was also known as Nkosinkulu (Great Lord). Even today Zulu praise songs address the king as 'you are the sky'. The distant origins of the Zulu are, like other those of Bantu groups, located in the Great Lakes region of east-central Africa, but local lore holds that the area between today's Ulundi and Eshowe is the founder's birthright, the 'cradle' of the nation, and it remains the burial ground of the kings. But until the turn of the eighteenth century the Zulu could scarcely claim to be lords of the sky, or of anything else for that matter.

Then, in 1816, Shaka succeeded to the chieftainship, and within months of his accession he had quadrupled the size of the miniscule army and, in a series of brilliant campaigns, conquered his powerful neighbours to both the north and south. By the end of 1817 the whole of what is today KwaZulu-Natal lay within his iron grip, and his influence extended across an even bigger area.

This explosive demonstration of Zulu military ambition, though, was not a sudden aberration, an unpredictable and surprising example of one remarkable man's unheralded rise to power. Its roots lay in the decades that went before, back to a time when good rains fell, the plains and rolling hills were fertile and there was space enough, and food enough, to support a multiplicity of small groups. This period saw a surge in population and an accumulation of wealth that was plentiful

enough to enable settlements, even homesteads, to break away from their titular rulers and lead what were effectively independent lives.

But the good times did not last. There came a period of drought, hunger and finally famine, which triggered a bitter struggle for resources. Chiefs forged alliances in order to protect their people, the survival dynamic creating bigger and bigger formations until, in the first years of the nineteenth century, the human landscape was dominated by just three major groupings: the Ngwane, led by Sobhuza; Zwide's Ndwandwe and the Mthethwa under Dingiswayo.

Dingiswayo's name means 'The Outcast' or 'The Wanderer', a reference to his banishment after a failed plot to assassinate his father. However, after five years in exile he returned to remove his brother from the chieftainship, declare himself ruler and to set about broadening the Mthethwa sphere of influence. And he succeeded – his triumphs based partly on the wealth garnered from the lucrative trade route to Delagoa Bay (now Maputo in Mozambique) and, more inventively, on a novel two-pronged approach to military conquest. First, he extended a generous hand to his vanquished foes, choosing mercy over massacre – an unexpectedly benign policy that brought him a lot of friends and enlarged the pool of men willing to serve in his *impis* (regimental groups). Second, he modernised his army by creating the *amabutho*, the tribally mixed, age-graded regiments that produced both a better fighting machine and, because group loyalties no longer intruded, a powerful sense of unity and aspiration.

But Dingiswayo's intellect seemed to fail him in the end. Astonishingly for so astute and worldly wise a man, he accepted an invitation to parley with his chief (and weaker) rival, Zwide, and was duly murdered. His death was to be avenged in decisive fashion by his young protégé and successor, Shaka.

Born to be king

Shaka had had a difficult – and, in terms of his future mindset, a significantly difficult – childhood. He was born near present-day Melmoth, the offspring of Zulu chief Senzangakona and Nandi, a member of the neighbouring and even smaller Langeni group. His parents' liaison was that of the casual, cross-cultural kind forbidden by Zulu customary law. The very name Shaka, indeed, refers to a type of unwelcome stomach worm, and in due course Nandi and her six-year-old son were forced out, taking refuge first with the Langeni, who treated them abominably, then with the Qwabe and finally, in 1809, with Dingiswayo and his Mthethwa. The two men, the established leader and the brooding young newcomer, had something in common: not only did they respect each other's abilities, but both had suffered outcast status.

And Shaka, now tall, strong, even imperious in his bearing, soon demonstrated both his brawn and his brain, leading Dingiswayo's IziCwe regiment with flair, helping to develop new fighting techniques. Foremost among the latter was the introduction of the short, broad-bladed assegai, which replaced the ineffectual long-handled throwing spear and so forcing men into close and lethal combat. Shaka led by example. Like the fighting leaders of biblical times, the captains of

ABOVE Stylised portrait of the warrior-king Shaka. Starting with practically nothing and plagued by a tumultuous childhood, he forged a mighty empire within just three years.

the Roman legions and the princes of mediaeval Europe, he personally showed how it was done, once accepting a challenge from the opposing champion and quickly dispatching him.

When Shaka succeeded to the chieftainship of the Zulu, though, his prospects hardly seemed bright. As noted, it was an insignificant group, its fighting force no more than 500 strong. But he quickly stamped his authority on this band of brothers, installed his mother Nandi as the Great She-elephant, enlarged the army and refined the age-graded regimental system. Zulu soldiers now lived with their peers, in celibacy (bachelors and maidens needed the king's personal permission to marry), and had their own unit markings and regalia. And, most importantly, there was now a novel and very special *esprit de corps* to bind the troops together. Significant, too, was the new form of initiation: circumcision was replaced by trial; youngsters had to prove themselves in battle, to 'wash their spears' in the blood of their enemies.

Finally, Shaka developed the famed Zulu military tactics. The regiments in the field – collectively known as the *impi* – were divided into four parts, together resembling the upper body of an ox. The most powerful, the 'chest', clashed head-on with the massed enemy while the second and third – the fastest runners (the 'horns') – flanked, harassed and encircled. The fourth remained

BELOW Zulu martial arts. Many youths, especially in the rural areas, continue to have a passion for this ancient form of mock-combat, using an *isiqwili* (offensive stick) and *uboko* (a longer defensive one), plus a small shield.

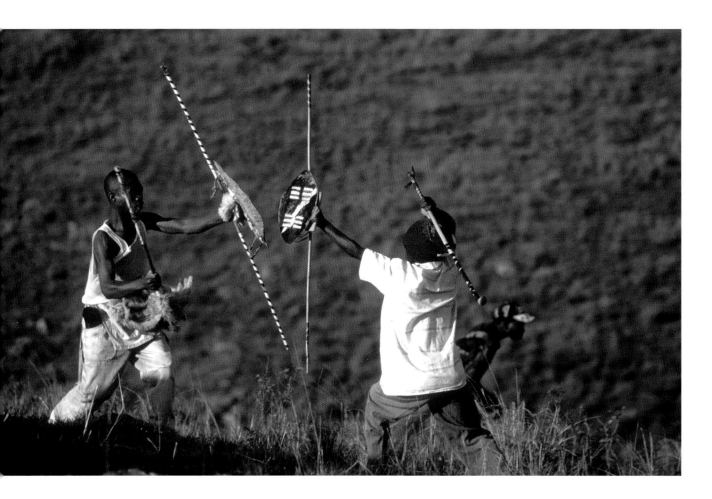

in reserve. In fact, all Zulu soldiers were now fleeter of foot than those they fought – Shaka had denied them the comfort of their traditional and rather clumsy sandals. And the Zulu ranks presented an intimidating sight, the men tall, in peak physical condition, superbly disciplined, each clothed in hide or pelt and adorned with his regimental plumes (the older, married men wore headrings) and patterned ox-hide shield.

Moreover, Shaka fought not just to win, but to exterminate – a new kind of warfare which, until then, had often amounted to virtually bloodless 'battles', the weaker forces retiring from the field after a token exchange of throwing-spears.

Within a year of the new leader's ascendancy, the Zulu army had overcome its smaller neighbours, among them the Langeni who, years before, had so humiliated Shaka's mother (his special enemies were impaled on the stakes of their homestead fences). They then went on to defeat the Qwabe, the powerful Ndwandwe and Zwide's federation of groups to the south. Their lands were devastated, their villages burned, the survivors either put to flight or – the men – recruited into the Zulu war machine, the women taken as concubines or wives. Shaka's iron hand soon spread across all the territory between the uKhahlamba (Drakensberg) and the Indian Ocean.

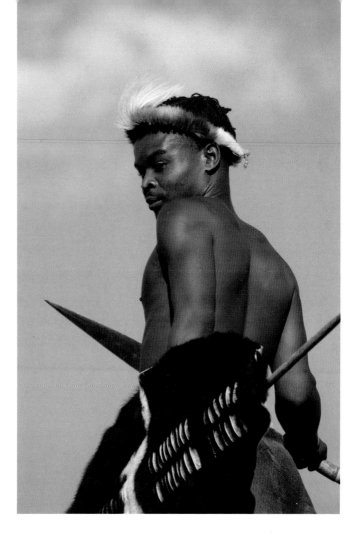

ABOVE A warrior armed with a short stabbing-spear. According to custom, his cowhide shield incorporates the markings of what would have been his traditionally age-graded regiment in the days of Shaka and his successors.

Historians differ in their assessment of the first Zulu king. The popular author Arthur Bryant described him as 'sublime, a moral leader, a martial genius. Submission to authority, obedience to the law, respect for superiors, order and self-restraint, fearlessness and self-sacrifice, constant work and civic duty – in a word, all the noblest disciplines of life were the very foundation stones upon which he built his nation.' A very Victorian, though perhaps valid character reference (Bryant was a modern writer, but his sentiments lay in an earlier and simpler age). Others, notably some who were personally acquainted with the Zulu emperor's methods, called him a 'tyrant' and a 'destroyer'.

The aftermath

Whatever the judgments, Shaka certainly did forge a nation, now some eight million strong, from next to nothing. He also triggered what is known as the *mfecane* (variously translated as 'the crushing', 'the time of emptiness', 'the scattering'), a succession of bloody local wars and forced marches as whole peoples fled Zululand, fanning out across the subcontinent to displace incumbent groups who in turn migrated. Much of the northern interior was devastated (but not, as was popularly believed by generations of white settlers, de-peopled), the lives lost uncountable, the misery unimaginable.

As for the Zulu people themselves, their pre-eminence proved short-lived, although they remained all-powerful on their home ground north of the Thukela River. Shaka's life came to an end in 1828, his death as dramatic as his illustrious career. His beloved mother Nandi had passed away the previous year and the king, grief-stricken to the point of derangement, struck out, commanding that all pregnant women and their husbands be put to death, all milch-cows slaughtered so that, in Desmond Morris's words, 'even the calves might know what it was to lose a mother'. In the following year he dispatched a force south, and on its return immediately ordered his generals to the north. This was just too much for his weary and by-now distrustful subordinates and for his family: on 24 September 1828, he was murdered by his half-brothers Dingane and Mhlungana.

The most significant element in the future fortunes of the Zulu was perhaps the arrival of the first white men four years earlier – a small group of traders and hunters whom Shaka had received amiably enough but who would be followed by other, much stronger and more aggressive settlers in the persons of the Boer Voortrekkers. Against these intruders the great warrior-king's successor Dingane waged a bloody but, in the end, unsuccessful war, his army suffering its most devastating defeat in 1838 at what the newcomers called the Battle of Blood River.

Shortly afterwards Dingane's half-brother Mpande invaded the Zulu kingdom and, with Voortrekker help, seized the Zulu throne. Mpande ruled for the next 32 years – a period during which the nation lost much of its military muscle and some of its territory.

The future looked bleak. When Cetshwayo became king in 1872 he very quickly came to realise that neither the recently established Boer republics to the west nor the British of Natal to the south would tolerate a strong black military state on their borders, an assessment that was to prove dismally accurate when, in 1878 and on the flimsiest of pretexts, the British insisted on the disbandment of the Zulu army.

The demand, however, triggered a new war. As expected, the ultimatum was rejected. British troops under Lord Chelmsford moved across the frontier at the beginning of 1879 and, as we have seen, suffered a crushing defeat at Isandlwana. But this was more or less the only major Zulu success. In the end, raw courage and the assegai proved no match for rifles and field guns, and Cetshwayo's army was finally routed at Ulundi, with the loss of some 10 000 warriors. Cetshwayo was taken away to be imprisoned on Robben Island, off the Cape coast, but he appealed to the British government, was granted an audience with Queen Victoria and eventually allowed to return as one among many chiefs in a now-balkanised Zululand. In due course, civil war erupted and he was forced to flee to Eshowe, where he died in 1884. In 1906 a section of the nation rose in revolt against colonial rule, but the so-called Bambatha Rebellion was only a flicker of the Zulu flame that had once burned so fiercely, and it was swiftly extinguished.

In more recent and even harsher times the country of the Zulu, or, rather, the ten scattered parts of it, was renamed KwaZulu, a designated homeland or 'national state' in terms of Hendrik Verwoerd's 'grand apartheid' scheme. It was the most populous and advanced of the ten or so such territories but its political leader, Mangosuthu Buthelezi, opposed the fragmentation of South African society and refused to accept what the regime considered full independence. Finally, in the mid-1990s, Buthelezi's country returned to the fold as an integral part of the new South Africa.

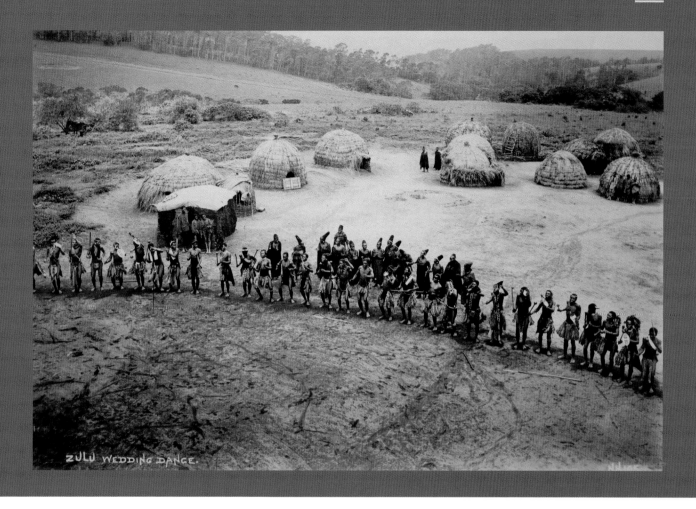

ZULU WEDDING DANCE.

Culture and custom

Of all South Africa's peoples (with the possible exception of the Swazi), the Zulu have perhaps held closest to their culture. Much, of course, has disappeared as the cities have grown and the imperatives of modern industrial society have taken over, but much also has remained intact. Travel through the country areas of KwaZulu-Natal and you will still see the occasional, exquisitely crafted 'beehive' hut, hear the throbbing sounds of tribal celebration, glimpse the beaded splendour of garments that belonged to another and more graceful age. The heritage is less visible but even more durable in the intangibles of traditional life: in the deep respect for chiefly authority and customary law, in the powerful ties of kinship, in the intense spirituality evident everywhere.

Among the Zulu the king is omnipotent, filling the roles of both lawmaker and what Westerners might call high priest, keeper of the sacred coil, or *inkatha* (headring), which unites his subjects. His royal ancestors are recognised as the guardians of the nation. His mystic power is renewed each year at a great gathering of the people in which the regiments parade in all their finery, and where they dance and sing in spectacular fashion. Traditionally, the king was also a father figure – a

ABOVE An early photograph of a Zulu wedding dance, a vibrant and sensual sequence performed by the brides-to-be. Each girl carries a small spear as confirmation of virginity.

61

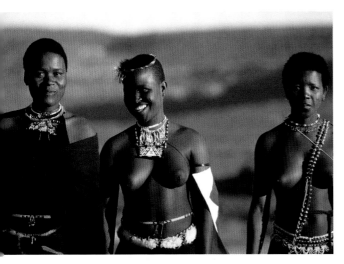

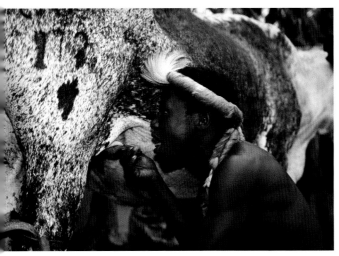

TOP Young Zulu women in the Masinga district of KwaZulu-Natal. While traditional rural life and customs may be much the same, beads and garments may differ slightly from area to area.

ABOVE Warm milk straight from the udder. Cattle are revered even today, occupying an almost mystical place in both the lore and the hearts of the traditional Zulu people.

despot, yes, but for the most part a benevolent one. He exercised his sovereignty – and, indeed, still does – with caution, ruling with the advice of his *indunas* (headmen of clusters of family kraals), men whom he could antagonise only at his peril.

The traditional Zulu 'village' is a small settlement of extended family homesteads arranged in a circle around the cattle pen. At the end opposite the entrance is the Great House, the home of the senior wife. Other wives have their own homes, each with its allocated land and cattle. Women, especially in the past and nowadays in many rural communities, provide the solid base on which the local economy is built: they work in the fields, care for the children, and see to the family's water, food and firewood needs. The young boys herd cattle, while the men hunt and handle political and legal matters.

Traditional Zulu society was highly centralised, structured for national security and conquest. Unique to this nation was the military kraal in which men were expected to live, bond together and train for anything up to half of each year. The regiments had their own dress and regalia, and what may be considered parade-ground drill consisted mostly of synchronised (and spectacular) dancing. Social life in general was regulated by the age-grade system, by rank and, importantly, by how closely or how distantly a man was related to the chief. As he grew older and passed through adolescence, marriage and parenthood, his social status rose. At the age of 40, and providing he was a husband and father, he became an *indoda* (man), later ascending to *indoda enkulu* (senior man).

The matrix of personal relations remains, to a large degree, precisely defined, intricate and determined by a complex web of law, custom and taboo. Those within the extended family itself remain close and highly protective – one's maternal aunt and paternal uncle are regarded as 'mother' and 'father' and behave as such. Their children, one's cousins, are widely accepted as bona fide brothers and sisters.

On the other hand, marriage between even quite distant relatives was forbidden by custom, so in the past a bride would often have found herself a total stranger in her new family. Then, within the marriage, behaviour and attitude were dictated by *ukuhlonipha*, a whole battery of inhibitions. Most notable of these is perhaps the degree of respect a wife was expected to show her husband and his family group. On no account, for example, would or could she mention his name, nor even part of it, nor the names of his relatives. As for the man, he would maintain a similar respect for the chief. All of which created a kind of special, euphemistic language, infinitely subtle and mysterious to Western ears.

Something of this reverential mindset is still expressed, more ritualistically and dramatically, in the custom of praise singing, which remains very much part of Zulu life. In theory, anyone can compose and shout the praises of an age-ranked individual who is considered to deserve

honour, but traditional poems had deeper and wider import, serving to confirm the value system and ideals of the Zulu nation as a whole. Leaders of subgroups – the *indunas* and the chiefs (as well, of course, as the king himself) – had their own, special praise singers and their *izibongo* (songs), which contained the body of Zulu heroic oral literature and were passed down through the generations.

Poems were also composed in praise of cattle. Among the traditional Zulu, the animals topped the list of honoured possessions, occupying an almost mystical niche in the social scheme, an affirmation of wealth and status and the link between one generation and the next, reinforcing the ties between families and groups through the payment of *lobola* (bride price). Some idea of the importance of cattle can be gleaned from the Zulu lexicon: there are nearly 50 different terms to describe individual beasts, each relating to a distinguishing feature, such as colour, size, markings, the shape of the horns and so forth. Sometimes, too, they serve as sacrificial instruments through which people communicate with their ancestors. More practically, perhaps, they were the traditional source of much-needed protein, their milk converted to curd (a staple food). Rarely – only on very special occasions – were they slaughtered for their meat.

ABOVE Tiny villages, or kraals, blend almost invisibly into the hilly vastness around Eshowe, the traditional Zulu heartland. Today, many such outposts remain simple, with few contemporary influences beyond Western attire and the rare modern convenience.

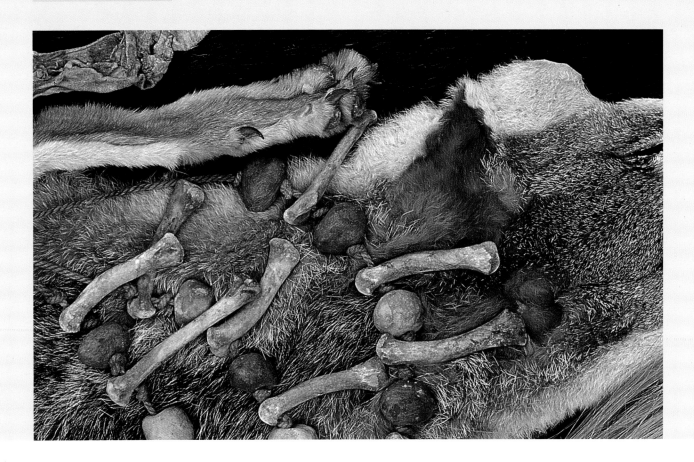

The spiritual world

Like other Nguni peoples, indeed like most Ntu-speakers, the Zulu have their supreme deity, an ill-defined, remote entity known as *Nkulunkulu* (Great One), the first being to emerge from the primordial reeds at a time 'when the stones were still soft'. Also part of the belief system, though – and here the hierarchy is perhaps reminiscent of the ancient Greek pantheon – are *Inkosi Phezulu* (Lord of Heaven), who controls the elements, and *Nkosazana* (Daughter of Heaven), the goddess of fertility and abundance. The latter two are generally disinterested entities, too, who have little impact on daily routines and concerns.

Much more personal and effective are the ancestors, who remain intimately involved in the affairs, health and wellbeing of their descendants and who are kept happy with sacrificial offerings. Also present, and in great variety and number, are unseen spirits that reside in people, animals and inanimate objects. Traditionally, these do not act directly on humans, but they can be used – by those with secret knowledge – as the instruments of both good and evil and mainly through the agency of charms and medicines (*umuthi*).

The link between the material and spiritual domains, between the dead and the living, is the diviner, a medium who is now generally referred to as the *sangoma*. This powerful figure interprets the messages of the departed in various ways but most often with the active help of

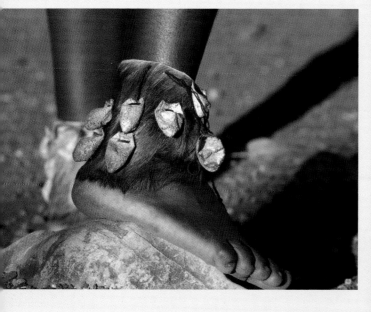

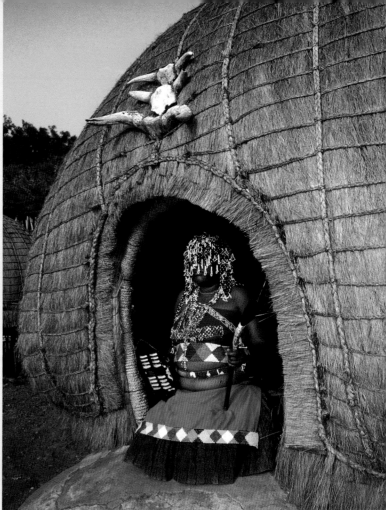

the client, who could be asked to clap his hands or beat the ground with a stick in responses to the diviner's questions. By contrast, a whole concourse of malign spirits haunt the shadowy world of the *umthakazi*, sorcerers or masters (and mistresses) of witchcraft, who go about their business covertly, who were customarily both feared and hated, and who had to be 'smelled out' and put to death.

Music and modes

Truly traditional Zulu weddings are joyous occasions, full of drama, colour and spectacle, the dusty ground of the kraal shaken by the thunderous stamping of feet in unison, the air filled with the sounds of hand-clapping and rhythmic chant. The words and phrases were originally punctuated by the clattering of ox-hide shields but later the Zulu took to the double-ended drum. Other instruments remain few. Most southern Ntu-speaking peoples produce music from animal horns of one sort or another, or from wood or reeds that are blown from the side; only the Zulu used a mouthpiece at the end of the horn. They also developed a simple flute with a two-note scale, and an unusual rattle, which is shaken by hand or worn on the ankles, and often made from the hard cocoon of insect pupae and filled with small stones.

TOP LEFT A Zulu girl's anklets feature butterfly pods filled with pebbles. They are both attractive and useful, producing a rattling sound during her dance.

ABOVE A *sangoma* at the entrance to his beehive hut, a sacred place that is the setting for his communication with ancestral spirits. Even today *sangomas* continue to play an important role in contemporary Zulu society.

But these devices are secondary features of the Zulu musical scene. The dominant rhythms and melodies are produced by human voices, powerful baritones that rise in vibrant two-part harmony to resonate and echo among the hills. Music remains a constant of the traditional Zulu world, honouring each stage of life and practically all activity ranging from childhood games and labour in the fields to hunting, warfare, worship, birth, coming of age, betrothal, the wedding, the funeral – and, of course, in praise of chiefs and heroes.

Costume and ornament vary enormously within the Zulu (or Northern Nguni) community, certainly in their detail, but there are some common features. For men, ordinary wear originally comprised a calf-skin back flap and a frontal 'kilt' of strips cut from antelope or monkey hide or the actual animal tails themselves, often decorated with the much-favoured feathers of the widowbird and with pieces of fur taken from various mammals (but not leopard, which was reserved for the chief). Single males customarily adorned their heads with plumes, the type or style dictated by the area or the age-grade or by simple fashion. Married men traditionally wore a headring.

A later and visibly striking addition to the outfit were coloured beads. When the first white traders appeared on the scene in the early nineteenth century they found a ready market for their bright baubles. The Zulu people immediately began stitching the beads together in intricate designs on various garments, each pattern of symbolic significance, indeed conveying a message worked in by a betrothed, a girlfriend (of which there would usually have been several) or a wife speaking of qualities and emotions. Yellow, for example, often symbolised wealth; blue stood for thoughtfulness; red for both love and sadness. For courting and celebration, the man carried a smallish shield and stick, replaced for warfare by a large shield and assegai.

Originally the women also wore 'kilts', shorter than those of the men and later, for festive occasions, fashioned entirely of beads. Later, too, daily wear included voluminous fabrics knotted at the shoulders and fastened by a heavy belt. During pregnancy, the young wife would wear an antelope-hide apron, which her husband had decorated with metal studs, an ensemble which, it was believed, would endow the coming child with the grace and strength of the animal.

When she was young, the girl would keep her hair in plaits, having it turned into a mop or topknot when she grew older. Before her marriage her brow would have been hidden by a beaded panel worn low over the eyes, a mark of respect for her husband-to-be's father. For her wedding, her topknot would have been graced by the feathers of a widowbird and she carried a short spear, a confirmation of virginity. During the marital years her hair was allowed to grow, the mop decorated with twine or clay or some other material, the hair cut only when she reached widowhood.

The dragon's teeth

KwaZulu-Natal is a sunny region of green uplands and a scenic Indian Ocean seaboard stretching 600 kilometres from the Mozambique border down to Transkei's Wild Coast in the south. Much of the interior is graced by a countryside of deep river valleys, hill upon rolling hill and sweet grasslands that once nurtured great herds of migrating antelope. To the west are the formidable heights of the uKhahlamba (Drakensberg). Today almost the entire area is contained within the

OPPOSITE TOP Zulu maidens gather for their coming-of-age celebrations near Melmoth in KwaZulu-Natal. Older women inevitably have sage advice for the new generation, especially regarding the customs and traditions of their forefathers and what may be expected in even modern society.

OPPOSITE BOTTOM Wedding gift. A bridegroom hands his decorative belt to one of the bride's maidens. A vast number of modern, Western-style weddings are still followed or preceded by traditional ceremonies that have changed little over the centuries.

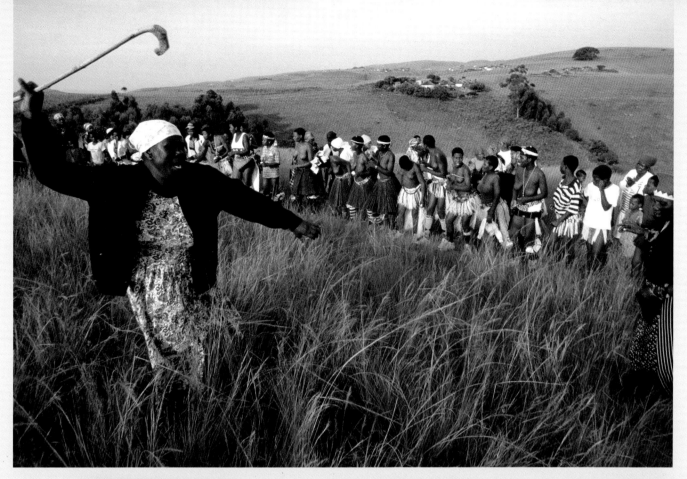

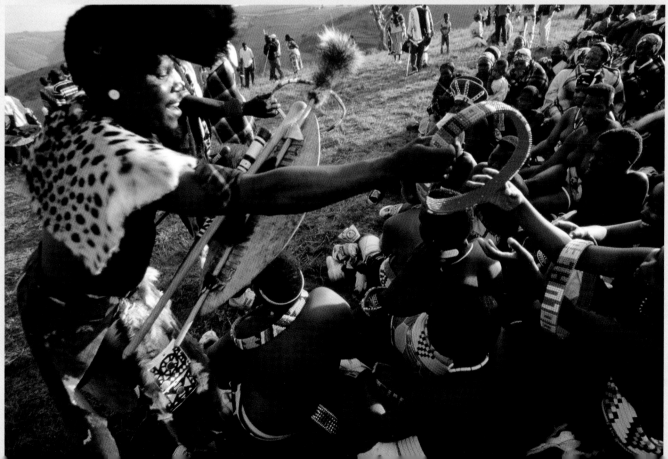

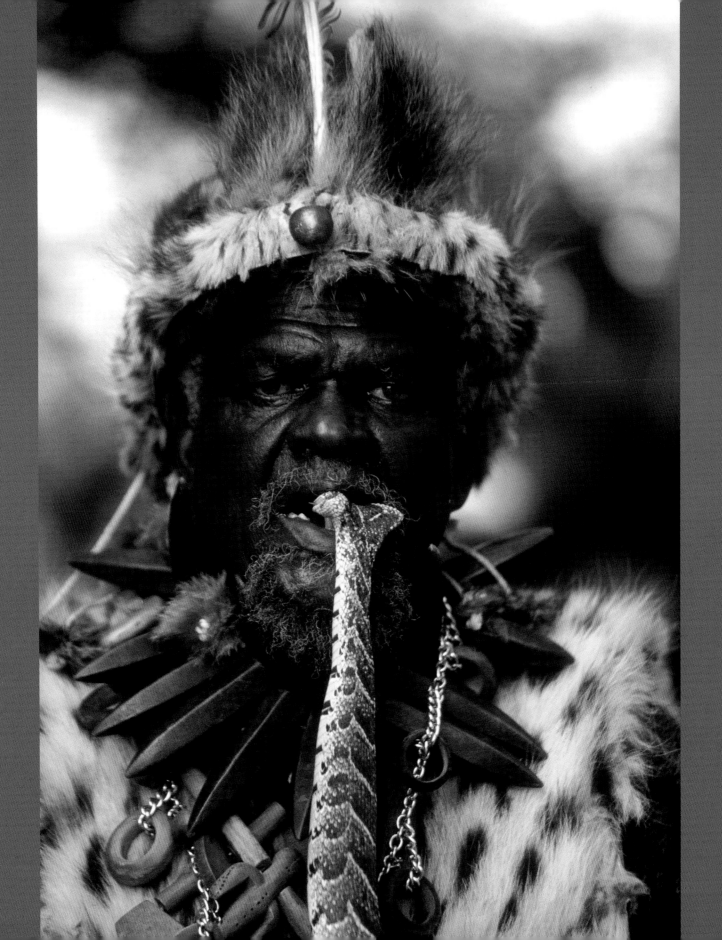

uKhahlamba-Drakensberg Park, a World Heritage Site and deservedly so not only for the majesty of its landscapes but also for its unique role as keeper of prehistoric rock art. There are cave paintings everywhere, most prolifically in and around the Ndedema Gorge (which means Place of Thunder), the location of some 150 caves and rock shelters that once gave asylum to the now long-gone San (Bushman) of the region who found safe refuge in the deep, almost inaccessible ravine from both the elements and the predations of their more aggressive fellow men.

Ndedema has 17 'galleries' holding more then 4 000 paintings (the walls of one cave alone provided the canvas for more than a thousand subjects), and there are a great many more in the Giant's Castle area just to the south. Together, the two places account for about 40 per cent of all known southern African rock-art sites.

Many of the paintings show the remarkably advanced techniques associated with San culture, a three-dimensional approach that lends a vibrant quality to the animals, the hunt or the dance depicted. Movement, power and fluency are all there in the leap of a buck, in the power of a fighting buffalo. Striking, too, are the colours, their essence drawn from the mineral oxides of the earth. Much of this priceless art has suffered over the passage of centuries, damage from damp, from the soot deposited by the San's less creative successor, and from sheer vandalism in modern times. But, still, much beauty remains.

Garden of the east

Not far from the coast, near Durban, is another jumble of uplands – the Valley of a Thousand Hills, which follows the course of the Umgeni River for some 65 kilometres from a flat-topped sandstone feature known as Natal Table Mountain down to its estuary north of the city. This is a rugged, scenically superb wilderness, though in parts it is heavily populated, mainly by the Debe group, many of whose members still live and dress in the way of their forefathers.

In the far north are the famed coastal wetlands of iSimangaliso (the Greater St Lucia Wetland Park), part of which, perhaps rather improbably, are given over to the drier Mkhuze Game Reserve, a medium-sized expanse of savanna, woodland, thicket and river-valley forest that lies beneath the Lebombo mountains. Here you'll find a host of indigenous flora and fauna – especially avifauna, but also Mkhuze's more charismatic residents: giraffe and black rhino.

Much larger is the Hluhluwe-iMfolozi Park to the south, a large tract of African countryside that hosts the Big Five – lion, leopard, elephant, rhino, buffalo – plus another 80 or so mammal species, as well as an impressive 425 different types of bird. The park began life in April 1897 as two reserves (a narrow corridor separated Hluhluwe from Imfolozi, once the hunting ground of the Zulu kings), the very first such sanctuaries to be proclaimed in Africa. As significant perhaps in the context of environmental protection was its role in saving the rhino from extinction.

This area, and that just to the south, is the heartland of the Zulu nation, a region fringed in the east by flattish coastal terraces and the higher ground of the interior. Here you'll find Eshowe, a town that fully encloses the spacious Dlinza forest; Ulundi, the Zulu capital, and the Nkwalini valley, where several commercial 'living museums' offer visitors an insight in the traditional lifestyles and customs of a proud people.

OPPOSITE The *sangoma*'s position can be filled by either a man or a woman. It is through this special person that the ancestral spirits continue to speak to the descendants of Shaka.

69

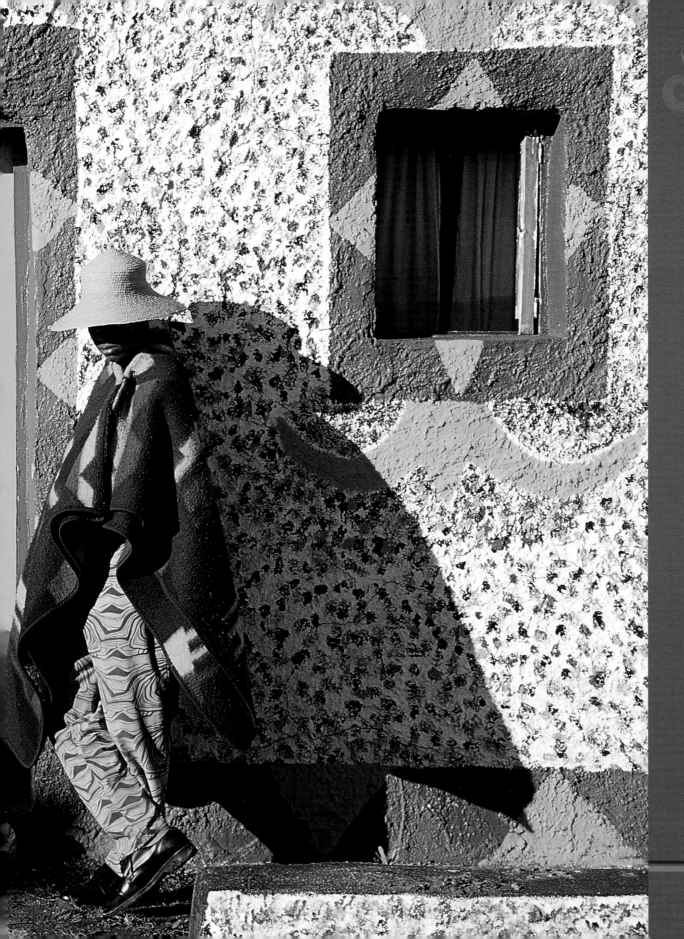

Southern Sotho

Mountain kingdom

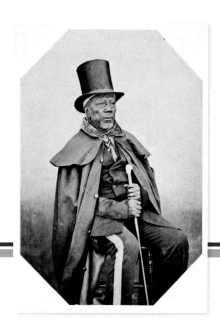

His given name was Lepoqo, and he was born just before the turn the eighteenth century, in that turbulent era that produced some of Africa's most brilliant military leaders. He grew up among the western foothills of the Drakensberg (known as the Maloti mountains in Lesotho) to become a village headman, a humble enough position that soon changed when he launched a series of cattle raids. These he led with such bravery and flair that his followers honoured him in praise song as Mshweshwe (also spelled Mshoeshoe or Moshoeshoe). The name had no basis in ancestry or kin, and simply echoed the cutting sounds of his knife, the weapon he wielded to 'shear the beards of the enemies'.

Mshweshwe went on to fight bigger battles, to found the Sotho (Basuto) nation and, through tactical skill, courage, opportunism and, especially, through diplomacy, to sustain it to the end of his long life.

Coming together

During the 1820s this rather ascetic young man (he never touched alcohol or tobacco, though he did accumulate 40 wives) managed to bring together several minor segments of a wider society caught up in the maelstrom of the *mfecane*, that devastating series of wars and forced marches that had been triggered by Shaka's meteoric rise to power (see page 57).

For all his courage, though, waging war did not figure as Mshweshwe's prime preoccupation. In fact, he regarded face-to-face confrontation as very much a last resort, preferring to bargain, flatter and scheme his way out of trouble – of which, for the weaker groups, there was plenty in those harrowing times. In the early days he made strenuous efforts to remain on good terms with Shaka, presenting the Zulu warrior-king with gifts that amounted to a form of tribute. This was part of his game: when the gifts stopped coming, Shaka asked him why and was told that the Ngwane,

PREVIOUS PAGES Basuto blankets are vital accoutrements on the icy mountainsides. Designs differ according to age and status.

TOP RIGHT The mighty Mshweshwe, founder and long-reigning sovereign of the Basuto nation.
OPPOSITE The conical hat remains a familiar sight in rural areas, but only chiefs and headmen may wear ones with the elaborately carved cone-peak.

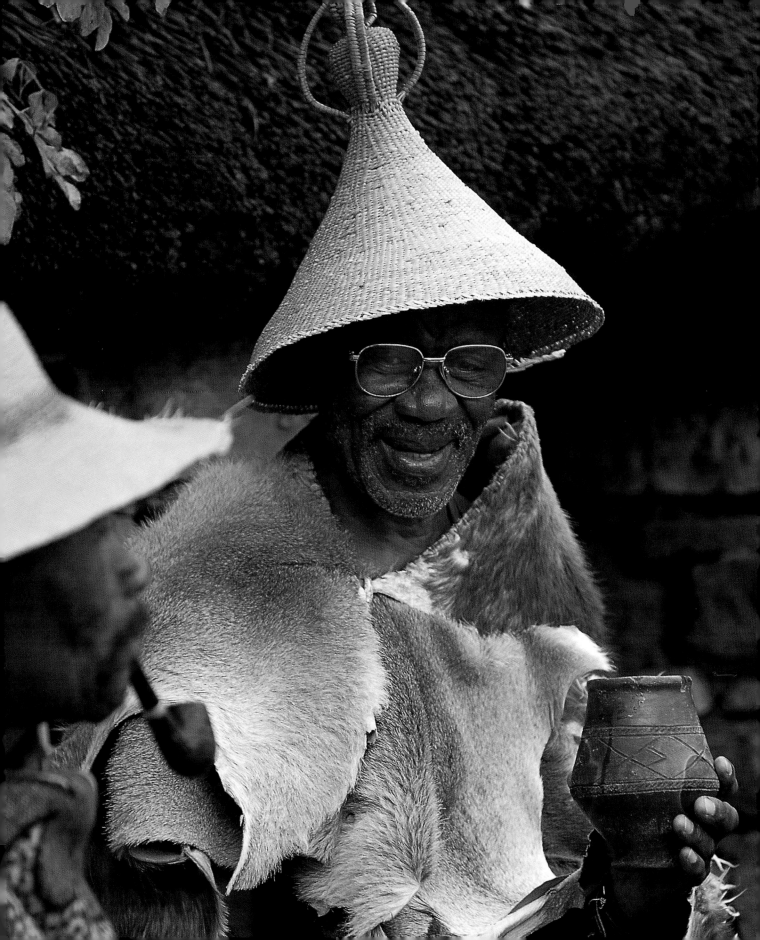

ABOVE Lesotho's high plateau countryside. Little has changed since this picture was taken in about 1915. Mesa and rugged outcrops provided founder King Mshweshwe's people with magnificent natural fortresses.

one of Mshweshwe's deadliest enemies, had halted the shipments – so Shaka's impis promptly marched against and defeated the Ngwane.

Dangers, however, still lurked and indeed intensified. The Ngwane were by no means finished, and although Mshweshwe's following grew as the disruptions of the *mfecane* took an ever-heavier toll, other groups remained bigger, richer and more coherently organised. Numbered among these were the Tlokwa, led by the formidable warrior-queen (or, more accurately, regent) MaNthatisi, a woman said by her enemies to be a Cyclops-like giant who sent her men into battle protected by great swarms of bees. In reality MaNthatisi was quite small in stature (she was known to the Tlokwa as Little Woman), clever, and much loved by her people. During the bitter winter months of 1824 Mshweshwe found himself besieged by the Tlokwa and retreated further into the highlands of the Maloti mountains, to a place called Thaba Bosiu.

Growing up

Thaba Bosiu means Mountain of the Night, and it was a virtually impregnable natural fortress, set in the lofty, scenically magnificent eastern reaches of the great plateau, guarded by rugged cliffs, snow-bound for some of the year, and well provided by good clean upland water. Nevertheless, threats lurked just beyond the horizon: the Ngwane headquarters were not too far away. And in 1828 the enemy hordes swept toward Msheshwe's new stronghold. This time, though, the Sotho chose confrontation and offered fierce resistance, driving the Ngwane to the south and occupying some of

their choicest lands. It was a signal victory, a resounding success that was to be repeated three years later when the young nation confidently repelled an incursion by Mzilikazi's Ndebele raiders.

These military victories proved highly profitable. As well as acquiring more land, the infant nation expanded rapidly when its former enemies, the Ngwane, were defeated by a British colonial force and many of their people, now refugees, joined the Sotho. The pattern was to be repeated as more and more leaders of displaced communities sought Mshweshwe's protection.

Shortly after the removal of the Ngwane threat, missionaries of the Paris Evangelical Society established a presence at Thaba Bosiu, the first white people to penetrate this remote fastness. Among them was Thomas Arbousset, who became a close friend and confidant of the king and who, with his colleagues, provided a conduit for information about the outside world. They also proved a significant influence in the affairs of the early state, among other things acting as advisers in Mshweshwe's complicated and often acrimonious dealings with the white settlers who, by the mid-1830s, were crossing the Orange River in growing numbers. With the help of the missionaries and reinforced by his own, innate diplomatic skills, Mshweshwe was able to play off the Voortrekkers against the British colonial authorities, both of whom had territorial ambitions in the general region.

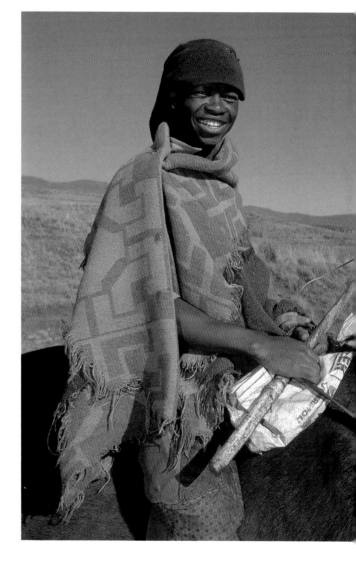

BELOW Basuto horseman. Man and famously hardy pony are well adapted to the difficult, sometimes bitterly cold terrain that covers much of the mountain kingdom.

In the end, however, the king simply had to choose sides, and in 1843 he allied himself with the British, who in due course annexed the northern lands to create the Orange River Sovereignty.

The move ushered in a messy period of horse-trading, raid, counter-raid and open warfare that lasted a full quarter-century. After the annexation Mshweshwe concluded boundary treaties with the British, but then relations turned sour when border violations provoked an invasion by a British force, which was soundly defeated at the Battle of Viervoet. A second and even stronger force, dispatched by Cape governor Sir George Cathcart in the following year, suffered the same fate at Mount Berea. Cathcart, a veteran of the Napoleonic wars, was impressed, especially with the cavalry of the Sotho, which he compared to the Cossack units with which he had once served.

Happy though he was that his army had prevailed, Mshweshwe had no illusions about the relative military and political muscle of the two sides. Ever the pragmatic diplomatic, he decided to quit while he was ahead. 'You have chastised me,' he tactfully told the defeated British. 'Let it be enough, and let me be no longer considered an enemy of the Queen', and went on to negotiate peace with a thankful Whitehall.

In the event, this proved a temporary respite. There were more border disputes after the Orange Free State gained full independence in 1854, leading to three wars between the Sotho

and the Boers in which the former gave as good as they got and more. But, finally, Mshweshwe had enough of the fighting and turned to the British for protection. This he received when the treaty of Aliwal North, signed by Cape governor Sir Philip Wodehouse and the Boer republican government, settled the frontier question once and for all. Mshweshwe died two years later, at the respectable age of 75.

Of all southern Africa's colonial-era leaders, he can perhaps be regarded as the most accomplished all-rounder. He was both soldier and statesman and, like Kgama in Botswana (see page 138), something of a modernist, well ahead of his contemporaries – white as well as black – in his thinking. He recognised the ultimate futility of war, and valued cooperation far more highly than confrontation. He also seems to have believed in a policy of what we might call wealth redistribution as a basic ingredient of social and political stability, favouring grants of land to poorer peoples.

Basutoland was incorporated into the Cape Colony and then, in 1884, reverted to Britain, later to become a British High Commission territory (along with Swaziland and Bechuanaland, now Botswana). Renamed Lesotho, Mshweshwe's state became a fully independent kingdom in October 1966.

Not so lucky were those many Southern Sotho who found themselves out in the coldness of apartheid South Africa. A tiny fragment of land was set aside by the regime as their 'homeland', the smallest and among the poorest of the so-called 'national states' granted a largely illusory degree of self-rule in terms of the white government's segregationist strategy. Named QwaQwa – which, rather ironically, roughly translates as 'whiter than white' – it covered just 500 square kilometres of rugged terrain on the republic's border with northern Lesotho.

Law and lifestyle

The Sotho, like nearly all the Ntu-speaking peoples, are a mix of diverse human elements, most of whom could at one time claim a degree of independence and individuality but which, for security and other reasons, were drawn into a larger fold by circumstance and by a strong leader, in this case Mshweshwe. Most fall into the classic Sotho mould, sharing language, custom and belief with two other main groupings, the Tswana and the Northern Sotho; a few have Nguni origins.

Domestic life followed the classic Sotho pattern. Mshweshwe himself belonged to the Kwena, a people who lived in circular or horseshoe-shaped villages (or hamlets). The huts surrounding the open cattle kraal were the basic unit of the monogamous family (though polygamy was permitted and indeed has remained fairly common), which was linked to a much wider group by strong kinship bonds. Running parallel to these family attachments were what one might call clan connections – membership of a wider community that did not depend on where one lived but on veneration of a *siboko*, a particular symbol or totem. The Kwena object of reverence was the crocodile, the Kgatla adopted the baboon, the Taung the lion, and so on.

The traditional Sotho homestead consisted – and, in many rural communities, still does – of a circular house (commonly referred to as a rondavel) with thick walls and unusually sturdy thatching, features that helped keep out the bitter mountain cold in winter. The unit had a

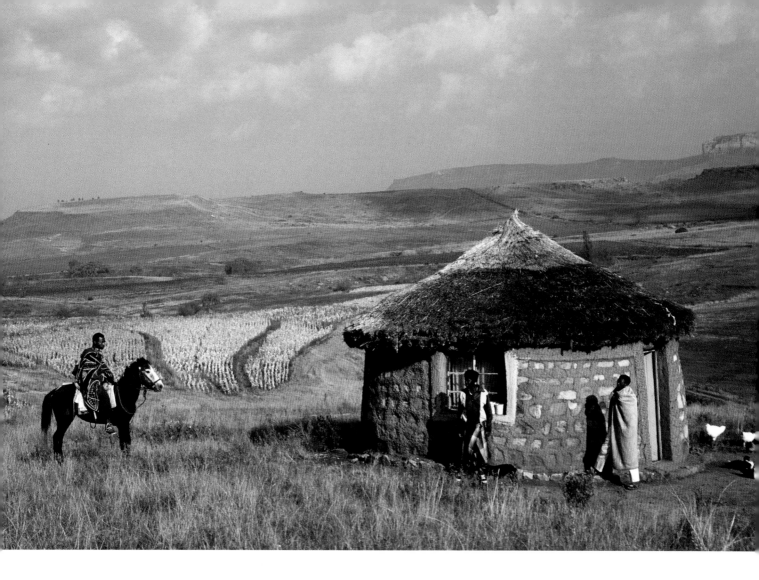

courtyard and, again, as further defence against the chill, two sets of hearths and grindstones, one indoors, the other outside.

Village life has much in common with the Northern Sotho and, especially, with the related Tswana. Group meetings are held in the *kgotla*, a spacious central area with three entrances – one for the people, one for visitors, and a secret one for the chief. Here, too, the old men gather with the pre-initiate boys and teach them the ways of the world.

Traditionally, marriage between cousins was not only allowed but actually encouraged among the Southern Sotho: a young man's mother's brother's daughter was a prize catch, the husband's family paying the *bohali* (bride-price), a smaller one for second marriages, a hefty one if the bride was of royal blood. If the husband died before his wife, the widow went to and was supported by his brother.

Initiation rites remain similar to those of many other Ntu-speaking groups, including the Xhosa (see page 47). Boys undergo circumcision following a period of seclusion, after which they are smeared with red clay and presented with new blankets. The seclusion hut is then burnt. For the girls, the process lasts longer, the youngsters learning all about the nature of womanhood and

ABOVE The lonely country. In theory, the land traditionally belonged to the chief, but once it had been allocated to a family it could not be taken away – provided the fields were still being cultivated. Today, much of the land has been given over to subsistence farming.

wifely duties over a period of months before they, too, emerge to be smeared with clay – white clay, in their case. They then don ceremonial grass skirts and, as confirmation of modesty, reed masks.

Like other Sotho groups, the Basuto embrace a hereditary chieftainship – the house of Mshewshwe – which governs with the help of advisers and whose chiefly authority is delegated down the line to the headmen of the various districts. The people's voices are more directly heard, though, at the great national gatherings known as *pitso*. Unlike the Zulu, the military muscle of the Sotho was traditionally organised around the local headman and his sons, each soldier drawing strength and pride from family, friend and neighbour rather than from allegiance to a laterally structured, age-graded regimental unit.

Music and dance are central to social, ceremonial and religious life in all traditional Ntu-speaking communities. Unique to southern Africa is the stamping routine that distinguishes the Nguni group – the Xhosa, the Tsonga, Ndebele, Swati and, most famously, the Zulu. It is performed in perfect unison, either by a line or sometimes two lines of men or (less often) by the women, but never the two together. The high-kicking steps thud piston-like onto the dusty surface of the kraal so that, often and certainly on big occasions, the very ground shakes. The music, or at least the rhythm, is supplied by the voices of the dancers themselves and supplemented by singers who stand behind them and who clap in time. Various simple percussion instruments complete the orchestra. Although the stamping dance is special to the Nguni, it is not reserved to them. Sotho groups have their own versions, notably the long-striding, leaping *mohabelo*, which

BELOW AND BOTTOM RIGHT
Traditionally, Basuto huts were not painted: instead, patterns were impressed into the plaster. Inside, the builder would mould decorated shelves into the walls.

is accompanied by a lot of hissing and shouting and, from the onlookers, the singing of a repetitive refrain.

On the face of it, the Sotho canon of belief is rather more complex than that of other groups: diviners and healers come in various guises; there are the *dilaoli* (bone-throwers) whose animal knuckles solve the mysteries of sickness and personal disaster; the *senohe* (seers) who diagnose illnesses with the aid of magic potions and who also 'see' the future; the *ngaka ea balwetse* who, among other things, use a doll to explain a person's troubles, sometimes by means of ventriloquism. The *lethuela*, on the other hand, specialise in psychological problems, often by means of hypnosis and exorcism, and who sometimes work in groups (usually of women). Also on hand is the rainmaker and the *moupelli*, the protector of the home and purifier of its occupants, a person who safeguards his flock members from lightning and other threats by treating them with special medicines.

The ancestors, of course, are pre-eminent in the Sotho belief system, each individual watched over by his or her own forefathers. When one dies, it is thought, one simply carries on with life in a new, different and wonderful place (known as *Moremo*). There is *Modimo*, a Supreme Being, but an infinitely detached one, too grand to be concerned with the affairs of a mere mortal. The ancestors are far closer and far more helpful.

And, of course, there is a firm belief in evil spirits – best known of which is perhaps the *tikoloshe* (or *tolose*) – and, certainly in the past, in the presence within communities of practitioners of witchcraft and sorcery. One should bear in mind, however, that witches are almost universal figures in traditional societies, though they come in different guises and under different names in different parts of the world. And southern Africa is no exception. Just as well known is the sorcerer.

The two practices are related but not identical. The witch or 'witchdoctor' has been endowed with supernatural powers and can become invisible, change shape at will, fly through the air and, in many southern African cultures, is able to send other entities, usually small animals in mystical form, to do harm. The sorcerer has no such endowment: he or she is an ordinary person who learns the craft and buys the required magical potions from a herbalist. Nevertheless the two practices can be embodied in the same individual, and indeed the Sotho term *baloyi* covers both.

Witches and sorcerers were feared and hated, because the evil-doer worked in secret – most often at night – and could be any member of the community, young or old, man or woman, friend, neighbour or kin. In the old days the culprit had to be identified, by the diviner, and put to death.

Much of the national heritage, the more visible elements at least, is on show at the cultural village near the QwaQwa park, now incorporated into the Free State's Golden Gate Highlands National Park. The most distinctive marker of identity is perhaps what is known as the Basuto blanket, made entirely of wool (which is pretty much unique to this group), its colours linked to the various

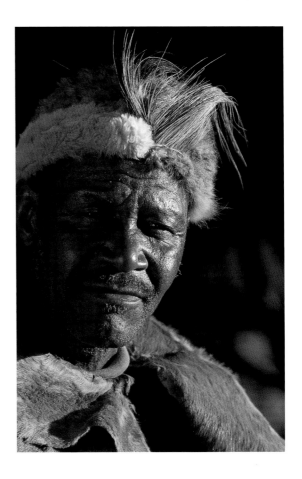

ABOVE A Basuto healer in his distinctive skin *kaross* (cloak) and traditional headdress. Diviners and healers continue to work in one or more of several disciplines, and remain integral to the spiritual life of the Basuto people.

stages of a man's life and to specific events – one kind of blanket for the initiation to manhood, for example, another (a fertility one) to confirm that manhood, yet others for the wedding ceremony and to signify the birth of a first child. The classic conical hat, too, is much in evidence. The hats are designed and made by the men of the community; the tall type with the interlocking arches, exclusive to the aristocracy and royalty, symbolises the country's high mountains.

The tough little Basuto ponies for which the Sotho are famed are of Arab stock, sturdy and adaptable and, in the high Lesotho fastness, selectively and superbly bred for the rugged conditions.

Also on view in the cultural village are the different kinds of homestead that did duty for the Sotho over the centuries, each built and decorated to reflect the period of its occupation. Especially intriguing to visitors is the herbal trail, a guided ramble through the countryside, which introduces one to the various veld plants used by the traditional healer. And, of course, there's the craftwork, here and throughout Lesotho: tapestries, rugs and mohair shawls as well as blankets, basketware, leatherwork, grass-woven goods (including the conical hat) and, in the remoter areas, traditional clay and copper jewellery.

Roof of the world

Lesotho is a place of forbidding heights, of immense buttresses and small villages tucked away in the valleys. The Central Highlands scenic drive leads from the capital, Maseru, on an easterly course, running over six spectacular passes to the moorlands of the central range and the nearly 3 000-metre-high Mokhoabong through-way, and then down to Thaba Tseka, a tiny administrative hub situated more or less in the middle of the country. As attractive but a bit longer is the Roof of Africa drive, which takes you over the northeastern highlands from Butha Buthe to the Sani Pass, sole gateway – for motorists, at least – to KwaZulu-Natal and the Indian Ocean. This is a superbly scenic route, a dizzying run of curves and sharp bends and striking new vistas that serves as one of the motoring world's better known and loved rally courses.

Adventure trails – on the back of one of those sturdy Basuto ponies, for example – enable you to reach parts of Lesotho that are inaccessible

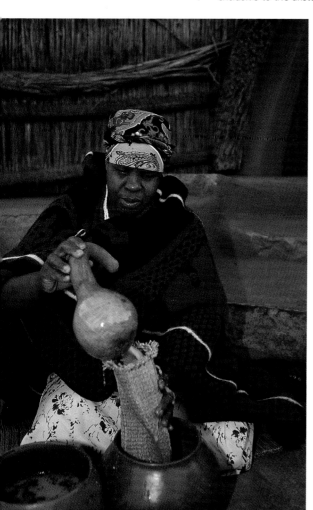

ABOVE Thick, nutritious beer is still brewed, even in the remotest of villages. Here, the liquid is strained through a specially made basket.

to road vehicles, among them some fine showcases of San cave paintings and a number of exquisite waterfalls. Most striking of the former can be viewed at Ha Khotso, also known as the Ha Baroana, which is just over 40 kilometres from Maseru. Here you will see the remains of some of the world's best prehistoric art although, unhappily, much of it has weathered and even more has been vandalised. The waterfalls include the 192-metre Le Bihan, southern Africa's highest and a well-kept secret of the aboriginal San until the Sotho discovered them. This remote area is also notable for the rare spiral aloes that decorate the mountain slopes.

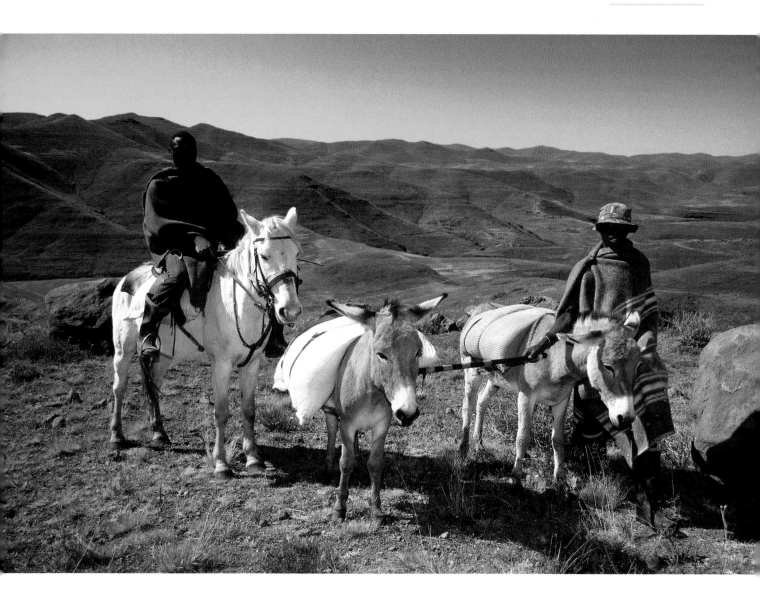

Looming skywards from a plateau not far north of Ha Khotso is the mighty Thaba Bosiu mountain itself, Msheweshwe's safe haven, a fortress with a single-entrance pass (across which the first Sotho built a stone wall). A guide will show you, among other things, Mshweshwe's grave, and will ask you to say a prayer for the king.

Finally, there is the Sehlabathebe National Park in the remote and lofty southeastern segment of Lesotho. The name means Plateau of the Shield, but it could just as simply been called the Place of Spears for its steep, starkly carved spires, the most prominent of which are The Devil's Knuckles and a trio known as The Three Bushmen. For all its isolation, winter snowstorms and snowscapes, though, this is a green and pleasant area for much of the year, the surprisingly rich plant life fed by the nurturing summer mists.

ABOVE Horse- and donkey-power on the great Maloti mountain plateau. Water from the winter snow sustains much of South Africa's otherwise somewhat dry northeastern region.

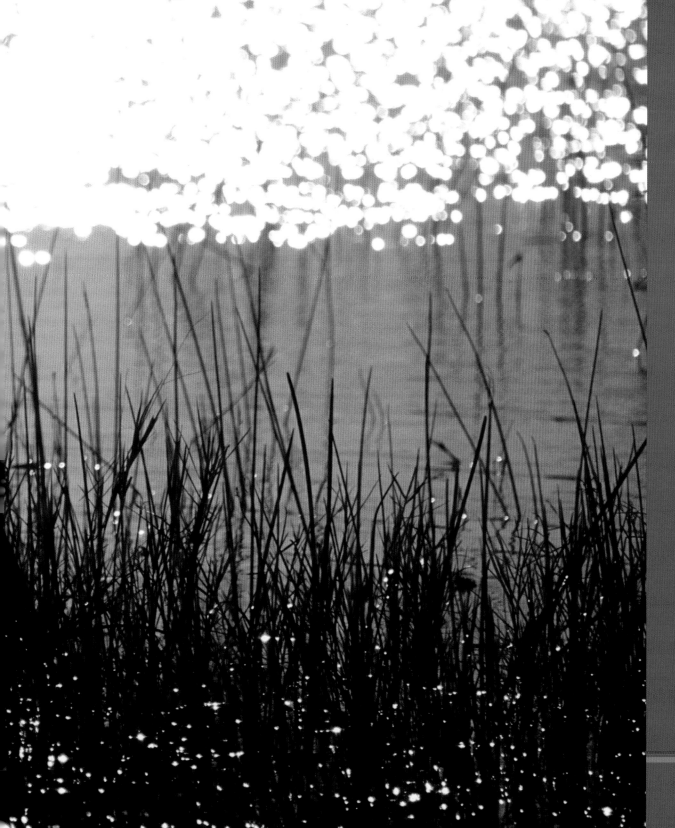

Tsonga
Where the lion feeds

PREVIOUS PAGES The original
Tsonga, or Shangana (the
term used in Mozambique),
are people of the hot, humid
and once fever-ridden Lowveld
plain and, for the most part,
they were fisherfolk. Their
fortunes and their lifestyle
changed dramatically when
Shaka appeared on the scene.
OPPOSITE Collecting waterlily
buds, a great delicacy, from the
shallow pans of Maputaland,
a region that has for always
provided the food, building
materials and medicines on
which the traditional Tsonga
have depended.

Some years ago Linda Tucker, a young London executive, visited one of her childhood haunts – the Timbavati Private Nature Reserve just west of the Kruger National Park. This is big game country, the 'real' Africa, sun-scorched, wild – and dangerous. The threat that is always here became immediate peril one night when Tucker's game-spotting party found themselves surrounded, suddenly, by a 24-strong pride of restless lions. The safari vehicle was of the open kind, its occupants unprotected and, understandably, they began to panic. And their fear was infecting the already agitated carnivores. It was a critical moment, one that could easily end in tragedy.

Then a remarkable thing happened … Out of the darkness of the dense bush came a woman carrying a baby and followed by two youngsters. They seemed, to the observers, to be in some kind of trance as they walked calmly through the group of lions to the vehicle. The creatures fell silent, and remained so calm that one of the tourists was able to make his way past the pride to summon help.

The woman's name was Maria, known locally as the Lion Queen of Timbavati. She later introduced Tucker to some of the cultural mysteries of her people, telling of the meaning of Tsimba-vaati, the place where star-lions descend from heaven. Maria belonged to the Shangaan group, known in South Africa as the Tsonga, and sometimes as the Shangaan-Tsonga. Her home language is Xitsonga.

The past in brief

The original Tsonga were a diverse group, organised in small and more-or-less independent chiefdoms mostly along or close to the lowlands of the eastern coastal belt. They were primarily fishers, and also farmed a little, although few kept cattle because the tsetse fly, bringer of the dread nagana disease, thrived on the hot and humid plains.

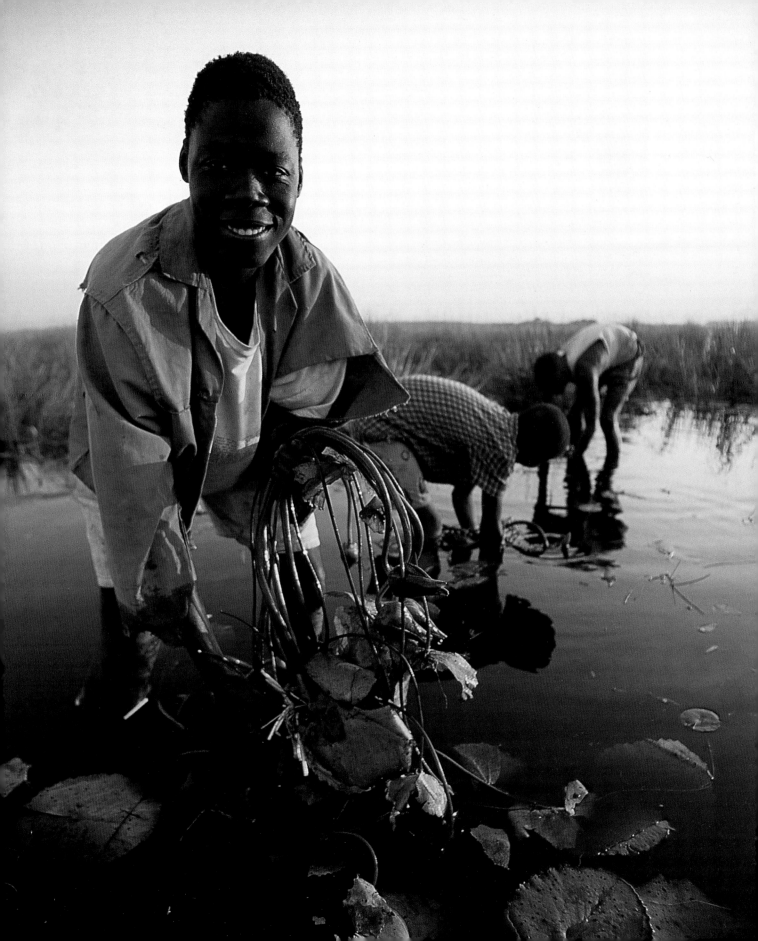

Then the human landscape changed, dramatically, when Shaka Zulu and his *impis* appeared on the southern scene in 1816. The Nguni wars and the great forced marches known as the *mfecane* proved hugely disruptive. Some of the Tsonga chiefdoms fled inland, but many more were caught up in the maelstrom, most crucially when the Nguni military leader Soshangane started out on his own road to empire, a campaign that rivalled Shaka's.

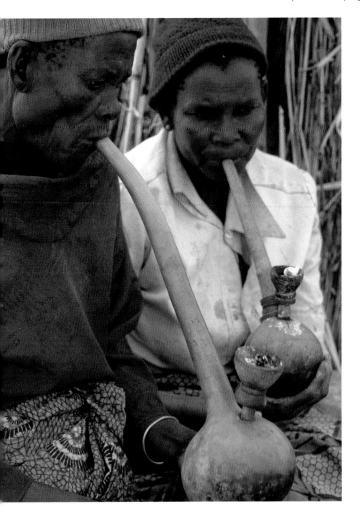

Soshangane, who gave his name to the Shangaan (or Shangana), eventually held sway over much of Mozambique (notably the entire Gaza region), southeastern Zimbabwe and some of what today are the eastern parts of South Africa's Limpopo and Mpumalanga provinces. In the process he had absorbed a good number of previously autonomous peoples. Thus the Shangaan-Tsonga are very much a hybrid group, though they share a common language and now, to a degree, a cultural heritage.

Especially distinctive are the people who moved west in about the mid-1800s, settling near the town of Louis Trichardt (or, incorrectly, Makhado, following an unsuccessful attempt at a name change in post-apartheid South Africa), and the distantly related Tembe of what is now the Maputaland region of KwaZulu-Natal and southern Mozambique. The former evolved an exquisite style of beadwork unknown to their eastern cousins; the latter, who share cultural elements with the Swazi people, survived the Nguni encroachments and have remained to a large degree in their ancestral home, their unique fishing skills most visible perhaps in the chain of lakes at Kosi Bay.

Many of these traditional people still follow the ways of their forefathers, but much of their past has in fact been lost. Recent history has not been kind to the Shangaan-Tsonga people. In their inimitably clumsy way, the social engineers of South Africa's apartheid regime restricted them to the 'homeland' of Gazankulu, a cluster of four patches of Lowveld countryside bordering the Kruger National Park and nourished by the Letaba and Sabie rivers. The territory has since been reincorporated into the country proper.

ABOVE Tsonga women enjoy a smoke of the traditional kind. This is a diverse people, their kinship and lineage systems complex, but the sense of community and family still important in modern societies.

Custom and belief

As noted, the Shangaan-Tsonga have very mixed origins. Praise-names, for example, indicate Zulu, Xhosa, Sotho and Lozwi (a Zimbabwean group) ancestry. In an examination of their cultural heritage, they can therefore only be described in very general terms and in broad approximations.

The way in which traditional society was structured is complex, but essentially it radiated out from the nuclear family – mother, father and their children. Polygamy was a powerful factor in the wider organisation. Each wife had her own homestead, as did her sons when they married.

The various families then lived in enclosed settlements, their more distant relatives residing in the same general area so that there were clusters of 'villages'. Those clusters, which recognised the authority of a particular chief, equated to a *tiko ra hosi*, a term that may be translated (although not entirely accurately or appropriately) as a 'tribe'. Cutting across these loyalties, though, were *nyimba* (clans) whose members could trace their lineages to a common ancestor.

Peculiar to the Shangaan-Tsonga were the unusually close relations a married person enjoyed with the spouse's family. Marriage within the wider blood-related familial network was absolutely taboo, at least within seven degrees of relationship. Traditionally, the in-laws' group, however, had a special place in a man's heart and in his social code: it contained what were known as 'presumptive wives', which obliged the husband to observe a strict pattern of behaviour in his dealings with his in-laws.

Generally speaking, the division of labour was historically organised along gender lines, but in some instances – especially in the realms of ceremony and healing – the sexes worked together. When a girl fell ill, for example, a boy would bring the medicine to her. When a woman performed a mystical rite, it was the man who killed the sacrificial animal – a male one. Hunting also demanded complementary rituals, which are shrouded in taboos and nuanced behavioural patterns.

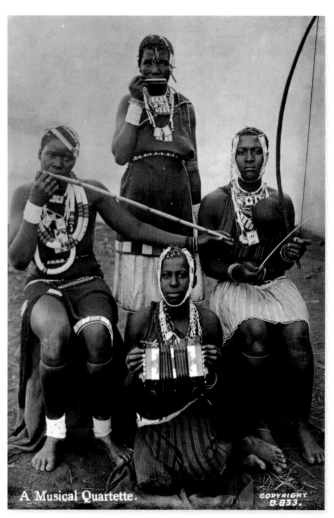

A Musical Quartette.

COPYRIGHT B-833.

Sound and spirit

The Shangaan-Tsonga have built up a rich canon of lore: more than 200 folktales and around 2 000 proverbs and riddles have been recorded, and their telling has become an art form in itself. The voice, its quality, its lilting tones and emphases are all-important, the story often recounted to the accompaniment of a xylophone-type instrument. Tradition-ally, stories are told by an older woman – a grandmother, perhaps – who enjoys the respect of her audience and who invariably begins the tale with the words *Garingani, n'wana wa Garingani* (I am the narrator, daughter of the Narrator). Music and dance are also prominent features of village life, the instruments simple but effective. They include a *fayi* (small flute), once much fa-voured by young herders, which produces a haunting rasp-like sound, and the *xitende* (a stringed bow-and-gourd). Migrant members of the group who entered the industrial society have become famous for their mine dances, which are accompanied by drums, horns and other instruments, and for the *muchongolo*, a lively set of routines that form the sonic backdrop to various ritual

ABOVE A Tsonga musical quartet in the early days of the twentieth century. Both the bow and flute are traditional instruments in Tsonga communities – the notes of the flute were believed to drive away thunderstorms.

87

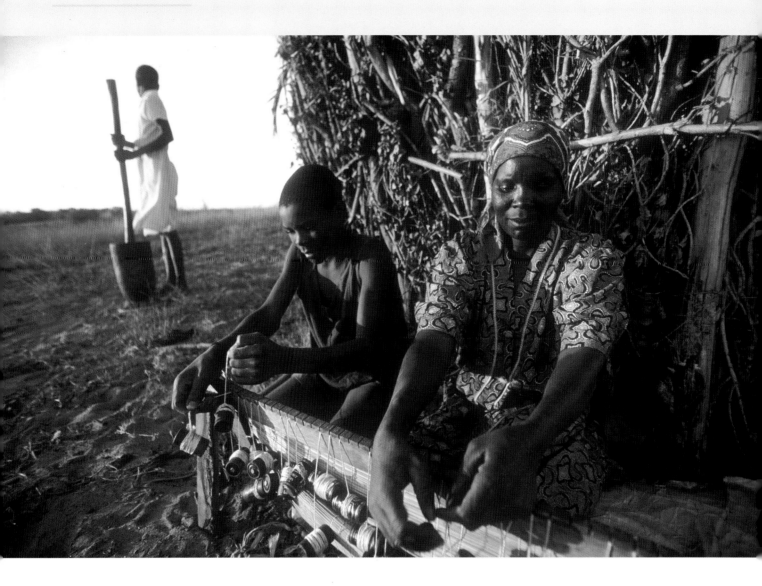

ABOVE While their city-dwelling contemporaries have welcomed the luxuries of urban society, most rural communities continue to rely on age-old customs and skills passed down over the centuries. These women are fashioning a sleeping-mat on their home-made loom.

ceremonies. Historically, these musical routines also celebrated victory in war, and paid tribute to the part played by women in Tsonga society.

Like other Ntu-speaking groups, the Shangaan-Tsonga recognise a Supreme Being, but the entity is vaguely defined. Its name is Tilo, which refers both to the Creator and to a divine realm. Much more definite though hardly less tangible are the ancestors, whose spirits are ever present and are served by their descendants rather than worshipped. Related to this is the perception of the human essence, which can perhaps be compared (albeit tenuously) to the Western concepts of body, mind and soul. In Shangaan-Tsonga belief, a person has three components: *mmiri* (the physical part) and two non-material elements, namely *moya*, the wind and the breath that enter all people at birth and depart at the moment of death, and common to all humanity; and the *ndzuti*, which is associated with an individual's shadow and reflection and is a very personal marker.

The overriding credo, however, is the belief that all of society is a unity, embracing both the living and the dead. Transition from one to the other is a protracted and solemn affair: traditionally, a family performs a 'welcoming' ceremony to ease the passage of their loved one into the spirit world. They then go through a ritual cleansing process because death leaves their household sullied, and the rites continue to be performed over the succeeding months. Meanwhile, they also gather in a hallowed, or at least in a special area to pay homage to their ancestors, presenting them with food and drink and with expressions of gratitude for looking after their descendants.

Magic, in fact, plays a prominent role in the traditional life of the Tsonga, notably when it comes to physical and mental health. Occasional sickness is accepted as part of life, but protracted illness and a severe or long run of bad luck may indicate the presence of *baloyi* (evil spirits), which demand that the healer consult the ancestors. He does so, determining the cause of the malaise through the agency of *tinholo* (bones) or shells or some other artefact and uses his knowledge of the veld and its plants to effect a cure. Some fascinating examples of early Tsonga medicinal and ritual vessels have been unearthed over the years, some of them carved from medicinal wood, and all individualised and decorated with beads. They also came with carved stoppers tapered at one end (to stir the mix) and a carved figurine at the other. These were considered to be the property of the ancestors; indeed, it was believed that they actually held the spirits of the ancestors, and were reverently passed down through the generations. When the contents dried out, the healer would ceremonially reactivate the vessel.

Perhaps the most distinctive cultural feature are the face-markings of women, who cicatrise (scar) the forehead, cheeks and chin. Some subgroups have adopted tattooing, with one northern community, the Chopi, taking the practice to extremes: defacement produced raised scar tissue (keloids) that were disfiguring enough for the Voortrekkers to refer to them pejoratively as *Knopneuse* (Knob-noses). Characteristic, too, was the pierced earlobe of the men, which probably had something to do with early initiation rites, and possibly with the recognition of collective subjection to the Nguni.

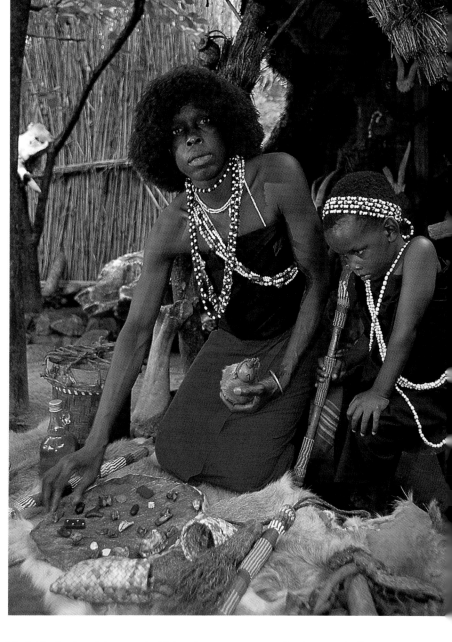

ABOVE In their rituals, diviners use any number of uniquely patterned medicinal receptacles that are said to have belonged exclusively to the ancestors and are passed down from one generation to the next.

The women once wore tanned and softened skin clothing but have long since taken to fabrics, often striped, with dark blue a favoured colour. Traditional skirts were knee-length, two-tiered, and decorated with beads. On ceremonial occasions the men appeared in their best outfits, which included skirts of animal tails or strips of goatskin.

The wilderness

The most celebrated of the wider region's natural assets is the Kruger National Park, one of the world's great wildlife sanctuaries and repository of the continent's largest concentration of big game. Millions visit it each year, and despite the tarred roads, it remains a wilderness. All the human intercessions affect less than three per cent of the park's broad acres; the rest belongs to the animals, the birds, and the bushveld.

Timbavati – where Maria the Lion Queen rescued Linda Tucker and her friends and today famed for its white lions (held sacred by the local Shangaan-Tsonga) – is one of the huge, privately owned game areas bordering Kruger to the west. There are no longer any fences between the public and private sanctuaries, and the animals are free to roam. Indeed there are no fences to the east either: in a strikingly imaginative bid to open up a much larger chunk of Africa to the animals, large enough to enable the herds (and their attendant predators) to follow their ancient migratory trek-routes, an extended haven called the Greater Limpopo Transfrontier Park has been inaugurated. This is one of several new cross-border 'peace parks' that free up southern Africa's wildernesses, and it links Kruger with vast game areas both in Mozambique and, across the Limpopo, in southeastern Zimbabwe.

Land of lakes

Quite different is the country far to the south in what used to be known as Tongaland and is now called Maputaland, after the river that flows through southern Mozambique. Maputaland lies at the junction of the subtropical and tropical zones, and this has created a striking number and variety of ecosystems, and of plant and animal habitats. The wetter parts are haven to hippos and crocodiles and to a remarkable array of water-related birds.

Northernmost of the major wetlands is Kosi Bay, a chain of four lakes separated from the sea by some of the world's highest forested dunes.

The lakes are beautiful and also yield a bounty: the local Tembe villagers erect timber-barred enclosures into which fish swim and are then guided, though a series of 'funnels', into smaller corrals where they are speared. Just across the dunes are beaches that serve as magnets for giant leatherback and loggerhead turtles to nest on these shores.

Inland to the east is the smallish Ndumo Game Reserve, set on the floodplain of the Pongola River, a lush complex of fever-tree woodland, marsh, reed-bed, evergreen forest, pan and lake that is famed for its trees, its birds and its haunting beauty. The next-door Tembe National Elephant Park was established as a refuge for the remnants of the once-great elephant herds of Mozambique's coastal plain, animals that had suffered grievously from human conflict and human encroachment.

OPPOSITE A Tembe fisherman of Kosi Bay with part of his catch. The fishing technique used, involving reed funnels and 'kraals' (corrals), is unusual if not unique to the fishing communities of the region.

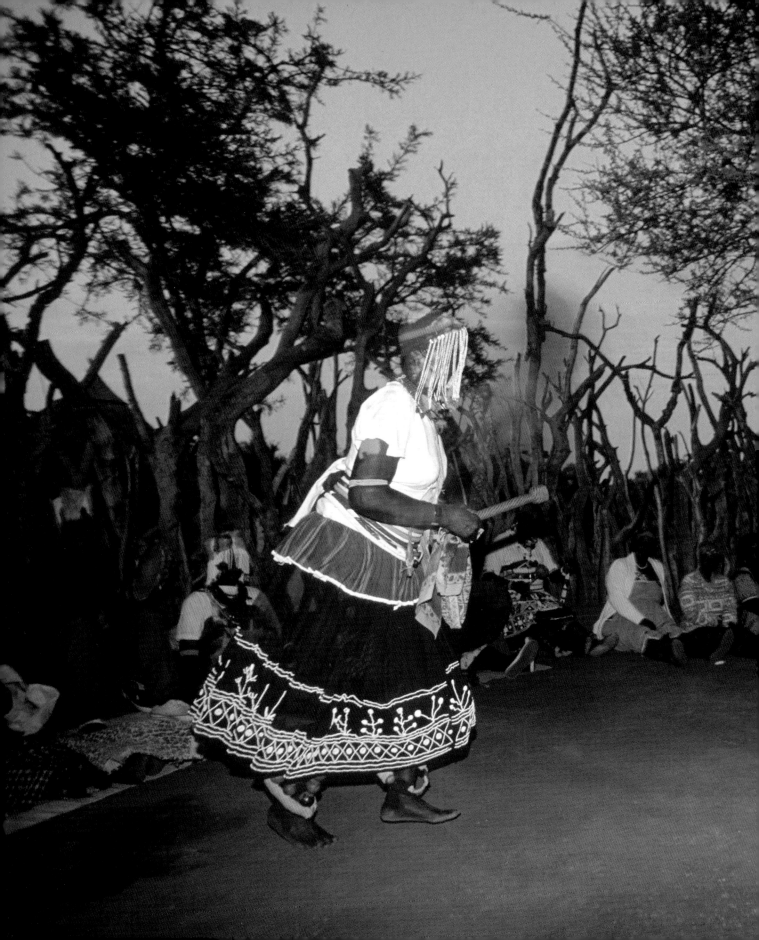

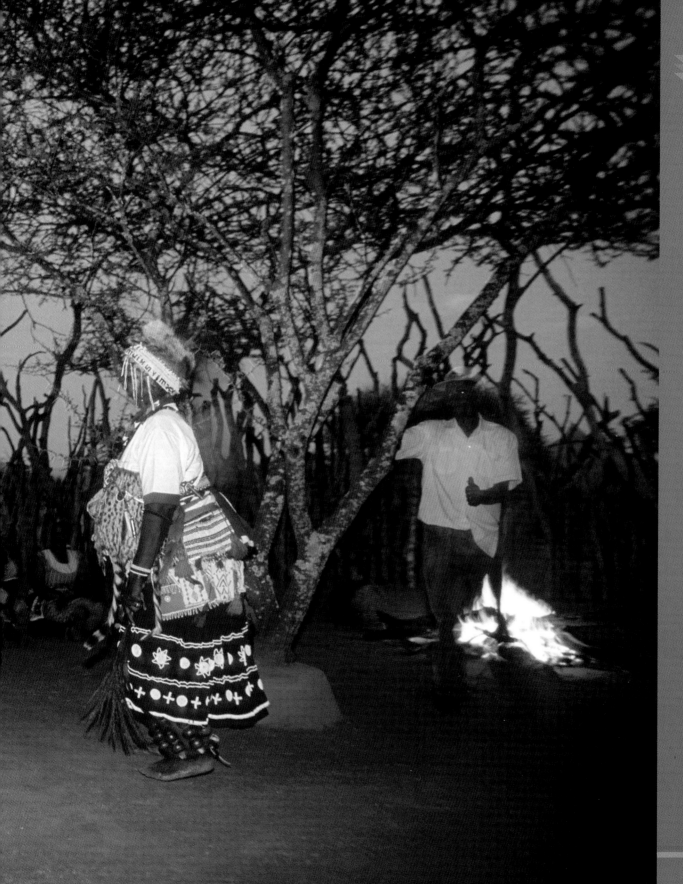

Northern Sotho

A tapestry

The official language is Sepedi but the appellation is misleading: the Pedi are just one group, albeit a major one, of a linguistic and cultural society that is more properly known as the Northern Sotho, and which originated as a confederation of small chiefdoms before the seventeenth century, in what is today Limpopo province. The forefathers of these diverse peoples were among the southward-moving Bantu migrants who, far in the past, began moving down in slow waves from the Great Lakes region of east-central Africa to populate the northern regions of the subcontinent.

Their story is an interesting one, but complex, as are the stories of all Ntu-speaking folk – if there is one feature that complicates the annals of southern Africa it is the constant movement of peoples.

The Northern Sotho are by no means a homogeneous group, and they have never been a coherent political entity. Some come from Nguni stock, distantly related to the Zulu and Xhosa; others drifted down from the Shona-speaking regions of today's Zimbabwe. The Pedi themselves are an offshoot of the Tswana.

A troubled past

Some time after the groups had settled in the Limpopo region, the Pedi gained control of the trade routes to the Indian Ocean, which gave them the wealth and power to dominate their neighbours, and to establish what amounts to the first Sotho monarchy – that of Thulare. Until then, the Sotho had been too dispersed to form an integrated community, too widespread even for the various segments to claim any close mutual relationships. Nevertheless, the various groups shared much, culturally at least – language, of course (though the dialects differed), but also architecture, custom and belief.

The human landscape became even more complex with the mayhem that accompanied Shaka Zulu's rise to power 200 years ago in present-day KwaZulu-Natal, though the Southern Sotho

did emerge as a nation, which became known as the Sotho under the inspired leadership of Mshweshwe (see page 72). The later appearance of Mzilikazi's Ndebele, and later still of the white colonists, brought further disintegration. However, the newcomers, specifically the missionaries, did help entrench the Sepedi language, adopting it as a medium for teaching, preaching and biblical study. Other groups were then steadily drawn into the linguistic net.

Generally, though, these were troubled years for the Northern Sotho. The great Thulare died sometime around 1820 and his sons competed bitterly for succession, a destabilising element compounded by shortages of cattle and grain and the consequent quarrels among the chiefs. In due course, however, some degree of peace and prosperity returned under the leadership of Sekwati – who, like the Sotho king Mshweshwe, was a clever man who could fight well when he had to but preferred diplomacy to war – and by the mid-1800s the Pedi had recovered much of their economic and military muscle. They made good use of it, too, for a time, anyway. Led by their paramount chief Sekhukhune and armed with modern weapons, they were able to take on and defeat a strong force of paramilitaries from the Transvaal Republic and their Swazi allies. The year was 1870; it was the first time that a black society had prevailed over the white settlers. A great deal of self-esteem, and privacy, was restored to this proud people.

But the good times did not last long. Shortly afterwards, an invasion mounted by white mercenaries forced Sekhukhune to sue for peace. In fact it was a kind of armed neutrality rather than peace – the chief had no intention of keeping to the treaty terms – and after the annexation of the Boer republic in 1877 the new British overlords marched in to establish their authority by force. Eventually the Pedi lands were absorbed into the Transvaal, though small portions of them were set aside for the exclusive use of Sekhukhune's subjects.

A century later this 'reserved' status was redefined and entrenched by parliamentary statute with the creation of the 'national state' of Lebowa, the Northern Sotho 'homeland' and product of an apartheid regime's attempt at social engineering on a massive scale. The territory was small, poor and entirely artificial, a kind of series of corrals intended to confine a widely distributed people. It comprised six blocks of grassland terrain stretching from Mokopane (Potgietersrus) eastwards to a point close to Phalaborwa and the central Kruger National Park. Lebowa, fortunately, is no more.

The old ways

Like all the southern African Bantu, the Northern Sotho venerate their forefathers. They also have a well-defined hierarchical system and, as the person closest to the ancestors, the *kgosi* (chief) serves as a kind of high priest.

The chief ritually inaugurated the ploughing season and, after preparation on the sacred fire, tasted the first fruits of the harvest. Thereafter, the grain – that which was not for immediate consumption by the people – was traditionally mixed with ash as protection against pests, placed in large baskets and stored away beneath the earth of the cattle kraal. The chief was also guardian of the rainmaking medicines, which he gathered on periodical 'rain hunts' and then poured on the ground to ensure fertility. He also used them to change 'smoke clouds' into rain clouds. That was the general pattern among the various groups, though Pedi procedure was a little different:

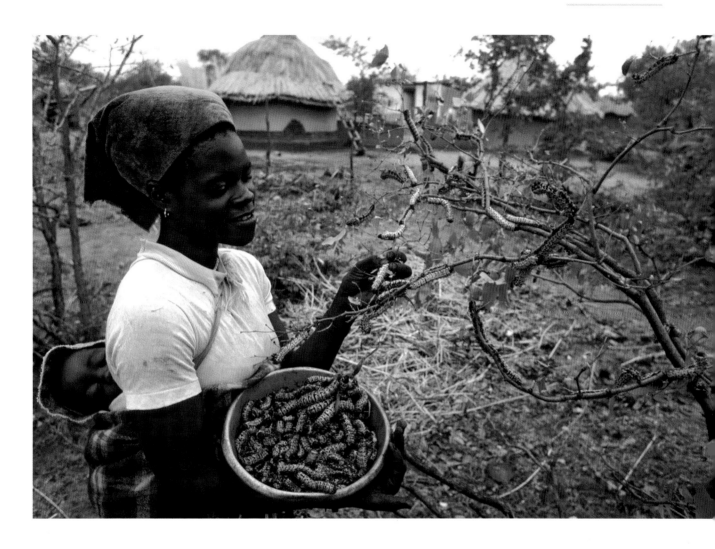

the chief would ask his *ngaka* (spirit medium) to perform the rituals at the royal kraal, one that involved a solution of honey from the royal hives, charcoal and the tail-fat of a black sheep and water, which was sprinkled over a group of boys and girls with a wildebeest tail-whisk. The youngsters then paraded around to the music of the rain song.

The office of chief remains hereditary – it is the first-born son who succeeds his father – and, traditionally, his authority was in theory absolute. But a good chief governed strictly in accordance with customary law and on the advice of his councillors, who were usually relatives or trusted members of his age group. His powers and duties are duplicated down the line of seniority to headmen of village clusters and thence to local leaders. Northern Sotho villages, unlike those of the Nguni, were historically fairly substantial, some of them large enough to qualify as towns divided into distinct residential areas, each with its own leader, the whole accommodating several thousand people. In addition to the benefits that flow from such complex urban-type structures, the bigger concentrations were that much easier to defend in times gone by.

ABOVE Traditionally, the Pedi have resorted to harvesting the fruits of the veld, such as mopane worms, for their sustenance and, while many communities enjoy the conveniences of modern shops, equally as many still rely on the delicacies – and gathering methods – of their ancestors.

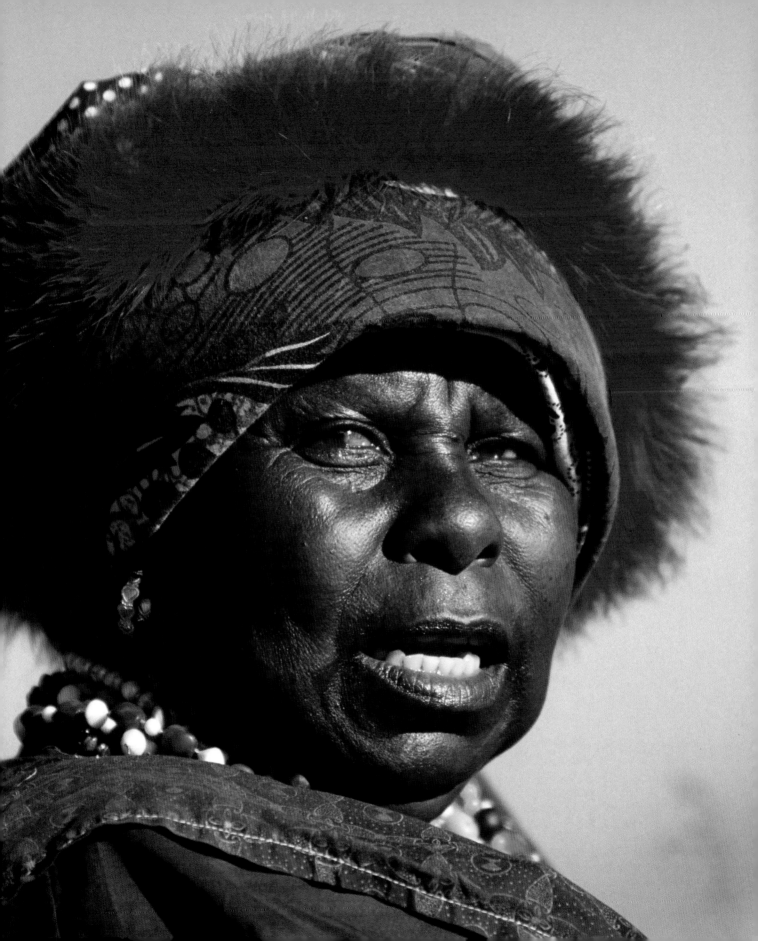

These hubs are neatly organised. Each thatched rondavel has its own cooking and storage spaces, its mud wall or reed fence forming the domestic boundary, a *lapa* (an adjacent open area) separating it from its neighbour, the whole grouped around the *kgoro* (communal meeting place). In more traditional times work was allocated according to gender. The women were responsible for the home and the children, the fetching of water and the gathering of firewood, cooking, brewing beer, and cultivating the fields. Preparing the land, though, was a man's job. He was also hunter, soldier (weapons included battleaxe and spear and, in the far north, bow and arrow), craftsman and builder of huts. These tasks were tackled collectively, with workers often coming together to thatch, weave baskets, carve bowls (pottery, though, was women's work), fashion skin clothing, and to talk.

Looking after the cattle, prize possessions and markers of wealth and status, is traditionally the duty of the boys, who work in groups or 'regiments' – an arrangement that once enabled them both to defend their beasts and, on occasion, to raid other people's herds.

A central figure in Northern Sotho society is the *seloadi* (diviner or seer), who also fills the role of *ngaka* (medium and healer). He or she – the vocation remains gender blind – has a sound knowledge of the veld, its plants and, less practically, its animals and their curative properties. The *ngaka* prescribes remedies for physical and psychological ailments and, in the mystical realm, diagnoses the causes of all manner of misfortunes, such as accidents, droughts, natural disasters, unexplained deaths and so on. The agents for such diagnoses, and for predictions of the future, vary: magic potions feature prominently, as do dreams during which the messages of the ancestors are received. And *bola* (bones), which the *ngaka* throws and interprets according to the way they fall, reveal the great mysteries. The main pieces of *bola* are ivory and bovid hoof (two of each), with smaller items including animal knuckles and seashells. All are scattered to the rhythmic sounds of an incantation.

Symbolism plays a significant role within the subgroups, some of which have evolved systems of animal totems – the lion (*tau*), the baboon (*thlwene*), the crocodile (*kwena*) and so on – that reinforce collective identity but also carry a deeper meaning. The names are honoured in folktale, dance and song; and the animals themselves, as well as their images, are regarded with respect verging on reverence. Historically, members of a group would address each other by the totemic epithet – a Pedi as *Noko* (porcupine), for example, a Lobedu as *Kolobe* (bushpig), a Mamathola as *Nare* (buffalo). No one really knows where, when or why these traditions began, but they were distinct and they did much to sustain social ties.

In early times the Northern Sotho wore animal-skin clothing (as, indeed, did all Ntu-speaking peoples) – loincloths and karosses for men, attractively fashioned for special occasions; back-panels and aprons for women, who also adorned themselves with metal neck rings and bracelets. Both sexes sported leather neckbands, but these were protective talismans (which they received from the *ngaka*) rather than decorative accessories. Later, fabric replaced skin, the women of several groups adopting what anthropologist and artist Barbara Tyrell described as an 'elaborate version of the European smock'. Young girls began to wear short, pleated skirts. Hairstyles varied, Pedi, Sekhukhune and Bantawana women traditionally distinguished by a kind of cap that fell away from the head and down the neck. Lobedu female hair was worn closer to the head and twisted into bead-encrusted plaits that covered the ears.

OPPOSITE Customarily, Pedi women tended the home and raised the children, brewed beer, crafted pottery and even cultivated the fields. Today, for the most part, they fill the same roles as their male counterparts in far more varied tasks than tending the home..

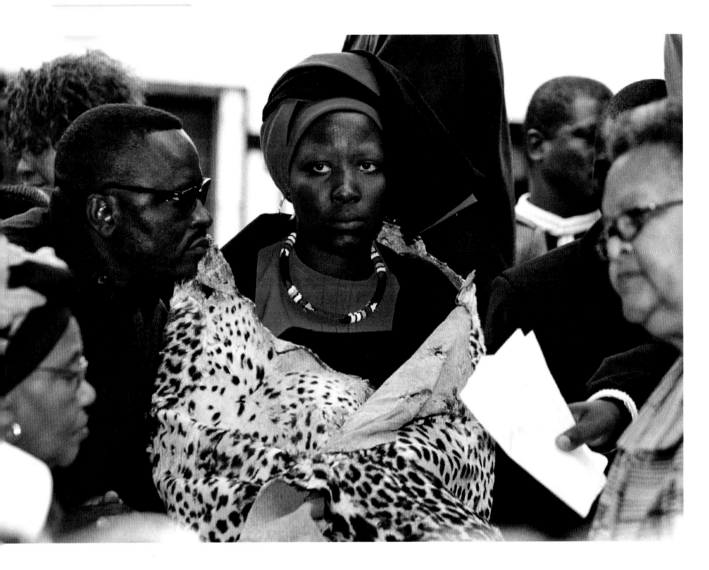

The majesty of Modjadji

ABOVE Makobo, Modjadji VI, remains a central figure in Lobedu culture. The Rain Queen is said to have power over the elements, and at one time she was expected to commit ritual suicide at a particular point during her reign in order to confirm her divine status.

The mist-wreathed hills of the Magoebaskloof form part of the far northern extension of the Drakensberg. It is here that the legacy of Modjadji, the mysterious Rain Queen, ruler of the Lobedu group of the Northern Sotho, originates. It is said that Modjadji is a linear descendant of a princess of the Karangan people of present-day Zimbabwe and granddaughter of the mighty Monomotapa himself. Around the year 1600, the original Modjadji fled from her enemies (an illegitimate child was involved), moving south across the Limpopo to become the central figure in a new group, the Lobedu, and eventually to found a dynasty. Stories about Modjadji spread through the subcontinent, with tales of her immortality and of her powers over the elements and over man. She was widely respected, even feared, by much stronger rulers. Even the great Shaka Zulu held her in awe. And one of British writer H Rider Haggard's best-known novels, *She*, was based on the legends surrounding Modjadji.

Of course it is the office of royalty, not the person herself, who lives forever. The title is mystically passed down from generation to generation, and the present queen was enthroned just a few years ago. She lives in seclusion in her official residence, protected from unwanted intrusion, though she does receive visitors. Requests for audiences are especially insistent in times of drought when farmers (white as well as black) plead for her intercession. Her realm is also famed for, among other things, its cycad forest, the largest expanse of the rare and valuable Modjadji cycad or Modjadji palm (*Encephalartos transvenosus*) in the world.

The pleasant land

The region to the west, stretching east from Tzaneen along the Great Letaba River, ranks among Africa's most fertile, and among its more attractive. The town of Tzaneen, neat and pleasantly embowered, began life as a research station for the fruit-growing industry, and the valley has a tropical feel about it, a quality drawn from its position below the highveld proper, from its good rains, from the river itself, and from rich soils.

Hugged by the hills to the southwest of town are the placid grey waters of the Ebenezer Dam, fed by the Letaba, which then flows down George's Valley. It was through the countryside here that, in a more adventurous age, the old Zeederberg coaches hauled their passengers and goods from Pietersburg across the Letaba to Digger's Rest and Agatha Hill and then, tortuously, to the fever-ridden Leydsdorp mining camp.

Farther south still is a rugged wilderness of peak and valley called the Wolkberg. A century and more ago the area was full of animals, but the game was shot out by the secretive growers of dagga (marijuana), who hid among the mountains and lived off the land. More organised, more commercial and perhaps better endowed with wildlife is the Hans Merensky Nature Reserve to the east. It is the site of a tourist resort (on an island in the middle of the Letaba), but most of the 5 000-hectare sanctuary comprises flattish grasslands that support classic Lowveld tree types. Residents include giraffe and zebra, eland, kudu, sable and other antelope; leopards stalk the Black Hills of the eastern boundary area.

From Northern Sotho country one enters the great sanctuary that is the Kruger National Park through the Phalaborwa Gate. Drive south from Phalaborwa and the dusty horizons of the Lowveld and the countryside are replaced by handsome, green-mantled hills and then by high mountains – a segment of South Africa's Great Escarpment, that 3 000-kilometre-long semicircular chain of heights that separates the interior plateau from the coastal terraces. Among the escarpment's attractions is the Blyde River Canyon, its sandstone cliffs plunging almost a thousand metres to the lake below. From the rim there are quite memorable views – from God's Window and other points across the Lowveld plain to the east and, much closer, to the Mariepskop massif and a trio of hump-like features known as The Three Rondavels. Mariepskop is named after a local Sotho folk hero who, in one of the most brutal battles of precolonial times, defended this natural fortress against repeated assaults by the army of the Swazi.

ABOVE Masked dancers of the Kgaga group (Lowveld Sotho, akin to the Lobedu) a year after their circumcision. The performances honour The Great Bird of Muhale (or of Zimbabwe), which is said to emerge from the river on moonlit nights.

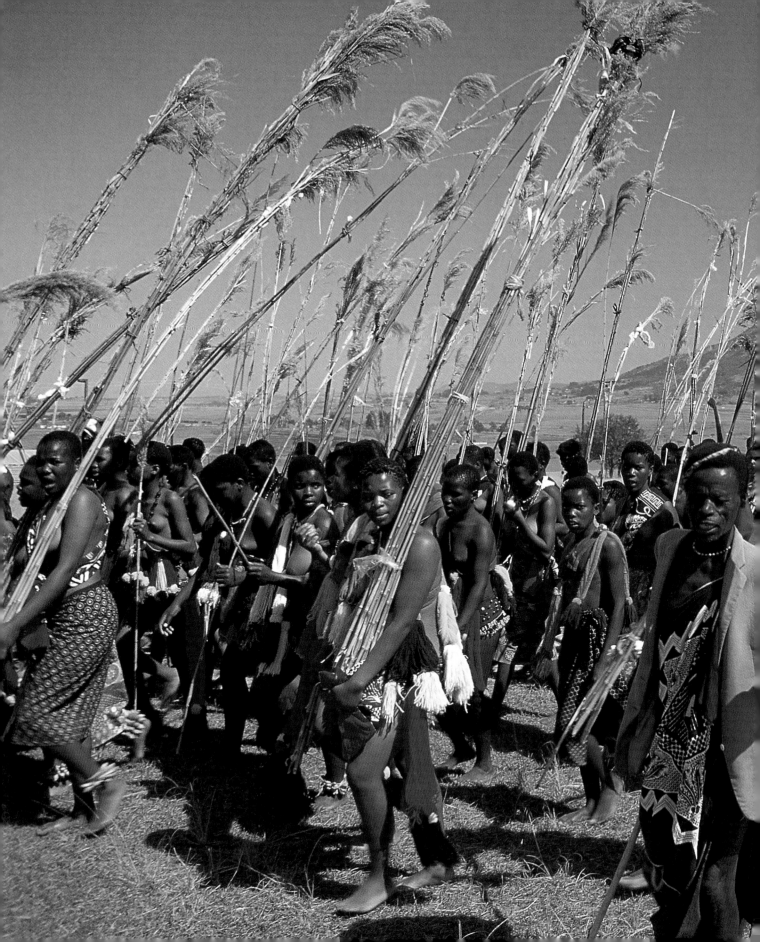

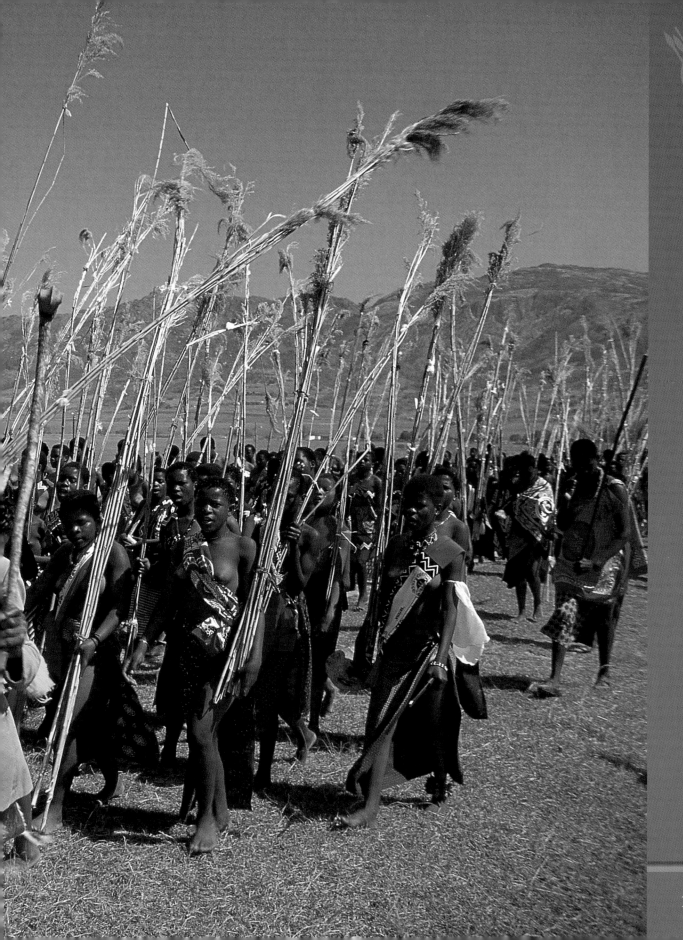

Swazi
Royal heritage

PREVIOUS PAGES A phalanx of marriageable girls on its way to the Queen Mother's residence. From there, they will set out to gather reeds and, finally, to perform their splendid Reed Dance.
TOP The Queen Mother, respected even by the early colonial overlords, remains a woman venerated by the people. Here the highly regarded Nohervukazi poses for the camera in 1901.
OPPOSITE A Swazi girl, dressed for occasion, performs at the annual Reed Dance celebration, where her king may select another bride.

Each year, during the first new moon phase, the Swazi gather together in the green Ezulwini Valley to celebrate the harvesting of the first fruits of the soil, to reinforce their cultural identity, and to confirm their loyalty to their king. Practically everybody of note is there, the royal princes and princesses resplendent in their traditional costumes and regalia, the regiments in their full-dress uniforms, and a great concourse of ordinary people, all clothed in the fashions of their forbears. The continuing drama is played out over six days; and the vividness of the scene, the ritual, the music and movement combine to create an occasion of unforgettable vibrancy. This is the Great Incwala, a premier event on the national calendar.

The nation is bound together by history and heritage – closely bound, so that traditional ways remain largely intact. About two thirds of the Swazi people live in the independent kingdom of Swaziland, a third in the next-door KaNgwane region, a low-lying corner of South Africa huddled between Swaziland and neighbouring Mozambique.

Ups and downs

The Swazi are of largely Nguni stock, related linguistically and in other ways to the Xhosa, Zulu and Ndebele, but with some elements of the Sotho and Mdzabuko, a grouping akin to the Tsonga of the wider region.

Their saga began in 1815, when a man called Sobhuza succeeded to the chieftaincy of the Dhlamini clan of the Ngwane, a powerful Northern Nguni group, and decided to compete with the ambitious Dingiswayo (of the Mthethwa) and Zwide (of the Ndwandwe) for control of both the region that is now northern KwaZulu-Natal, and of the increasingly lucrative trade routes to the port of Delagoa Bay (now Maputo, Mozambique). Sobhuza lost out, and led his followers into what is today southern Swaziland, defeating and absorbing a number of Nguni and Sotho peoples

104

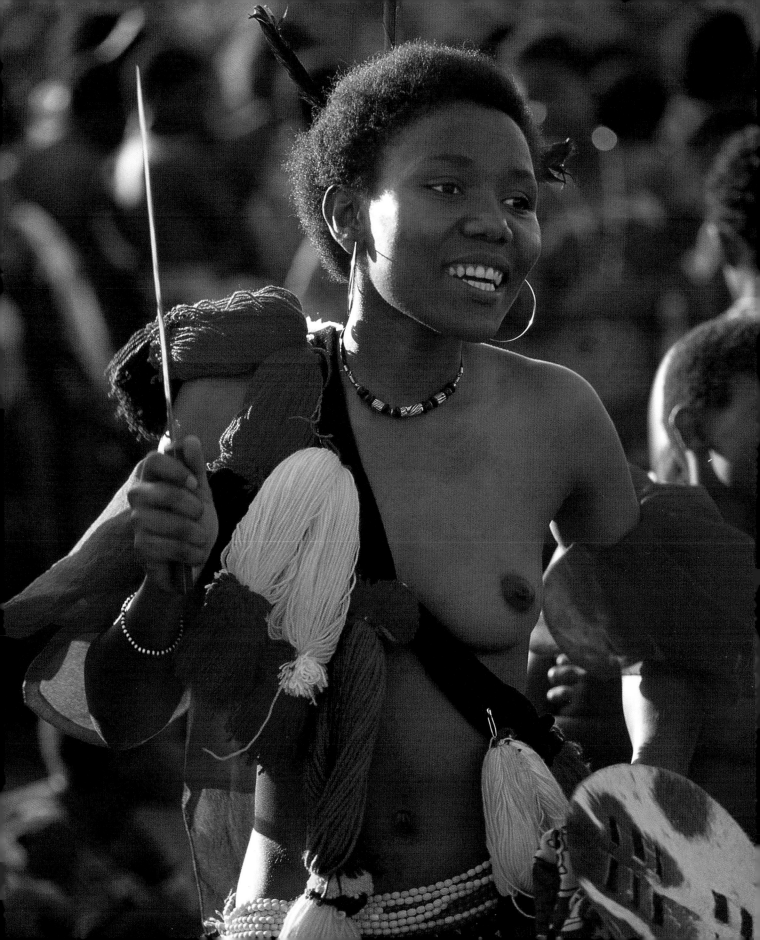

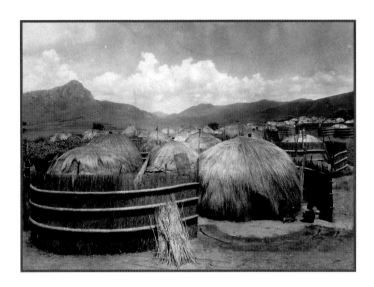

ABOVE A traditional Swazi homestead. Much has changed since this early photograph was taken, but plenty of examples of the simple architecture can still be seen in the remoter rural areas.

along the way. Although not yet exposed to the new fighting methods shortly to be introduced by Shaka Zulu (see page 57), his army was both big and efficient, well able to conquer lands as far to the north as modern-day Lydenburg. He also managed to resist Zulu expansionism, largely through clever diplomacy.

The new community had a long way to go and grow, however, before it reached full bloom. The man who would guide it upwards and outwards was Mswati, the succeeding paramount chief, or king, a scion of the Dhlamini lineage who came to the throne in 1840, monopolised the secrets of rainmaking, gave his name to the nation, and went on to establish an all-conquering army. This was modelled on the age-graded Zulu fighting forces, and with it he marched victoriously through the human landscape as far north as the present-day Limpopo province. He also crushed rebellion at home, and brought about a degree of unity between the Dhlamini and other clans.

But these were the salad days of the nascent Swazi nation. Many troubles lay ahead, and eventually the kingdom found itself squeezed into impotence by, on one hand, settler ambitions (notably the Boer urge to carve a clear route between their inland republic and the Indian Ocean) and, on the other, by British determination to stop such access. The confrontation between the two white tribes was settled only after the Anglo-Boer War of 1899–1902, when a British governor was appointed to administer the Swazi territory and legislate by proclamation (powers that were transferred to a high commissioner shortly afterwards, in 1906). The kingdom progressed to full independence in 1968.

Power and privilege

Despite all these intrusions and impositions, though, much of the traditional Swazi political and nearly all its social structures were left alone – the classic British approach to colonial governance.

The monarch, King Sobhuza II for much of the twentieth century, was a constitutional leader and in theory could not act against the advice of two bodies: the *Liqoqo*, a council comprising royal kin and appointees, and the much bigger *Libanda*, an unwieldy annual gathering of all Swazi men (all who were physically able to attend, that is). The people charged with the day-to-day running of the country were the chiefs, each of whom had his own *liqoqo* and *libanda*. It was a valid kind of democracy, although the sovereign was powerful enough to suspend the constitution occasionally to reinforce his authority. And Sobhuza did so on two occasions.

The rules of regal succession were – and remain – strict and intricate. The king does not appoint his own successor, and his heir is never the eldest son. Instead, when he dies the royal family put their heads together to choose one of his many widows as the Great Wife – the Queen Mother or *iNdlovukazi*, literally translated as the She-elephant. Traditionally, she is not the

king's first or even second spouse – these two are classed as 'ritualistic' – but a woman of good character and birth and who has borne the monarch a single son. And it is the latter who ascends to the throne, but only after a two-year mourning and regency period.

One might wonder how such an elaborate selection process could work in practice, but bear in mind that the Swazi are a traditionally polygamous society and the royal network produces plenty of candidates. Sobhuza reigned for 65 years, usually chose a new bride at the annual *amhlaza* (reed dance) and had 70 wives who, between them, produced 210 children in the 50 years between 1920 and 1970. His grandchildren numbered more than a thousand.

Under South Africa's apartheid regime a small slice of largely lowveld countryside was hived off to serve as a 'homeland' for those Swazi living outside the borders of the kingdom. This was later (in 1984) categorised as one of those odd patches of countryside officially termed a 'national state' (more popularly known as a Bantustan).

Meanwhile, old Sobhuza had died, to be succeeded by Prince Makhosetive, a then-shy young English public school boy – studying at Sherborne, in the county of Dorset – who had been affectionately known as 'Mac' until early in 1986, when he ascended as King Mswati III. The youthful diffidence soon gave way to regal authority and a kind of flamboyant confidence when Mswati took firm control. He established an absolute monarchy, dismissed the prime minister and, in an extraordinary show of royal prerogative, chose his new premier in public, at the first 'gathering of the nation' at his Ezulwini village. Apparently, the new man – an obscure former police official named Sotja Dhlamini, who stood at the back of the crowd – was as surprised as everybody else by the appointment.

BELOW Double-sided drums provide the sonic base for the characteristic Swazi stamping dance. These routines were not, as sometimes perceived, war dances, but sequences designed to instil discipline.

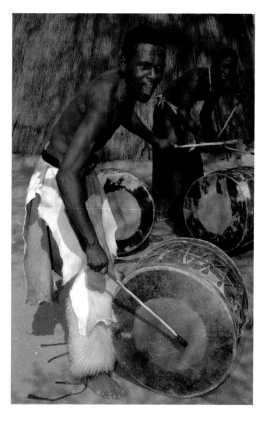

Premier occasion

The Incwala, as noted, is the grandest of the Swazi gatherings and sometimes perceived by foreigners as a celebration of the 'first fruits' of the harvest. And indeed this is so – but not exclusively, or even primarily. The unifying element was and is, in fact, royalty. Indeed the very name can be translated as 'kingship ceremony'. It's a prolonged occasion, and it is preceded by what is known as the Little Incwala. This takes place at full moon in November, when groups set out from the Queen Mother's residence, marching many kilometres to collect symbolically significant loads of water. They return to the royal capital with the new moon in December for two days of song, feast and ritual.

Fourteen days later the Incwala proper begins its exuberant six-day sequence. Branches of specific, mystically defined acacia trees feature throughout the ceremonies. Day three is the Day of the Bull, when a black beast is slaughtered to yield sacred medicines for the king. On day four the regiments parade in military finery. Day five is given over to strict abstinence and, on day six, the finale, to pageantry, dance, praise-song and an enormous bonfire in which ritual objects are burned. During most of this the king is in seclusion and remains so until the coming of the next full moon.

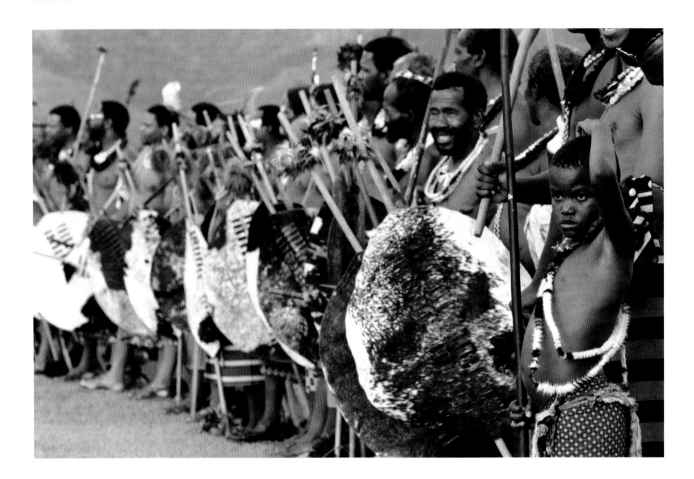

ABOVE Swazi men gather for the visit of royal dignitaries, wearing the traditional gear of warriors of less-recent times. In the past the youngster would have played no obvious role on a ceremonial occasion such as this.

But the Incwala is not the only national gathering. Rivalling it in length, if not quite in importance, is the Umhlanga, a sustained process centred on the much-revered Queen Mother. Young girls spend four days gathering reeds to renew her residence and, on the fifth, don magnificent costumes of beaded skirts, anklets, necklaces and bracelets. Their ceremonial dances, complex and pulsating with energy, are held on the sixth day and on the afternoon of the seventh.

There are other festivals that are equally colourful, though perhaps with not as ceremonially significant dances. Among the more vibrant and joyful is the Sibaca, in which teams of men vigorously perform a routine that has become a favoured spectacle with both the Swazi and visitors.

Custom and conviction

Like those of most if not all traditional African peoples, the belief system of the Swazi is under-pinned by animism – the endowment of natural features and objects such as rock formations, trees and streams with spiritual personalities. Indeed the 'other' world is crowded with spirits of one sort or another, some of them kindly, others mischievous, still others downright malevolent. In particular, the Swazi are much like their Nguni cousins, the Xhosa and Zulu.

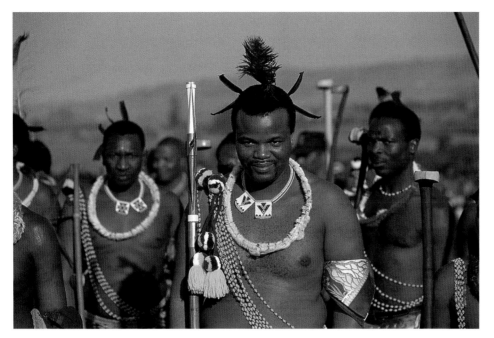

LEFT King Mswati lll, regent since 1986, and his councillors arrive for the Reed Dance. It is at this ceremony that he may choose a new wife from the parade of eligible young women.

In Swazi society, too, the ancestors are powerful presences, their wishes made known to the people by the *sangoma*, or diviner (often through dreams), and by the nature of a person's illness. Animal knucklebones, seashells and other objects are 'read' by the *sangoma* to predict events and outcomes. Rainmaking remains a vital part of the mystic tapestry. The king himself is the chief agent of the power, and keeper of the rainmaking medicines. Above all this, distant and disinterested, is a Supreme Being, *Umkhuluncadi* (He Who Made Everything). He is not, though, well defined, and plays no direct role in the affairs of the people.

A *sangoma*, who can be either a man or a woman, is selected by the resident diviner (the choice is often suggested by abnormal behaviour) and receives intensive training, in secret, from his or her mentor. Strict distinctions are drawn between the practices of the *sangoma*, the *nyanga* (who heals with home-made medicines) and the *umtsakatzi* (a witch or wizard who creates misfortune).

By law the land belongs to all the people and is held in trust for them by the king. Traditional homesteads are designed in a horseshoe shape although, somewhat unusually, they do not encircle the cattle kraal. Like the Zulu, however, the homes themselves were once built in the classic Nguni 'beehive' style, which has now given way to the arguably more durable and functional rondavel type.

Traditional Swazi society is organised according to clan as well as chieftaincies (the structures are typical of the wider Nguni). Historically, each man served in an age-delineated regiment, which was mobilised from time to time both for war and, four times a year, for labour on the royal estates. The regiments were identified, and *esprit de corps* reinforced, by the colours and patterns of the shields and by decorative accessories.

A man may take more than one spouse, but each wife and her children are respected as a unit, their unity reinforced by the privacy of their dwellings. Each wife occupies her own *indlu* (largish home) and *emandladla* (two smaller huts), and the modest cluster is traditionally surrounded by a reed screen or fence. The ceremonies of betrothal and marriage are much like those of other Nguni groups, though some preferences are special to the Swazi. Traditionally, the man, for example, could not marry someone with the same *sibongo* (clan name) as his own. Instead, he had to choose a girl from the clan of his father's or mother's mother.

Birth, coming of age, marriage and death are all still attended by ritual and ceremony, some of it muted, much of it vibrant in sight and sound. A newborn baby's distinctive clan items – specific plants, pieces of animal fur and so on – are collected and burnt to confirm its clan identity and assure its wellbeing. The young bride and her relatives dance at the groom's homestead before, in an ancient ritual, she stabs the ground of his cattle kraal and is then smeared with ochre – the culmination of the betrothal period. Funerals serve to bring extended families together, and commoners are buried next to their homes, whereas royalty – the kings and their wives, princes and princesses – are buried in the caves of the mountains.

Music and dance are joyfully inseparable from feast and ceremony among the Swazi, the most dramatic show perhaps the thunderous unison stamping of feet in the *indlamu*. Musical instruments are few – voice and the clapping of hands are the predominant accompaniments – but they do include the drum, a five-note flute and stringed items based on the bow.

Costume varies, with the different styles historically dictated by age, status and the occasion. Traditionally, male children wore loinskins, females little grass or cloth skirts and strings of beads, the former graduating to a penis cap, the latter to a short toga-like garment. Unmarried females donned a dress and put their hair up in a small bun, and when they married they changed intro skin skirt and apron.

Ceremonial outfits remain much more elaborate and colourful. The two great occasions – the Incwala and the Umhlanga – involve special modes of dress and accessories for the princesses and their commoner cousins. At the Incwala, the men are resplendent in their regimental 'uniforms', a composite of skins, plumes, spears and great ox-hide shields.

The green land

Swaziland is a small country, covering less acreage than the Kruger National Park, for example. In fact you can take in pretty well its entire 17 000 square kilometres from viewpoint at the summit of Mlembe, which forms part of the Khalamba range running along the northwestern border. The range itself is a segment of the mighty uKhalamba-Drakensberg rampart.

Descending towards Mbabane, Swaziland's modest capital, the landscape changes to savanna, at its most attractive perhaps in the valley of the Great Usutu River, otherwise known as Ezulwini (Heaven's Place) and the site of the Royal Village and of the parliament buildings. Beyond, farther east, is classic bushveld country, hot and humid, the lowland plains lying little more than 300 metres above sea level at their highest. Finally there is the Lubombo plateau, which rises sharply to the Lebombo mountains, the eastern border with Mozambique.

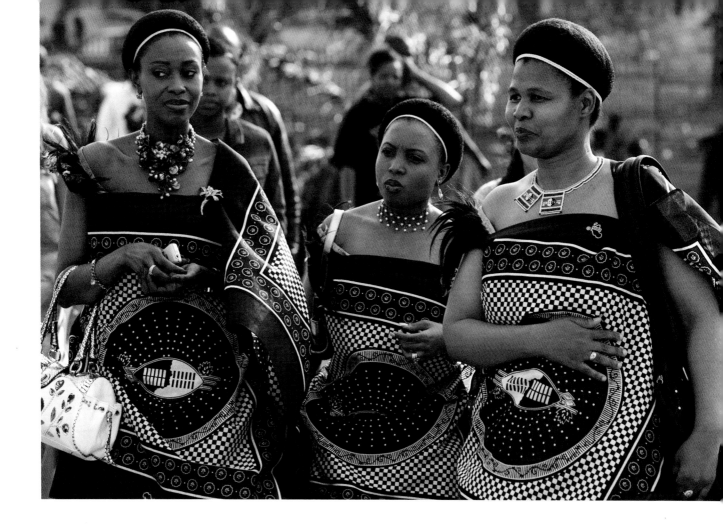

The Swazi are justifiably proud of their conservation areas – not large by African standards, but each with its appealing character and its wildlife complement. The pathfinder among them is the Mlilwane Wildlife Sanctuary, the product of a conservation crisis that saw much of the land disappear under plough and plantation. Today Mlilwane, most of which lies within the Ezulwini Valley at what was once the terminal point of both the westerly and easterly game migrations, is home to more than 50 different kinds of large and small animal. Most of these are buck of one sort or another (among them the eland and the stately sable) but there are also leopard, crocodile, hippo, giraffe, blue wildebeest, buffalo, zebra and an attractive array of birds.

Not quite so well endowed with life forms but magnificent in its scenery are the Malolotja Nature Reserve, a hiking paradise, and the Mlawula Nature Reserve, perhaps better known for its giant Lebombo ironwoods than for its great diversity of wildlife. The latter honour goes to Swaziland's largest game repository, the Hlane Royal National Park in the northeast. This 30 000-hectare expanse of parkland savanna and dense bushveld once served as the king's hunting ground and now counts elephant, rhino, lion and a great many antelope among its residents.

Finally, there's the small Mkhaya Game Reserve southeast of Manzini which, like Mlilwane, began as part of the royal-sponsored effort to rescue Swaziland's diminishing wildlife heritage. Animals that were long gone from the area – elephant, buffalo and especially rhino – have now been very successfully reintroduced.

ABOVE While Swazi society is patriarchal in nature, women play a pivotal role within the social structure. In this polygamous environment, however, the chief's wives are subject to a strict ranking order that is not necessarily based on the chronology of their marriage date.

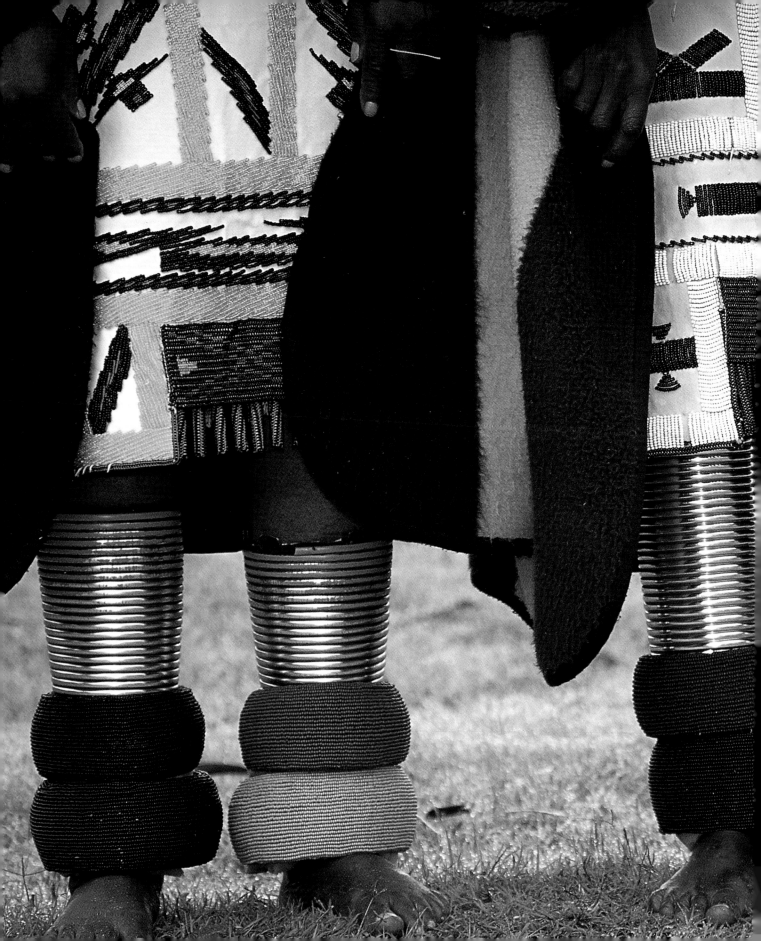

Ndebele
Pride of the north

The wider Ndebele nation is difficult to define in specific terms, for its origins are mixed, its segments differing in both character and culture, and its regional distribution disparate. It was born of conflict, its founder a product of those historic events that marked Zulu king Shaka's meteoric rise to power in the early nineteenth century. The story of the Ndebele begins with an epic march across the great northern plains and culminates, thirteen years later, with the creation of a powerful kingdom beyond the Limpopo River.

Root and branch

PREVIOUS PAGES Metal leg-rings and beaded, patterned aprons are integral to the traditional costumes of married women. OPPOSITE Tight neck-rings can be removed only with great difficulty and were a more-or-less permanent part of a woman's traditional costume. The large *isigolwani*, or collar, plays a significant part in Ndebele symbolism.

Shaka's conquests triggered what is known as the *mfecane* (sometimes translated as The Crushing, and known to the Sotho as the *difaqane*), a succession of local wars and forced marches as whole peoples fled what became Zululand, fanning out across the subcontinent like ripples on a pond to displace incumbent groups who in turn migrated, causing turmoil among those in their way – the classic domino effect in brutal action.

Arguably the most notable of these 'ripples' was Mzilikazi's remarkable, 1 500-kilometre journey at the head of his new and ever-growing band of followers.

Mzilikazi – young, headstrong, born of the royal Ndwendwe house (he was a grandson of King Zwide) and chief of the independent northern Khumalo group – had been forced to choose between two formidable enemies and, in 1818, decided to throw in his lot with Shaka. This was a wise move in the circumstances. Shaka came to both admire and trust him, and for a time Mzilikazi repaid that confidence in full, serving as one of the great man's ablest commanders.

It seems, though, that his commitment to the Zulu cause was little more than temporary. Following a successful military campaign, Mzilikazi deliberately challenged Shaka's authority by keeping to himself the plundered cattle and added insult to injury by humiliating Shaka's emissaries (he cut the plumes from their headdresses). Then, choosing discretion over valour,

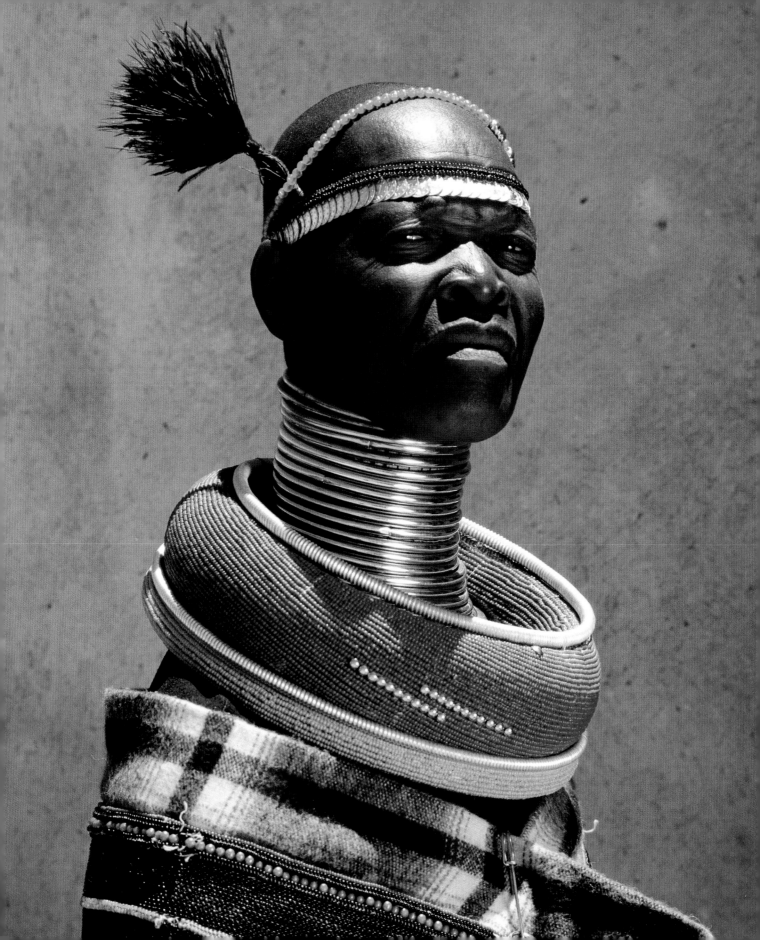

he led his 300-strong party of loyal Khumalo soldiers across the Drakensberg and onto the highveld, where he and his forces proved an almost unstoppable force, rivalling Shaka's in its military ethic and fighting skills, conquering and absorbing innumerable small groups of displaced and otherwise vulnerable people.

Then, in the mid-1820s, ever conscious of Shaka's *impi*s, Mzilikazi moved farther west into the Magaliesberg region, near today's Pretoria, where he challenged the local Tswana chiefdoms.

Mzilikazi's Ndebele fought well beyond their weight during these years. They prevailed not through numbers – they were a small group – but by their sheer fearlessness and fighting expertise. Their usual tactic was to warn the enemy of their coming (which triggered anxiety, sometimes panic), advance during the night-time hours, surround the village and then, at dawn, beat their shields in terrifying fashion before charging in for the kill. Only those who could add value to the invaders – young fighting men, young women – were spared; everyone else was dispatched and the homesteads burnt.

The Ndebele forces were concentrated around Mzilkazi's capital, housed in age-graded compounds, but they controlled a much wider area with their military outposts. The king's troops were well organised, his laws strict, covering everything from farming the land to waging war, and his state – unusually in those troubled times – was remarkably stable. Its structures were based on discipline and a code of honour, a canon that appears (to outsiders) to have been a curious mix of high morals and unbridled aggression. An American missionary observed: 'Although these people are accustomed to plundering on a large scale, stealing from a stranger in the community is unheard of.'

BELOW The founder and first king of the Ndebele nation, Mzilikazi, confers with his councillors. His most influential confidant, however, was the white missionary Robert Moffat – an unlikely relationship that worked well for them both.

Moving on

Meanwhile Shaka, driven almost insane by the death of his beloved mother Nandi in 1827, had embarked on what many historians have described as an unprecedented orgy of destruction that, this time, was directed against his own people as well as his enemies. It proved too much for his surviving family, and Shaka Zulu was murdered in 1828.

Mzilikazi, in his western fastness, kept himself well away from these dangerous upheavals but, nevertheless, he had few illusions that the anger of the Zulu would dissipate. And indeed Dingane, the new king, did send his army in search of what his people still regarded as treacherous renegades. In the event the pursuing Zulu *impi*s, three regiments strong, met their match and were forced to retreat.

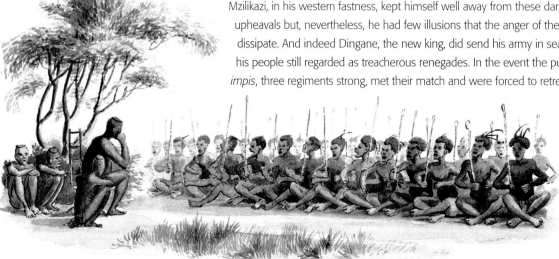

But the pressures were mounting. Mzilikazi also had to fight off mixed-race Griqua and Rolong (Tswana) incursions, and there was always the chance that the Zulu would return. Eventually he cut his losses and moved even farther west, settling along the banks of the Marico River. Here, shortly afterwards, he received some of the white travellers and clerics who were trickling north, some seeking new lands to explore, others in search of souls. The most notable among them was Robert Moffat of the London Missionary Society, who became a close and loyal associate – a strangely improbable friendship between a widely respected man of peace and one of the great warrior kings.

Not nearly so amiable, though, were Mzilikazi's next visitors – the vanguard of the Voortrekkers. These hardy and well-armed colonists posed an immediate threat to the king's territorial authority, a threat translated into violent action when the Boers – with the help of Griqua and Rolong forces – defeated the Ndebele at Vegkop, at Kapain, and finally at the Ndebele capital Mosega. The fighting was hard; the Ndebele simply outgunned by their opponents. But rather than submit to an alien regime, Mzilikazi decided to move his people on to yet newer pastures, and in 1836 he led his followers north across the Limpopo to re-establish the militaristic Ndebele state in what is now the Matabeleland region of Zimbabwe.

This offshoot of the Northern Nguni managed to retain its integrity for half a century and more, its regimental villages proving tough enough to repel a series of Boer encroachments. Then, in 1852, Mzilikazi concluded a lasting peace with the Transvaal republican government. He died, close to his eightieth year, in 1868, and was buried among the jumbled rocks of the Matobo hills, a place of haunting beauty not too far from the Ndebele capital, Bulawayo.

ABOVE Lobengula, son of the great Mzilikazi and king of the far-northern Ndebele (or Matabele), seated with one of the many concession-seeking white men at his capital, Bulawayo, in what was to become Rhodesia, now Zimbabwe.

Wars with the Boers

Despite their nominal identities, Mzilikazi's people are only tenuously connected with their South African namesakes. All Ndebele people, though – the Zimbabwean, the northern and the southern groups – share a distinct if distant ancestry: all stem from proto-Nguni stock.

The Ndebele had made their home south of the Limpopo River well before the arrival of Mzilikazi, some of them as early as the 1600s, others much later, probably during the wars that preceded Shaka Zulu's rise to power in the 1820s. Eventually they consolidated into two groups, separated by some 200 kilometres of highveld countryside in what is now Limpopo province. However, the northern segment, based in the area around present-day Mokopane (formerly Potgietersrus) and Polokwane (formerly Pietersburg), were gradually assimilated into Sotho society and lost most of their heritage.

The demise of the northern group as a distinctive people was hastened by the arrival of well-armed Boer settlers in quest of land and cheap labour, or what they called 'apprentices' – a euphemism for slaves – and who were not too fussy about their methods of getting what they

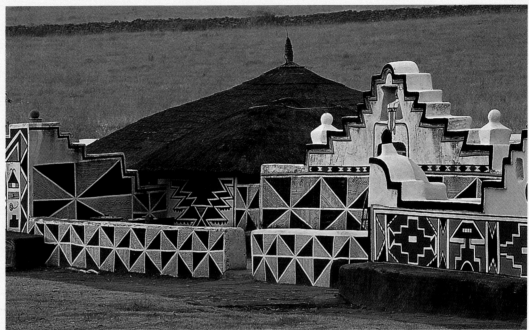

ABOVE A bridged and decorated gateway to what is considered a 'traditional' Ndebele homestead. Today, however, Western architectural influences are evident and play an important part in the overall aesthetic.

ABOVE Pots decorated in Ndebele style are somewhat unusual and rare: in days gone by few daily-use utensils and implements would have been treated in this way.

wanted. One particular episode illuminates this murky scene with special poignancy. In October 1854 an entire community of Ndebele, led by Chief Mokopane, sought refuge in a cave system near the present-day town that bears his name. Racial tensions had been rising for some time: Ndebele retaliation for a series of abductions had brought about the death of the Boer leader Hendrik Potgieter, and the settlers wanted revenge. They surrounded the caves and waited it out. Days and even weeks went by and then, maddened by thirst, about a thousand of the Ndebele emerged and rushed for a nearby stream. Almost all were killed. When the Boers finally entered the labyrinth, a month after the siege had begun, they found another thousand dead.

The southern Ndebele community, resident in the region north and east of modern Pretoria, proved more durable. They were also renowned warriors, able to defend their lands against Boer encroachment, the confrontation erupting into open warfare in 1883. They fought fiercely for five years until finally they were overcome, most dramatically in the Caves of Mapoch. Their punishment was harsh, and degrading: Chief Nyabela was taken away in chains, the king's village destroyed, the lands of the Ndebele confiscated and divided among the settlers, and the people taken into what amounted to bondage.

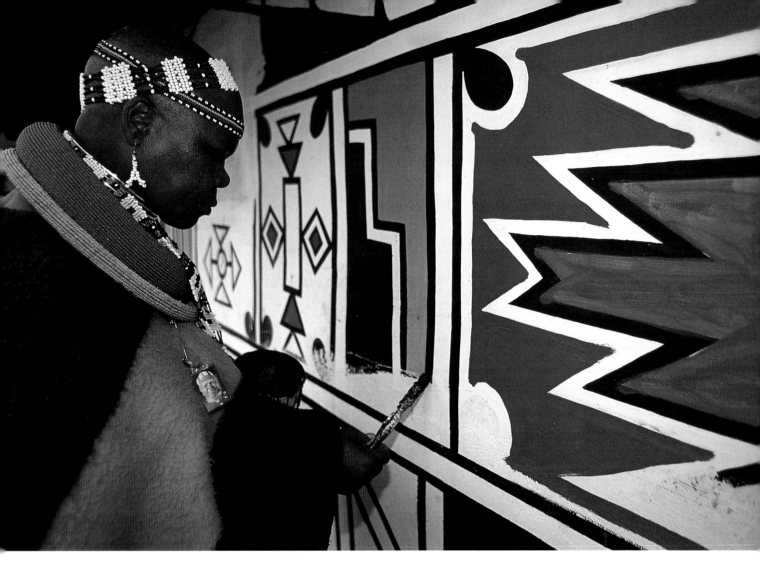

Custom and conviction

Like most, if not all, Bantu groups, the Ndebele celebrate the beginning of the harvest in grand style. However, they also adapted the Zulu approach by using the festival to strengthen loyalties with the chief, and to strengthen the army. This and many other ceremonies belong to the past. Other elements of the cultural heritage, though, have survived.

Scattered across the region to the north and northeast of Tshwane are a number of museum villages, 'living museums' that display some of the continent's most colourful examples of mural art – courtyard and house walls covered with bold hues and even bolder patterns. These are the work of the traditional Ndebele people.

Ndebele communities, notably the Ndzundza, developed their unique style of artistic expressionism – paintings that are generally geometrical, the colours vivid – relatively recently and probably from the original Sotho (specifically Pedi) tradition. At first natural ochres were used to produce the pinks, yellows and browns; lime and soot providing the whites and blacks. The early designs, created in rectangular panels, were simple: parallel lines, V-shaped patterns, triangles and so on. Later came stylised depictions of such recognisable objects as animals, rudimentary human

ABOVE Bright colours and bold geometrical patterns are distinctive – if not unique to – Ndebele mural art. Design and decoration was once considered women's work, and most of the examples we see today are still the handiwork of local craftswomen.

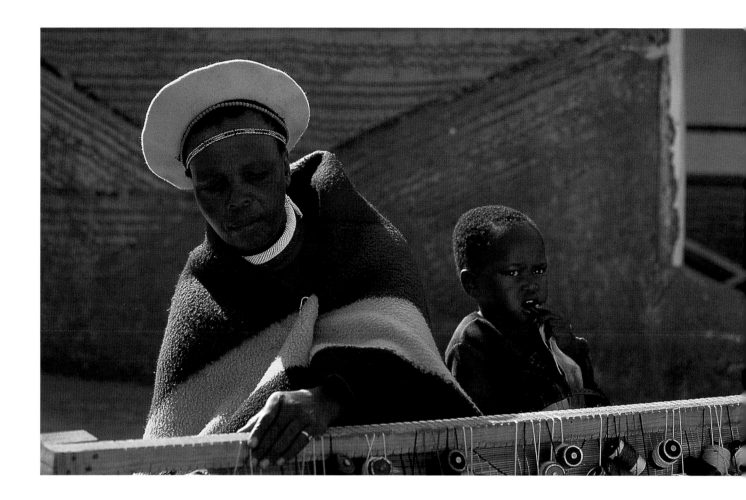

ABOVE Weaving with a home-made loom. Traditional crafts have largely disappeared beneath the onslaught of Western commercialism, but bright fabrics are still produced to provide a source of income, especially in rural villages.

figures and trees. And then, with the growing influence of urban life and the ready availability of synthetic paints, the range of both design and colour expanded to include city scenes, numerals and other artefacts of the modern age.

The classic homesteads of the Ndebele are rectangular affairs, thatched dwellings surrounded by walled *lapa*s (courtyards). Features unusual in the Ntu-speaking architectural context are the gables and their ornamentation. It is usually the outside walls of the house and *lapa* that are most vivaciously painted, and it is traditionally the women of the village who provide the artistry, applying the pigments with their fingers.

The paintings are not just simple decoration, intended only to please the eye. In a sense they are messages, 'instruments of cultural transmission', as one writer puts it, that tell passers-by and everyone else that 'here live the Ndebele', a once-oppressed people who have retained their legacy despite decades of persecution.

Moreover, the women of the region, those who cherish their heritage, are often themselves works of art. Favoured are distinctive cloaks – blankets striped in red, yellow, green, dark blue or purple. Although they are indeed colourful, it is the apron that catches the eye: fringed for matrons,

decorated with elaborately beaded flaps for new brides on special occasions, sometimes enhanced by a beaded sheepskin kaross. Even more striking are the big collars, and the multiple rings worn around the neck, wrists and ankles, fashioned from grass ornamented with beads for youngsters, made of metal (usually brass) for married women, Although these accessories look uncomfortable and even painful to outsiders, they are more or less permanent. They cannot easily be removed, and seldom are.

The beads and style of garment say a lot. Historically, young girls were given little beaded dolls to ensure their fertility, and traditional healers continue to use the figurines as mystic agents of wellbeing.

Traditionally, outfits denoted status. After initiation and during the betrothal period, the young woman – clothed in beaded goatskin apron – customarily retired for two weeks of seclusion in a special part of the family homestead. Then, during the latter part of the protracted marriage rituals, and after the birth of the first child, she donned another type of apron, and finally dressed herself in a striped blanket (the stripes are vertical) and adorned herself with a metal necklace. Metal was traditionally worn only by a married woman. The necklace was presented to her by her husband, and only after the couple's new house had been built (before then, the traditional bride was usually resplendent in a large, beaded grass hoop). During all this, the bridegroom's mother wore beaded material at the sides of her head. The flaps are known as *linga koba*, which means 'long tears' and signified sorrow at losing her son, but also joy for the impending marriage.

Traditional hairstyles were distinctive: much of the head was shorn, leaving small amounts of hair bright with beads and coins and often worn modestly, low over the eyes.

In most communities, chieftaincy remains deeply respected, even venerated, but it is the office, not the man, on which reverence is lavished. Moreover, much of traditional government is exercised not by edict but by consensus: the chief is obliged to listen to his councillors, who are directly answerable to the people. Local matters are handled by the headmen, who mirrors in microcosm the chief's responsibilities, duties and values.

The qualities expected of the chief are fairness, impartiality and generosity, and history has shown that if the chief ever failed his people he was replaced by a more benevolent member of the family or his subjects simply drifted away, either to join different groups or to form their own.

A great deal of traditional Ndebele custom and ritual conforms to the classic pattern of the Northern Nguni, notably the Zulu. Once every four or so years youngsters are ritualistically admitted to adulthood. Historically, boys were organised in age-group schools that provided the structure for military service, producing disciplined and effective armed forces. Unlike the Zulu, however, the Ndebele have retained the practice of circumcision. The nature and requirements of kinship, too, though basically similar, differ somewhat between the two peoples. To both, clan is all important; both prohibit marriage within the *isibongo* (clan), but the rules of the Ndebele, influenced by contact with the Sotho, are not quite as rigid.

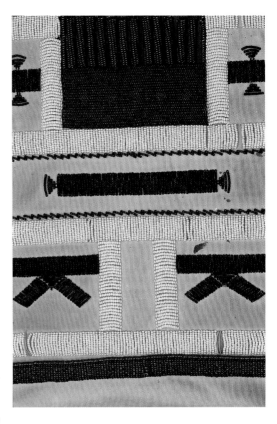

ABOVE Beadwork panels are loaded with hidden meaning, often expressing a woman's recollections, her hopes, or simply her feelings. Beads are prominent in local crafts, and beaded dolls are given to Ndebele girls as fertility charms, for example.

The spiritual life of the traditional Ndebele is a mix of ancestor worship and animism (the endowment of natural features and objects with a mystic persona). There is a Supreme Being, called Mulimo (alternatively, Mlimo or Zimu), lord of the universe and provider of rain but otherwise too grand and too distant to be involved in the affairs of mere mortals. Much more intimate are the *abezimu* (ancestral spirits), who speak to their descendants through a medium or diviner.

Music and dance feature prominently in traditional communities, though instruments are simple, usually comprising a kind of flute and a bow-plus-calabash. Perhaps the most important ceremony is the Luma, a festival reminiscent of the celebration of first fruits. The name means 'bite', a reference to the ritual sampling of the new harvest's products by the chief or headman.

Land and landmarks

The Ndebele of Mzilikazi are long gone from the Magaliesberg area, but it was once their home, and the hills remain much as they were in the days of the great king. The mountain range runs eastwards for about 120 kilometres from a point near the town of Rustenburg, rising little more than 300 metres above the flattish, fertile plains. The heights are modest in size and elevation, but the soil is rich and red, the slopes well wooded and rainfall is usually generous, the upper levels the source of streams that feed into the northward flowing tributaries of the Limpopo.

The region attracted great concourses of game animals in the early days and in turn the wildlife, especially the elephants, became a magnet for the white hunters who came with their guns, and they left behind uncountable numbers of carcasses, wastefully unwanted, abandoned to the hyenas and the bleaching African sun. They were followed by Mzilikazi's *impi*s, who named the region after the local chieftain Mohali, or Magali, and finally by the Voortrekker pastoralists.

The Magaliesberg and the KwaNdebele region (the artificial 'homeland' created for the southern Ndebele by the apartheid regime, but which did not reflect the actual distribution of the isiNdebele-speaking people), has its own cultural, scenic and wildlife assets, most notable of which is perhaps the fairly new Borakalalo National Park, already well known for its impressive bird life.

Further north lies a belt of hills known as the Waterberg for its many perennial streams, beyond which are the Springbok Flats and a great swathe of rugged bushveld countryside. Some of the larger properties here have been retained as private game areas, many of which have been and are being sensibly managed, and thus rank among the country's more rewarding game-viewing venues. Most notable of these is Lapalala, a huge expanse of bushveld that has been set aside as a wholly untouched wilderness, and another 7 500-hectare chunk for environmental education.

Far to the north, across the Limpopo and the sere, sandy fringes of the Kalahari, are the Matobo hills, where the ancient Karangan oracles once received the words of the all-powerful god Mwari, a sacred site to the Zimbabwe Ndebele (known as Matabele to the Sotho) and last home of their founder Mzilikazi. The hills are now the centrepiece of a national park, a place of craggy, hauntingly beautiful landscapes, of far horizons, of a profound silence and an air of primeval mystery. The Matobos are known for, among other things, the huge granite domes and 'whalebacks' and for their balancing rocks, bizarre formations created during the cooling of the earth's surface three billion years ago and refined over the aeons by wind and rain.

OPPOSITE Youngsters in traditional clothing. Metal and beads are notably absent, but aprons and thick leg-bands speak of an earlier and perhaps more graceful age. Today, even rural youngsters seldom dress in traditional fashion, unless for special occasions, and are more likely to be seen in contemporary gear.

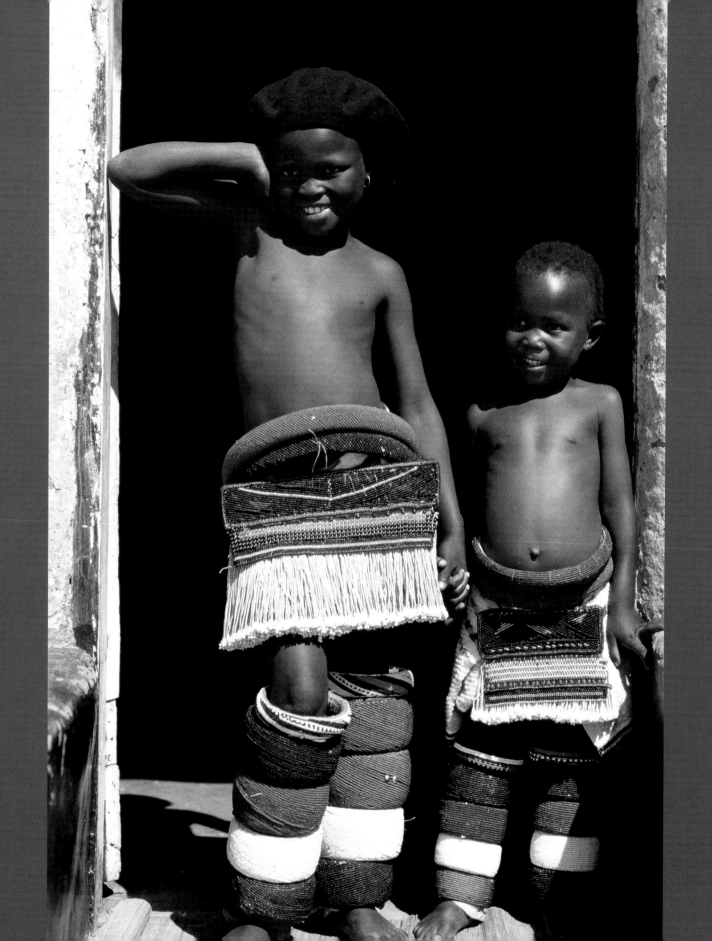

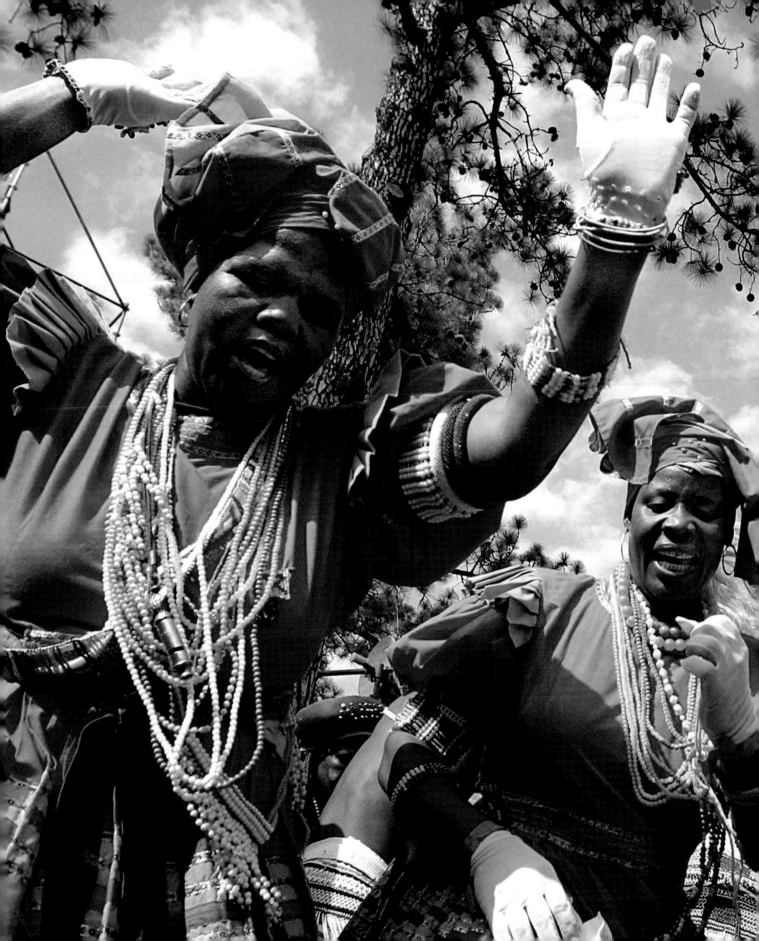

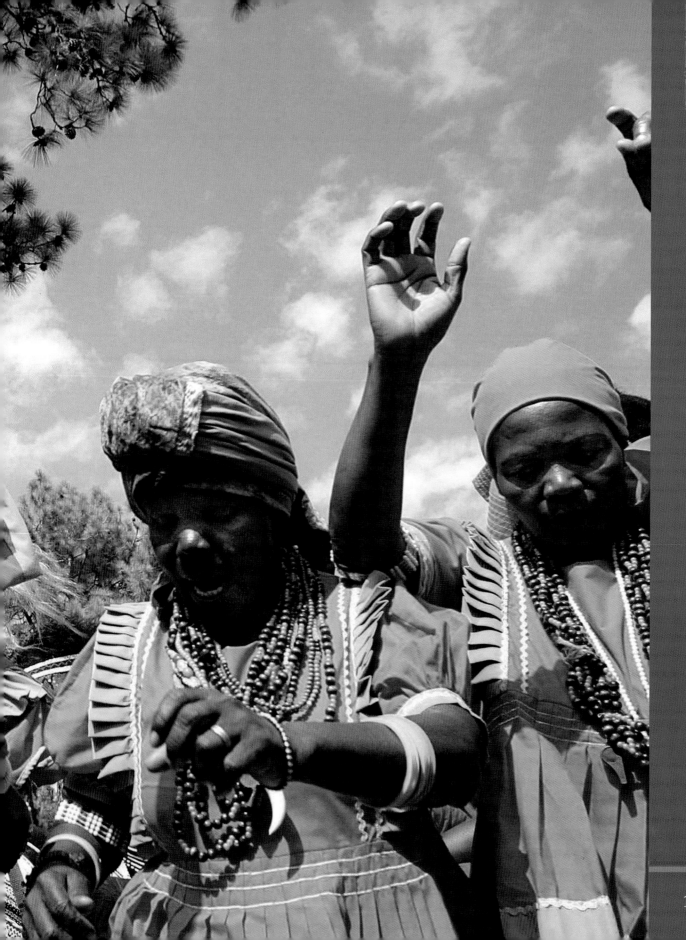

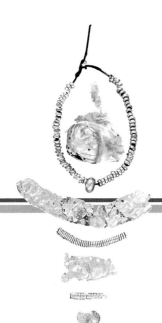

Venda

Water world

Fundudzi, South Africa's largest lake, is a five-kilometre, limpid stretch of water wreathed in legend, lore and myth. It lies beneath the Soutpansberg in the far northeast, part of Limpopo province, home to the ancestral spirits and lair of the python god of fertility, sinister in its associations with human sacrifice. To the Venda, it is a sacred place.

Stories of Fundudzi's origins vary. Most traditional Venda ascribe its creation to Roluvimba, a divine being who built the world and left his footprint behind. He also bequeathed to this place his magical drums, instruments that – if you stand still and listen carefully – may sometimes be heard among the hills and valleys. Moreover, Roluvimba himself returns to the lake from time to time to bathe in its coolness. Another story tells of a troubled stranger who asked for food and shelter, and of his rejection by the local people. Before leaving, it is said, the stranger cursed the village, which disappeared beneath swiftly rising water. The cries of the drowned and the bellows of their cattle also sometimes rise from the placid surface of the lake.

Water and drums are a recurring theme in the folklore and ritual. Water indeed is the essence of the mystery and beauty of the traditional Venda land. Upland streams nurture the soil, and there are waterfalls – among them Phiphidi – as well as thermal springs. Each of these elements has its significance in the local belief system. *Zwidutwande* (water sprites), for example, are beings who live partly in this world and partly in the spirit world and inhabit the pools below the falls. But the *zwidutwande* cannot grow crops under water, so the people of the area take them offerings of food.

Mysteries of the past

How the Venda came to occupy the region, who they were, and where they came from are questions that cannot be answered with precision even among historians. The picture is blurred, perhaps because not all Venda share a common ancestry. Most are thought to have originated in

PREVIOUS PAGES Venda women sing and dance in celebration of the 10th anniversary of the end of apartheid and the swearing-in of Thabo Mbeki, Nelson Mandela's successor as president in April 2004. OPPOSITE Venda woman gather thatching material for the homestead. The society is traditionally polygamous, with wives strictly ranked within the family.

MAGATO'S HOUSE & STRONGHOLD.

ABOVE A Venda village and the stronghold of some 120 years ago. Historically, settlements tended to be large, stockaded and, preferably, built on the more easily defended terrain of a mountain slope.

the vicinity of the Great Lakes, and parts of the language, Tshivenḓa, and elements of custom too, point clearly to East African roots. From here they moved down the continent in slow migratory waves, some arriving as early as a millennium ago, at a time when the remarkably advanced kingdom of Mapungubwe flourished in the region south of the Limpopo River. They brought with them some of the features and skills of the Great Zimbabwean culture to the north, notably a talent for building citadels – a skill already well developed by the architects of Mapungubwe.

Others remained north of the Limpopo, sharing in the power and prosperity of the Roswi-Karanga empire before they too moved further south in the early eighteenth century. Foremost among the early stone-walled centres of the Venda was D'zata, home to the folk hero Thoho-ya-Ndou, which means Head of the Elephant and reflects the awe and reverence in which he was and is held. Even today, when a chief dies, he is buried with his head pointing towards this ancient citadel.

Over the centuries the Venda have shown themselves to be an independent-minded people, prepared to fight hard for their land when challenged. Voortrekkers found this out when they began encroaching on the Venda territory in the 1840s. The northernmost Boer settlement was Schoemansdal, founded in 1847 and a place that embraced all the eccentricities of a Wild West frontier town. Ivory traders, cattle rustlers, hunters, gunmen and all kinds of other adventurers made Schoemansdal their base. Feuding and fighting became a way of life (30 tons of lead, for the making of bullets, was being imported each year), and the townsfolk closed ranks only when they were harassed by resident clans, which was often. Two decades after its unwelcome birth, Schoemansdal faced and fell to a major assault led by Makhado of the Venda. The victors reduced the town to rubble. The struggle continued under Makhado's son Mphephu, but in the end modern firepower and experienced military organisation won the day, and Mphephu finally fled across the Limpopo into Zimbabwe.

A hundred years later, as part of the 'grand apartheid' segregationist programme, the Venda were given a form of autonomous statehood. The homeland of Venda was the smallest of the four 'independent' republics (there were six other regions scheduled for the same status before history overtook the legislators) and, in material terms, probably the poorest. Its income was derived in large measure from migrant labourers working on the Witwatersrand, the country's industrial heartland.

Costume and dance

Diverse origins, interaction and intermarriage with such other groups as the Swazi and Sotho have left their imprint on the culture of the Venda, but most of the original heritage remains in place – including social structure. This comprises a number of 'tribal' units, and some two dozen clans, which differ somewhat from each other in custom and ritual. There is no paramount chief; each group owes allegiance to a particular dynasty.

Traditional culture, lifestyle and costume were and are distinctive. According to custom, pale blue is the colour most favoured. Traditionally, women wear a striped cotton-cloth cape, which serves as both a back-panel and a skirt. Among the adornments are necklaces of small cylindrical beads, the many strands brought together by a seashell (often a handsome cowrie) or some other revered object. Amulets, many-ringed anklets and bracelets complete the ensemble. Ancient trade beads were especially treasured and were used in ceremony, and in communication with the ancestors, the best known and most effective of them the blue *uhulungu hamadi* ('beads of the sea') and the white *limanda* ('beads of power').

Much about the belief system of the Venda is hidden behind a veil of secrecy, but parts of the hallowed coming-of-age process is both visibly spectacular and occasionally accessible to outsiders. The boys undergo *murundu* or circumcision. The girls stay at the chief's homestead throughout a somewhat protracted initiation period (though since formal schooling became so important, the sojourn has been limited to weekends) during which time they are prepared in the ways of the forbears for marriage, child-bearing and raising children, and for the proper relationship between husband and wife. At one time, in fact, the two sexes shared the premarital seclusion, but prudish Victorian missionaries soon put a stop to that.

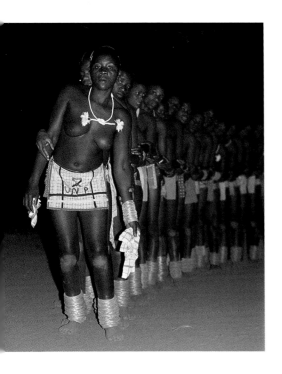

The last ceremony in the long lead-up to initiation is the striking *domba* python dance, which both pays homage to the ancestors and honours fertility and sexual love. The girls form a long line, each holding the forearm of the one in front, and gracefully move around the sacred fire to the heady beat of drums. They are almost naked (nakedness is not shameful among most traditional peoples), their only clothing a *shedu*, a strip of cloth worn between the legs and held in place with metal beads. To watch the *domba* is a memorable experience, and to be one of the dancers is to undergo the most important of transitions, that from childhood to womanhood.

There are, of course, also traditional dances that have little or nothing to do with initiation. The chief, for example, has a special one to himself. *Tshikona* is danced to what can be called the 'national music', in which men play bamboo pipes, each player blowing just one note and the whole combining to produce both harmony and melody. *Tshikona* still features at such major events as weddings, feasts and funerals. *Tshibombela*, on the other hand, is an all-female dance performed by married women, sometimes at the same ceremony, while *tshihasa* is reserved for unmarried girls. Traditional instruments include the *mbila*, a wood-and-nail keyboard, although creating its evocative sound is now fast becoming a lost art. It is the drum, though, that remains king.

Relics of empire

ABOVE The sinuous *domba*, or python dance, perhaps the high point in the rituals of initiation into womanhood. Each dancer holds the forearm of the girl in front, their swaying action mimicking the movement of a serpent.

Historically, the Venda were skilled metalworkers, builders and traders, accomplishments derived at least in part from their distant associations with Great Zimbabwe and the Mapungubwe culture.

The ruins of Mapungubwe (translated as the Hill of the Jackals) lie to the west of the Great North Road, at the confluence of the Limpopo and Shashe rivers. The stones are silent now, but between the years 800 and 1200 they served as the hub of a highly advanced society whose entrepreneurs formed part of a then-global commercial network that covered not only Africa but extended, it appears, all the way across southern Asia to China. Especially significant within the citadel is the area known as the Burial Ground of the Kings, from which some fascinating artefacts have been unearthed, including an exquisite little gold-plated figure of a rhinoceros, together with a golden bowl. Among other finds are jewellery, pottery, iron implements and the sites of numerous Iron Age mine workings.

The people of Mapungubwe eventually abandoned their kingdom, most making their way across the Limpopo to help create the flourishing state of Great Zimbabwe. The ruins, now a national heritage site, are enclosed within the Mapungubwe National Park, itself part of the Limpopo/Shashe Transfrontier Conservation Area, one of the subcontinent's progressive cross-border peace parks.

A rather strange element within Venda society, one that has puzzled anthropologists and historians, is the Lemba component. Its members refer to themselves as Black Jews, and also as Lungu, which roughly translates as 'respected foreigners'. They believe that their forefathers, who entered Africa around AD 700, were descendants of one of Israel's lost tribes. And indeed there are hints of a Semitic ancestry. They are dark-skinned, of course, but many individuals have sharp

faces and thin lips. The Lemba also prohibit the consumption of pork and will eat other meats only if the animal has been slaughtered in the Middle Eastern fashion. At one time, their language contained non-Bantu words, and names such as Hadzhi and Sadiki are still found in the community today. These unique people are not numerous, and are scattered in the wider society, but they do tend to keep to themselves, and to marry within their group.

The northern wilderness

The traditional land of the Venda hugs the northern reaches of the Kruger National Park. This was one of the last parts of the country to feel the controlling hand of the settler, and indeed that stretch between the Limpopo and Pafuri rivers, familiarly known as Crooks' Corner, remained so isolated from the mainstream that, during the early 1900s, it served as a perfectly safe refuge for poachers, illegal labour recruiters and fugitives of various sorts.

No fewer than nine of Africa's major ecosystems meet and mix at this far northern section, which accounts for its extraordinary diversity: grassy plains and dense bushveld, wetlands and sandveld, lava flats and granite koppies, woodlands, evergreen forest and much else. And, of course, this complexity is reflected in the character of the plants and animals of the region.

The Kruger, though, is not the region's only wildlife haven. To the north of Thohoyandou, on the slopes of the Soutpansberg, is the Nwanedi Nature Reserve, an expanse of mopane and mixed woodland. And there can be few more attractive ranges than the Soutpansberg (Salt Pan Mountain), a 130-kilometre chain of sandstone hills that rise to a little over 1 700 metres at their highest. The slopes and plateau are graced by dense exotic plantations, but also by areas of natural forest.

ABOVE The gold-plated figurine of a rhino, unearthed from the Burial Ground of the Kings at Mapungubwe. This advanced trading culture had connections with regions as far afield as China.
BELOW For more than ten centuries, the 30-metre Magungubwe Hill served as an impregnable fortress, the stronghold and treasure house of a civilisation that was remarkably sophisticated.

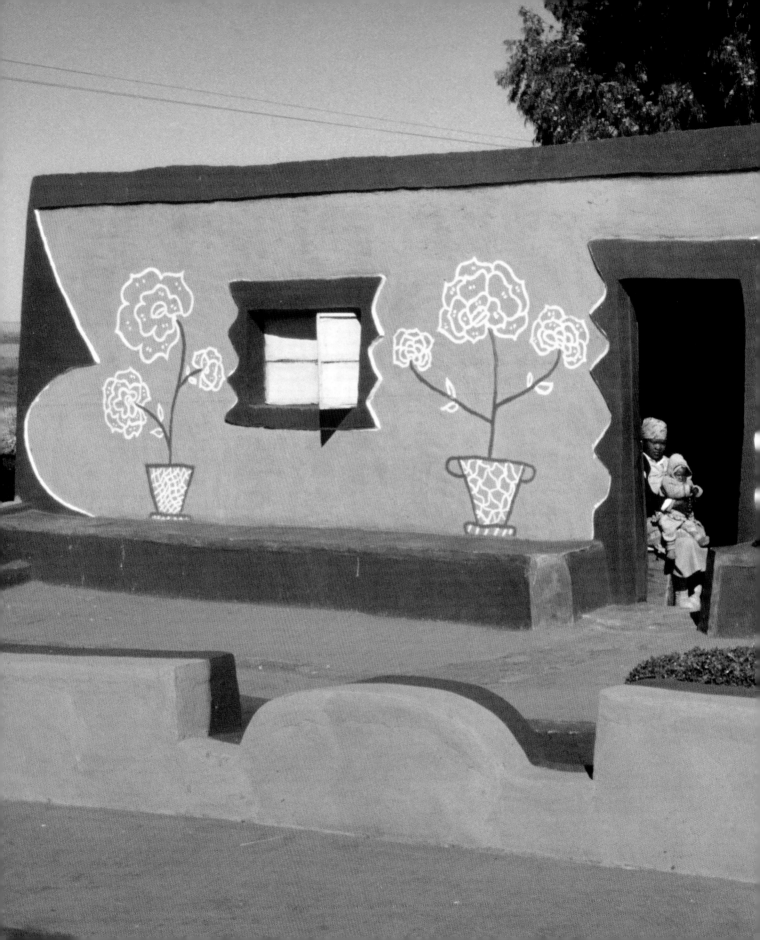

Tswana

Big sky country

The origins of the Tswana in southern Africa – how they came to occupy what is now South Africa's North West province and the great plains of the Kalahari to the north – are clouded by the passage of time and the inconsistencies of folklore. Oral history, legend and modern research suggest that they were preceded by the San (Bushman), who had been resident for centuries and even millennia, and then by the Kgalagadi, who had a cultural affinity with the Sotho-speaking peoples and who migrated to the region in the 1400s.

It seems that the main body of the 'true' Tswana, however, crossed the Limpopo sometime in the sixteenth century and that their chief, Malope, ruled the region to the west of what is today Pretoria. One of Malope's sons then, it is thought, gathered a following and trekked to the Zeerust area in the north. This sounds valid enough: one of the constants in the story of the Tswana, and a characteristic that tends to confuse amateur historians, is the tendency for communities to split, migrate and then, often, to merge with other, usually bigger groupings. Unlike many Bantu-speaking societies, the Tswana rarely experienced internal strife when the chief died. His progeny and their rivals for succession preferred simply to move away rather than fight it out, and the result was a continuous process of fission.

But there were also counter forces that encouraged fusion. These were cattle-owning communities; wealth and respect were related directly to the number of livestock, and the poorer groups would naturally gravitate towards and allow themselves to be absorbed into richer ones.

The major groups were the Ngwato in Botswana, the Tlhaping around Taung, the Ngwaketse and the Kwena. But although they were coherent groupings they could not claim to be homogenous, certainly in terms of the heritage. The Ngwato, for example, originated from more than 20 separate communities; the Ngwaketse from 14. And there are almost as many dialects of Setswana (or Sechuana) – which is itself more or less a dialect of Sesotho – as there are groups. Still, the ties that bind remained stronger than the distinctions imposed by individual legacy and language.

PREVIOUS PAGES A typical traditional homestead. Like the Venda, though perhaps less spectacularly, the Tswana are known for their colourful murals. Chevrons are a consistent element.
OPPOSITE A roadside pot market. The decoration of utensils usually involves a circular band, often containing the characteristic chevron pattern, which is first painted on and then burnt into the clay.

134

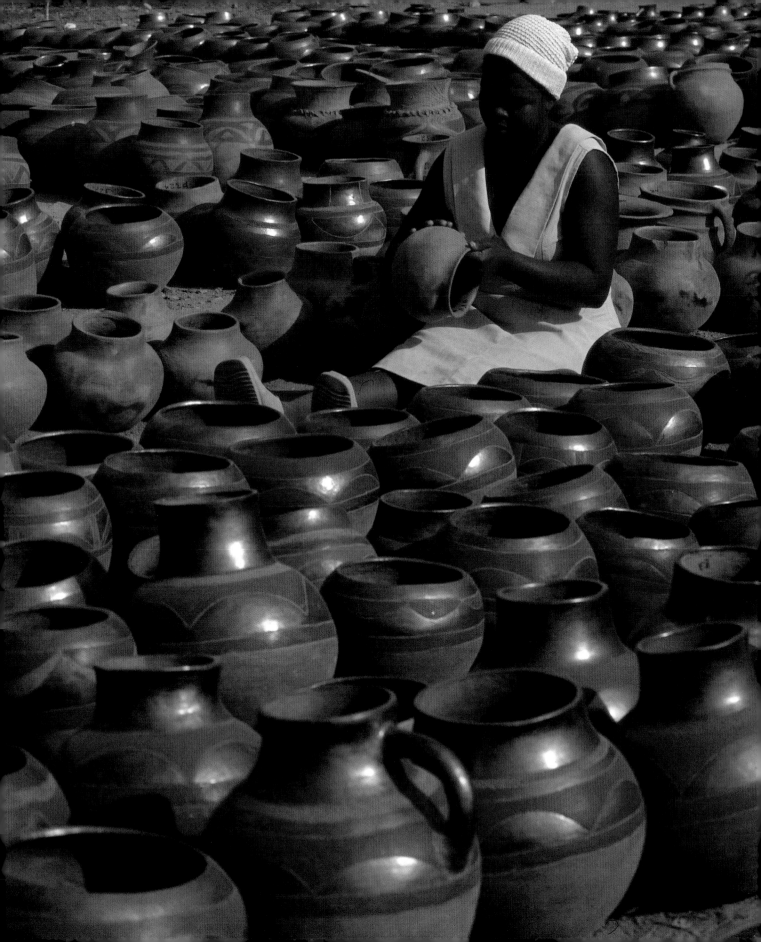

No 32. Bacquain Salutation (Chuare l'nko) pull the nose or making Brothers — 1834

LEFT *Kwena Rites and Customs*, a watercolour by well-known artist Charles Bell (1813–1882). Bell accompanied Andrew Smith's mid-1830s expedition into the interior, later serving as Surveyor-General of the Cape Colony.
BELOW The large Kwena town of Molepolele, or rather – according to the early photographer – 'a very small portion of the town of 15 000 inhabitants'. Special note is made by the photographer of the local trader's tin home, which contrasts with the humble kraals of the locals.

Pain and progress

The two geographical divisions of the Tswana-speaking people – those who live in Botswana and their South African counterparts – have very different political tales to tell. The former have, on the whole, a happy story, certainly over recent times. Botswana ranks among Africa's most stable countries, richer than most, drawing its wealth from diamonds, cattle and tourism, democratic, efficiently governed, unspectacular but effective in its embrace of the modern age. The most controversial of its internal issues is perhaps the status of its minorities, most notably that of the San of the central Kalahari, locally known as Basarwa.

Conversion to Christianity was one of the early and arguably most powerful dynamics. White explorers, notably William Somerville and PJ Truter, had made their way into the then-remote Tswana region during the first year of the nineteenth century; naturalists and travellers Heinrich Lichtenstein and William Burchell followed shortly afterward. But it was the arrival of the churchmen that sparked the first move towards modernism. John Campbell of the London Missionary Society entered the land of the Tlhaping in 1813 and was cordially received by Chief Mothibe, who urged his guest to 'send instructors, and I will be a father to them'. Most important of these instructors was Robert Moffat.

This was a turbulent time in the region, indeed across the entire subcontinent, or at least the eastern half of it. The ripples of the *mfecane* had spread far and wide. Among the foreign intruders – part refugees, part aggressive marauders – were the Tlokwa, led by their warrior-queen MaNthatisi and her son Sekonyela. Then there was Sebetwane and his Kololo people, who eventually established an independent kingdom astride the middle reaches of the Zambezi. In 1825 the Hlakawana and Phuting descended on the old Tlhaping town of Dithakong intent on doing battle and resisting Robert Moffat's efforts to bring peace to the land. Moffat eventually lost patience and brought in a detachment of well-armed, mounted Griqua (mixed race) soldiers to rout the invaders (and, incidentally, to take slaves, which Moffat duly sold).

Most formidable of all the newcomers, however, was Mzilikazi and his Ndebele, who eventually settled around the Marico River, close to present-day Botswana's southeastern border. By this time the missionary presence was well established. And, remarkably, Mzilikazi, the scourge of the Tswana, became Moffat's close friend, admitting the cleric into his inner circle and listening carefully to his advice on both moral and practical matters.

Mzilikazi, though, never committed himself to the Christian faith. In fact the missionaries found it hard going in the early days. It was six years before Moffat could claim his first convert. The Tswana were more interested in the worldly knowledge he and his small band brought with them than in The Word – which was understandable enough, because the unwelcome intrusions were continuing apace, the threat to Tswana integrity intensifying with the encroachment of the white Voortrekker vanguard from the south. Sensibly, the chiefs turned to the most benevolent of the newcomers, those who came to preach the Gospel (and who were surprisingly well connected on the outside) for help.

Moreover, the Boers were deeply distrustful of the English-speaking men of God, and most especially of the explorer-missionary David Livingstone, who had converted the Kwena chief Sechele, married Moffat's daughter Mary and who, the Boers suspected, was inspiring Kwena

ABOVE True to the customs of old, many rural homes still boast the traditional thatch roofs. Thatching, an excellent insulation against both the heat and cold, is an intricate and time-consuming skill passed down from one generation to the next.

resistance to their territorial ambitions. There were incidents. In 1852, after the Kwena capital Dimawe had been ransacked, the Kwena chased the invaders out of their country. This was a portent of things to come, the first of a series of confrontations in these far-northern places – most of them confined to the political arena – that involved three quite different sets of interests. Those involved were the Tswana (notably the Rolong group), who were anxious to preserve their independence and identity; the Boers of the new and expansionist Transvaal republic; and the British, who had commercial ambitions. Outside attention became even more focused when diamonds were discovered on the interior plateau, which instantly elevated the wider region from forgettable backwater to potential El Dorado. Moreover, signs of gold had been discovered in the far north – and the only practical access to the fields was the so-called Missionaries' Road, which passed through the lands of the Tswana. Whoever controlled the road could, just possibly, control the future of the subcontinent.

Enter the Ngwato chief Kgama (or Khama), the third to bear the name, a ruler of independent mind and the very embodiment of natural wisdom. Kgama took office in 1872 and served his people until his death in 1923 at the age of 96. He had embraced the Christian faith in the 1860s. He also demonstrated his courage when, while his father Sekgoma seemed content merely to evoke the powers of the spirits, he led his troops to victory against the Ndebele of the north and then turned his back, decisively and uncompromisingly, on many of what he perceived to be the

antiquated ways of his people. He refused to attend the customary *bogwera* (tribal school). Nor would he marry a second wife, provoking such fury among the traditionalists that his own father tried to kill him. He was thus forced to take refuge.

Kgama, though, was too popular to be discounted and in due course his supporters, after some skirmishes, forced his father to flee and enthroned the young man as paramount chief of the Ngwato. Far in the future he was to be succeeded by his own son Tshekedi Khama who, in turn, handed the reins on to his nephew Seretse, first executive president of an independent Botswana. Seretse, who died in 1980, was a pragmatist to whom skin colour meant little (he married a white Englishwoman) and a worthy heir to the conventions established by his great-uncle.

Thus Botswana enjoyed what, in Africa, was unparalleled continuity of good leadership. For more than a century its affairs were in the hands of just three men, each well capable of handling the affairs of state and meeting the challenges of a changing world.

The Tswana who live, in greater numbers, across the border in South Africa were not treated nearly as well by time and political circumstance. Like other cultural and linguistic black groups they were regarded by the apartheid state as second-class citizens, given a modicum of local self-government in the 1960s and confined to their own 'homeland', which comprised seven small tracts of overcrowded veld scattered across three of South Africa's four former provinces and collectively named Bophuthatswana, which means That Which Binds the Tswana. It was granted republican status at the end of 1977, but no one except the Pretoria regime recognised its independence.

The legacy

The most striking part of Tswana heritage is probably the structure of society in much of Botswana, underpinned by the unusually large traditional village, which serves as the capital of the grouping. Of these groupings there were (and are) about a dozen, biggest of which is the Ngwato (Bamangwato). Headquartered at Serowe in the east, it accounts for about a quarter of the country's population and was generally recognised as the dominant force. Rather smaller but still major Tswana societies include the Kwena, the Ngwaketse, both of whom are concentrated in the Gaborone area; and the Kgatla, the Malete and the Tlokwa in the southeast. Around the border with South Africa are the Rolong, and, in the interior, the Tawana.

All these peoples are interrelated, although each traditionally had its own lands and its own chiefdom. None, however, is a homogenous unit – over the centuries, they absorbed other peoples of both Tswana and non-Tswana origin. It has been reckoned, for example, that the majority of the Ngwato – up to 80 per cent of the group – comprises 'foreign' elements.

Historically, cattle were the great common denominator, the element that spoke of wealth and of social status, even venerated in ritual. In days gone by most of Botswana's inhabitants were involved in stockfarming, even though the big villages may have been far from the vast communal grazing grounds. For much of the time herdsmen would find shelter in outlying cattle posts, returning to home base and their families at intervals. Some of the wealthier farmers owned dozens of these posts, which could be anything up to 100 kilometres away from their nearest neighbour. Much closer to the village were the cultivated lands, and these too were subject to

ritual and magical practices: rain-making had deep significance; the diviner would 'treat' seeds before the planting season; sacrifices would be made to the ancestral spirits; the first fruits of the harvest were received, or 'tasted', with elaborate ceremony.

If there is a modern phrase to describe the political life of the Tswana it is 'village democracy'. Each concentration of people was divided into *dikgotla* (community councils), and each one of which was served by an open meeting place in which local affairs were debated. There was also a composite village *lekgotla*, a centrally located, rather grander, more spacious place reserved for the local chief (or subchief). As with other Sotho-related groups, each Tswana family also had its open space, or courtyard.

Traditionally, the smaller human hubs maintained close relations with the tribal capital, seat of a government that was embodied in the person of the paramount chief, whose authority was technically absolute but who ruled largely by consensus and always with the advice of his senior relatives and officials. Moreover, really important public issues were often decided at a great gathering to which the people, all of them, were invited. The chief's responsibilities were heavy, especially so when it came to the land, which he held in trust for and used to the benefit of his subjects. In return he was venerated, serving – as one writer put it – as 'the symbol of tribal unity, the central figure around whom tribal life revolves. He is at once ruler, judge, maker and guardian of the law, repository of wealth, dispenser of gifts, leader in war, priest and magician of the people.'

Status within traditional Tswana society is well defined: it stretches down from the paramount chief and his kinsmen, through the aristocracy to the commoners. Historically, bottom of the social heap were the newcomers, outsiders who had been accepted into the group but were not yet wholly assimilated. Relationships within the groups, however, were complex. The extended family was – and remains so in traditional homes – the basic unit. The eldest son of the senior wife succeeded to the leadership, but cutting across these linear arrangements and loyalties was the network of age-graded groups, or 'regiments', comprising young men from different places collectively trained and mobilised for defence. There were general call-ups to military service every four years or so, and initiation into the regiments was an elaborate affair involving circumcision, seclusion and intricate ceremony. Young girls also gathered together in sets to learn the skills needed to become a good woman, a good wife, and a good mother.

Tasks were gender-driven in the early days. Men tended the cattle, waged war, embarked on cattle raids, and hunted; the women looked after the crops and the home. Some of the culture, custom and costume of the Tswana was similar if not identical to that of other Sotho peoples, including the nature of betrothal and marriage, which were arranged as much, indeed more, in the interests of the two families as in those of the young couple. The latter really had no say in the choice of partner: they simply had to follow the rules, and the dictates of their elders. A girl would often become betrothed while still a child, never having met her future husband. And the system worked very well indeed – the marriage institution was stable, solidly bound by the formal regulations and routines of ancient precedent, the rights and responsibilities of each spouse recognised and respected.

Religion, too, was cast in the general Sotho mould, with belief in and reverence for the *badimo* (ancestral spirits) being the central dynamic. These unseen entities remain guardians of family, kin and tribal grouping, and to make sure of their kindliness – and to avert their anger – their

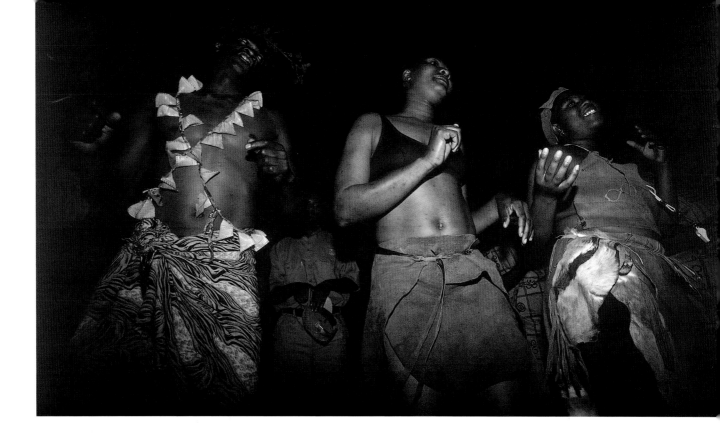

descendants make regular offerings and prayers. The various types of spirit mediums – diviners and healers – are key figures in communication between the dead and the living. In common with other Bantu, there is also acceptance of a Supreme Being, Modimo, the Creator of all things, who is infinitely remote and uninvolved in human affairs.

The Tswana have their distinct musical traditions, although the type and variety of their instruments were restricted by the generally semi-arid terrain of their traditional lands and consequent lack of natural materials. The people of what is now North West province, for example, are known for a stately dance routine in which each man blows a pipe while the group slowly revolves in a series of choreographed steps. One favoured instrument is a fairly elaborate whistle made up of several reed flutes of different lengths and played as a unit – a kind of Pan's pipe. Other common dance accompaniments include conical hand-beaten drums, ankle and wrist rattles, animal horns (used mainly for signalling), stopped pipes and various stringed items.

Creative talent is also traditionally expressed in mural art which, although most dramatic among the Ndebele, actually originated with the Tswana, emerging only after the reed 'beehive' house was abandoned in favour of the more solid, vertically walled rondavel (circular) dwelling. Patterns are generally simple, geometric, bold – full of triangles and diamonds, rectangles and chevrons (the most common motif in the highly advanced Great Zimbabwe culture to the northeast). The spaces inside the symbols were usually filled with straight, coloured lines or with solid ochre. Later came more recognisable decorative figures, especially of animals.

Craftwork has always been of a high standard. The missionary John Campbell noted in the early 1800s that the southern Tswana 'were more advanced' than their distant Nguni cousins. Their homes were 'not only larger and more carefully constructed, but the walls were painted and adorned with various patterns'.

ABOVE Traditional dancing may see the men playing a pipe instrument, while the dancers – occasionally wearing beaded ornamentation and animal-skin clothing – follow steps and sequences of long-gone choreographers.

Further reading

Non-academic books on South African indigenous cultures, certainly works of recent vintage, are few in number – perhaps because the apartheid regime singled out the various linguistic groups for 'special treatment', and publishers have tended to shy away from anything that hints of racial compartments. However, there have been some worthwhile releases during the past few years, among the best of which is David Hammond-Tooke's *The Roots of Black South Africa* (Jonathan Ball, Johannesburg, 1993). Less informative but visually splendid are *Vanishing Cultures* by Peter Magubane (Struik, Cape Town, 1998), and *Peoples of the South* by Roger and Pat de la Harpe and Sue Derwent (Sunbird, Cape Town, 2001).

The Standard Encyclopaedia of South Africa (in 12 volumes, published in the 1970s) is somewhat out of date but, despite the nature of the times, contains detailed and generally honest coverage of the subject. For a more modern perspective, read Frank Welsh's excellent *A History of South Africa* (HarperCollins, London, 1998). Also fairly current is *The Heart of Redness* by Zakes Mda (Oxford University Press, Cape Town, 2000).

Most of the titles listed below are out of print, but publishing, availability and other details can be accessed via the Internet.

- Three works by the noted costume historian Barbara Tyrrell, published in the 1970s and 1980s, are recommended. They are *Tribal Peoples of Southern Africa, Suspicion is My Name,* and *African Heritage*.
- The early pages of Nelson Mandela's *Long Walk to Freedom* (Little, Brown & Co., London, 1995) offer a fascinating insight into the world of the Xhosa people.
- Among classics are Sol Plaatje's *Native Life in South Africa*; J.H. Soga's *The Ama-Xhosa: Life and Customs* (1932); Donald Morris's *The Washing of the Spears* (Zulu), Laurens van der Post's *The Lost World of the Kalahari*; and Credo Mutwa's *Indaba My Children*, subtitled 'African tribal history, legends, customs and religion'.

Works of interest to students and researchers include:
- Ashton, EH. *The Basuto* (Oxford University Press, London, 1952)
- Barnard, John. *Hunters and Herders of Southern Africa* (Cambridge University Press, Cambridge, 1992)
- Edgerton, Robert. *Like Lions They Fought*: The Zulu war and the last black empires in South Africa (The Free Press, New York, 1988)
- Ehret, Christopher. *An African Classical Age* (University Press of Virginia, Charlottesville, 1998)
- Krige, EJ. *The Social System of the Zulu* (Longman Green, London, 1936)
- Krige, EJ and Krige, JD. *The Realm of a Rain Queen* (Oxford University Press, Oxford, 1943)
- Krige, EJ and Felgate, W. *The Tembe Thonga of Natal and Mozambique (University of Natyal, Durban, 1982)*
- Hammond-Tooke. WD, *Boundaries and Belief: The Structure of a Sotho Worldview* (Human Sciences Research Council, Cape Town, 1982)
- Hammond-Tooke. WD, *Bhaca Society* (Skotaville Publishers, Johannesburg, 1987)
- Hoagland, Jim. *South Africa: Civilizations in Conflict* (Houghton Mifflin, Boston, 1972)
- Mostert, Noel. *Frontiers*: An epic of South Africa's creation and the tragedy of the Xhosa people (Knopf, New York, 1992)
- Schapera, I. *The Tswana* (International African Institute, 1953)

Index